IMAGES
of America

SAN FRANCISCO'S
SUNSET DISTRICT

IMAGES
of America

SAN FRANCISCO'S
SUNSET DISTRICT

Lorri Ungaretti

ARCADIA
PUBLISHING

Published by Arcadia Publishing
Charleston, South Carolina

Library of Congress Catalog Card Number: 2003110806

For all general information contact Arcadia Publishing at:
Telephone 843-853-2070
Fax 843-853-0044
E-mail sales@arcadiapublishing.com
For customer service and orders:
Toll-Free 1-888-313-2665

Visit us on the Internet at www.arcadiapublishing.com

This book is for my mother, Dorothy Bryant, who has always inspired me.

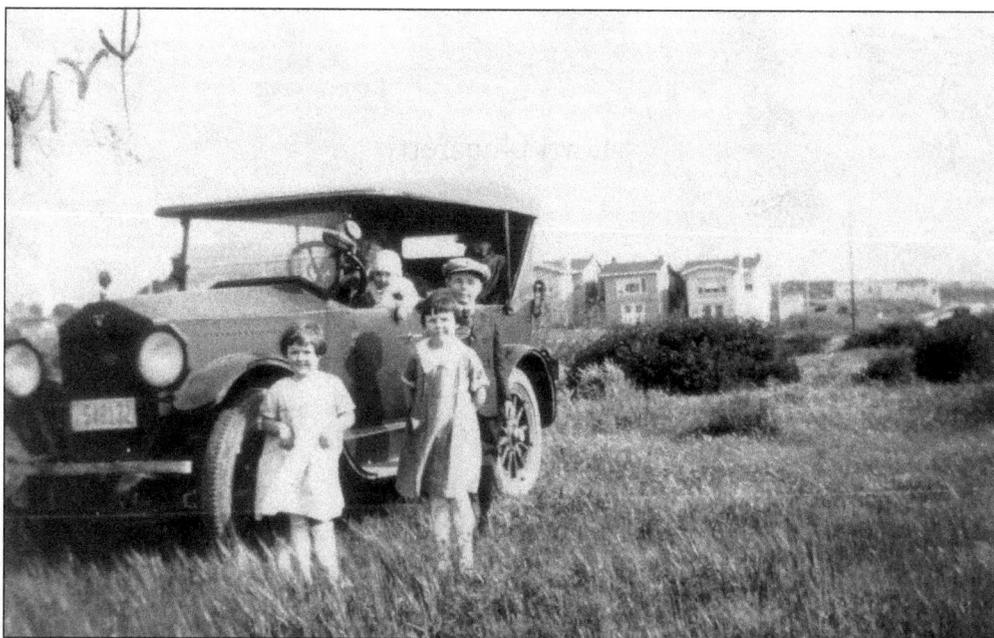

Cover, and Above: By 1924, when Rosemary Trodden (at right) posed with her family in the Sunset District, houses had begun to spring up among the dunes. Rosemary recalls, "We lived on Laguna Street, and on Sundays we would drive to the Sunset, see how many houses had been built that week, and play in the dunes." (Courtesy Rosemary Trodden French.)

CONTENTS

ACKNOWLEDGMENTS

I especially wish to thank the San Francisco History Center in the San Francisco Public Library, whose staff and resources are indispensable to anyone studying San Francisco history. Thanks also to the Sunset-Parkside Education and Action Committee (SPEAK), which funded my use of library photographs in this book. Dorothy Bryant's encouragement and editorial help were indispensable.

I express deep appreciation and respect for the many people who helped me collect the wonderful stories and photographs related to the history of the Sunset District including:

Gary Allyne, Jerry Ames, Archives of the Archdiocese of San Francisco, Kent Bach, Bob Barnhouse, Richard Brandi, Alan J. Canterbury, Nancy Chan and the San Francisco Zoological Gardens, Katrina Coombs, Jerian Crosby, Cecilia and Ken Deehan, Ron Downer, Mark Duffett, Emiliano Echeverria (an old friend, rediscovered through our mutual love of SF history), Carol Faulker and the Lawson-Faulkner family, Evelyn Florin, Rosemary French, Greg Gaar, Tom Gray, Jane Hudson, Murray Hushion, Marcella Iwersen, Teresa James, Joan Juster, Ellen Kieser, Dr. Richard and Evelyn Koch, Bernice Lassiter, Woody LaBounty, Helene Lavelle, Frank Levin, Pamela LeBeau, Richard Lim, the Little Shamrock, Beth Lyon of Hogan Sullivan & Bianco Funeral Home, Ken Malucelli, Patricia Dowden Mayer, Mark McBeth of the Seventh Avenue Presbyterian Church, Robert Menist, Dennis Minnick, Edythe Newman, Maryhelen Nightingale, Mary O'Connor, St. Anne's archives, Marshall Sanders, San Francisco Deputy City Attorney Sarah Owsowitz, San Francisco Municipal Railway, Jerome Sapiro, Grace Guildea Scholz, Kathleen Sullivan of the *San Francisco Chronicle*, Roy C. Thomas, Jack Tillmany, Scott Trimble, the family of Ada and Chas Williams, Al Williams, Jenny Williams, Western Neighborhoods Project, Jane Wiard, Ray Young, and Wilma Zari.

INTRODUCTION

The development of San Francisco's Sunset District is one of startling change over a relatively short period of time. Other, more well-known neighborhoods of San Francisco, such as Chinatown, North Beach, and downtown, developed early. By 1900, houses in these areas lined graded streets where transportation lines ran. In contrast, unpaved sand dunes covered most of the Sunset District in 1900.

In the 1800s, what we now call the "Sunset" was in the area called "The Outside Lands." This land was not part of the City of San Francisco. It was Mexican land until the Treaty of Guadalupe Hidalgo gave it to the United States Government in 1848.

In 1850 San Francisco incorporated for the first time, describing its western boundary as Larkin Street and what is now Ninth Street. (Note: This was Ninth Street, not Ninth Avenue.) One year later, in 1851, the city re-incorporated and changed the western boundary to Divisadero Street, giving a new neighborhood its name: the Western Addition. No mention is made of the Outside Lands as part of San Francisco until 1852, when the city petitioned the federal government for ownership of that area. After various court battles and rulings, an Act of Congress in 1866 confirmed that the land belonged to the City of San Francisco.

At that time the Outside Lands were virtually unoccupied, except for some squatters. People considered the western side of San Francisco uninhabitable, with its rolling sand dunes and frequent fog and wind. A few hearty souls set up ranches and farms. A few others built vacation homes, road houses (of varying reputations), and bordellos out along the beach. Some moneyed San Franciscans purchased acres of sand dunes in the Sunset, hoping to make money from their investments.

Long before many people moved to The Outside Lands, maps displayed a grid-like arrangement of streets. For example, the 1875 Langley map (see page 11) showed all the streets laid out in the Sunset, even though most of the area was still unpaved sand dunes. The streets running north-south were numbered and called "avenues" to differentiate them from the "streets" on the eastern side of the city. (This gave rise to another term for the Sunset District: "The Avenues.")

The streets running east-west, parallel to Golden Gate Park, were simply an alphabetical list. Starting north of the park with A Street, the names continued south of the park to W Street. In 1909, the Board of Supervisors approved the renaming of streets, in part to eliminate confusion from duplicate street names around the city. The new names reflected Spanish, American Indian, and other contributors to California history. The planners chose to keep the alphabetical order of the streets. Except for Lincoln Way, which had been called H Street,

all the streets from I to W kept their initial letters: Irving, Judah, Kirkham, Lawton, Moraga, Noriega, Ortega, Pacheco, Quintara, Rivera, Santiago, Taraval, Ulloa, Vicente, and Wawona.

Events that spurred growth in the Sunset included the construction of Golden Gate Park, beginning in 1870; the establishment of the Affiliated Colleges (now University of California) in 1898; and a devastating earthquake and fire in 1906 that drove many San Franciscans west.

The final critical element needed for Sunset District growth was transportation. Most people did not have cars; they needed to live in neighborhoods that had public transportation to downtown jobs. When the Twin Peaks Tunnel opened in 1918 and the Sunset Tunnel opened in 1929, streetcar service downtown made residency in the Sunset feasible, even desirable. People began building houses in large numbers in the 1920s, and more houses were built in the Sunset during the 1930s than at any other time.

Today's Sunset District is bounded on the south by Sloat Boulevard, on the west by the Great Highway (along the ocean), and on the north by Lincoln Way. The eastern boundary jogs a bit, starting at Lincoln and Arguello (or First Avenue), but excluding the University of California, as well as the Forest Hill and West Portal neighborhoods.

Long before the development of suburban areas outside San Francisco, city residents considered the Sunset to be the suburbs. It seemed far from the "action" and from work. Many families, wishing to get away from the busy, dirty, dangerous downtown, saw the Sunset as an affordable and attractive place to live.

This book divides the Sunset into three major areas: the Inner Sunset, the Parkside, and the Central/Outer Sunset. However, these areas have never truly been separate; they overlap. The Golden Gate Heights area is not included here; photographs and stories were not readily available for that neighborhood.

One

A CHANGING
LANDSCAPE

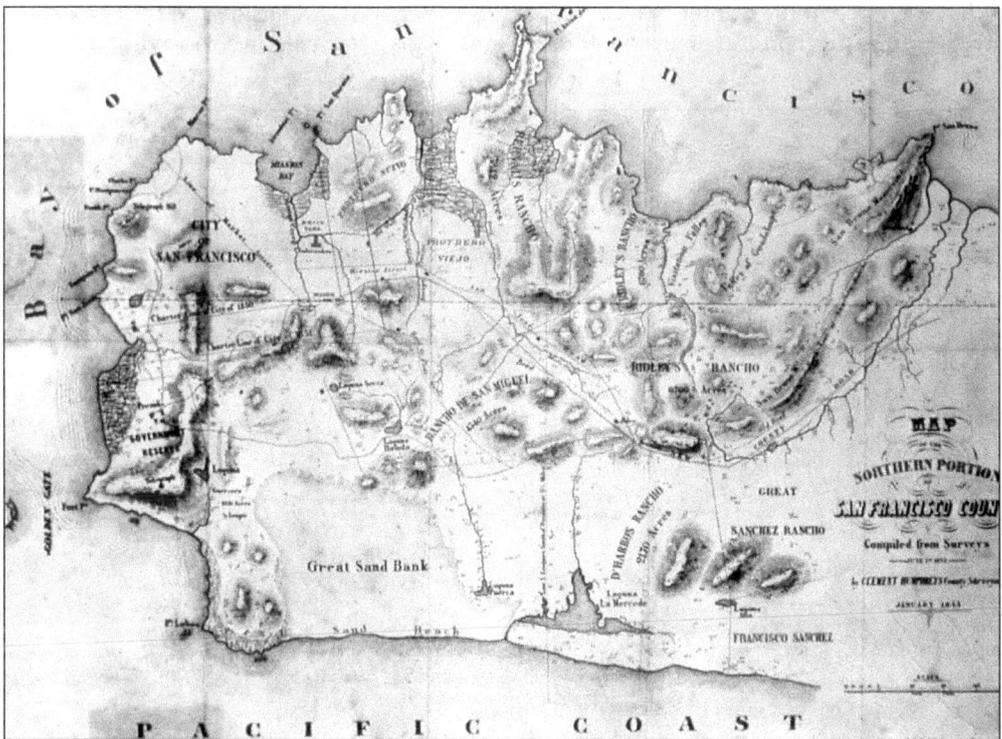

In the early 1800s, the western side of the San Francisco peninsula was owned by Mexico. In 1848, it became federal land. Sand dunes, heavy fog, and winds prevailed. This 1853 map described that part of San Francisco as the "Great Sand Bank." (Courtesy Richard Brandi.)

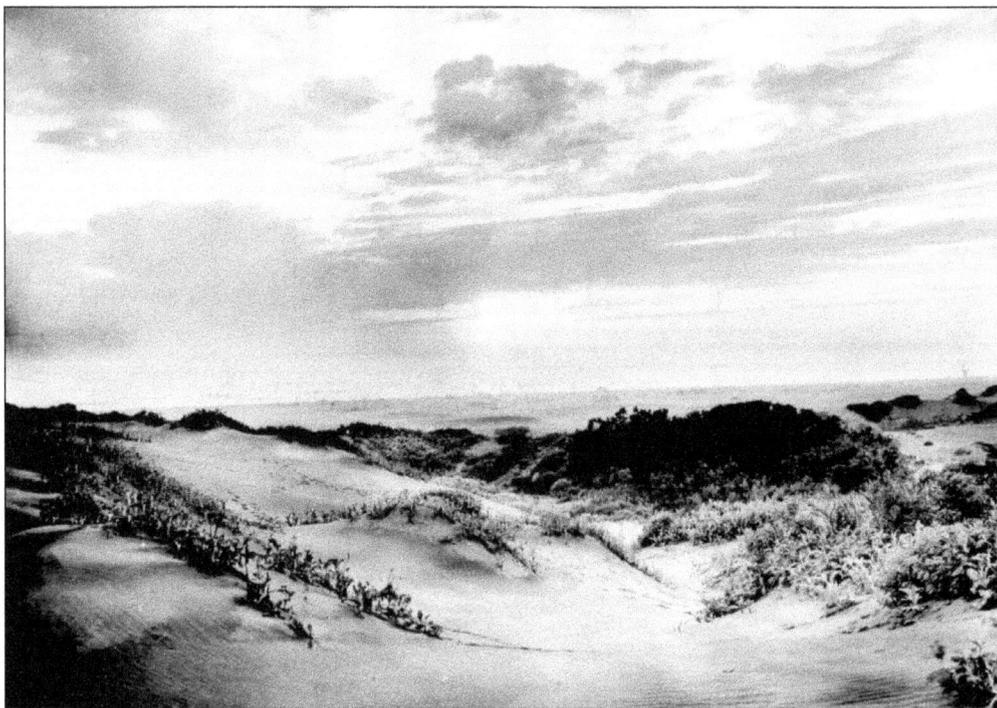

What we now call the Sunset District used to be known as the "Outside Lands." Few people lived or traveled there. There were no roads, and it was a difficult area to navigate.

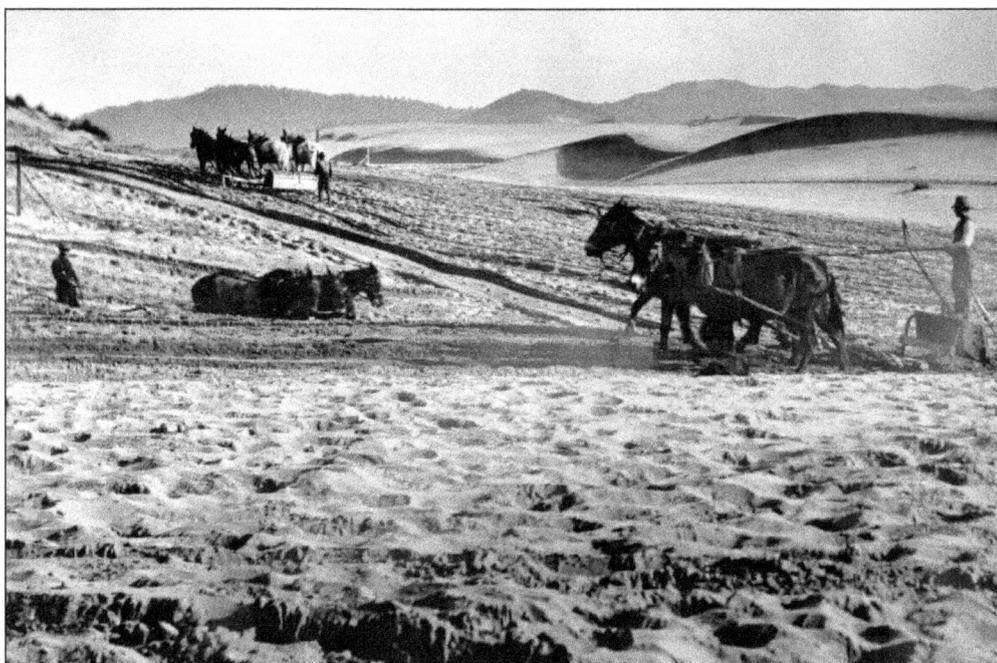

By the late 1800s, a few hardy people were grading the land for vegetable gardens and rustic homes.

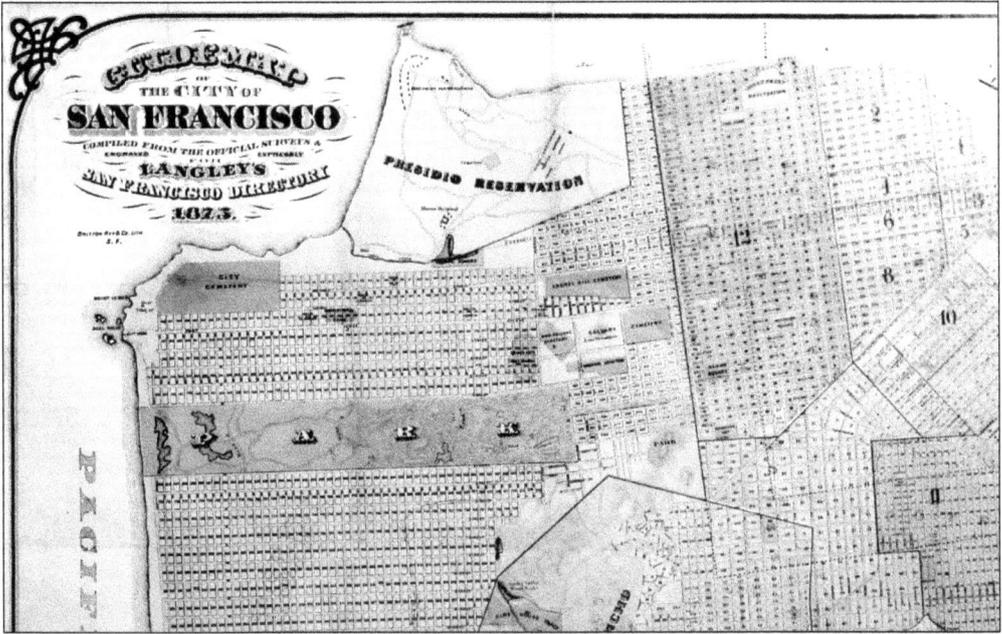

In 1866, Congress declared the Outside Lands part of San Francisco. The Outside Lands Committee, appointed by the board of supervisors, recommended building a huge park, starting from Baker Street and going west to the beach. As Golden Gate Park grew, so did the desire to settle in the Outside Lands. The 1875 above Langley Map shows the planned streets throughout the city while below is a close-up view of the Sunset District, south of Golden Gate Park. The map is complete, even though at that time streets in the Sunset had not been graded or laid out. (Courtesy Dennis Minnick.)

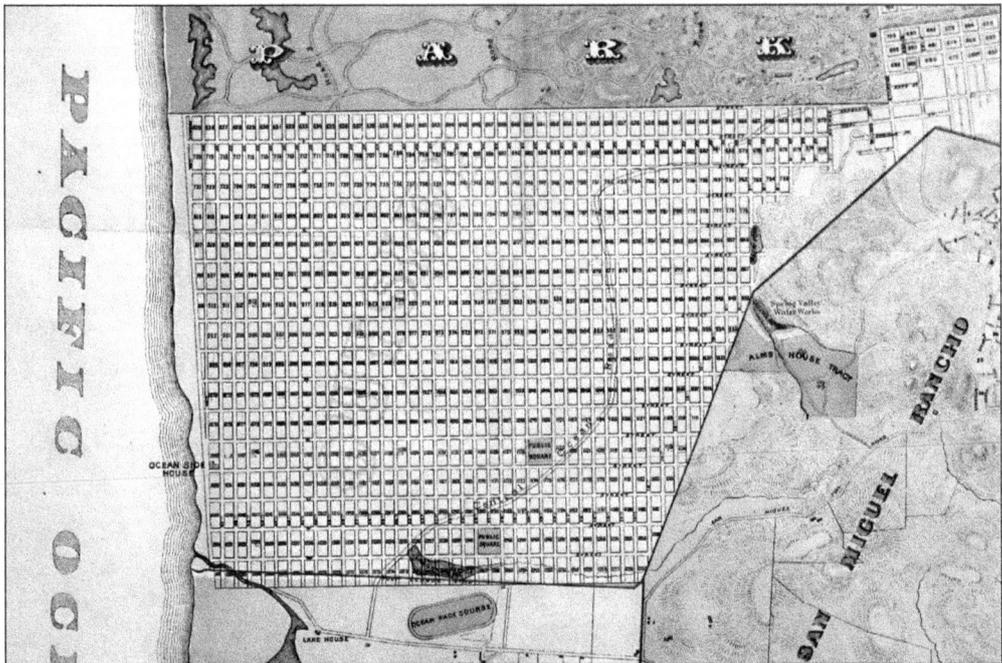

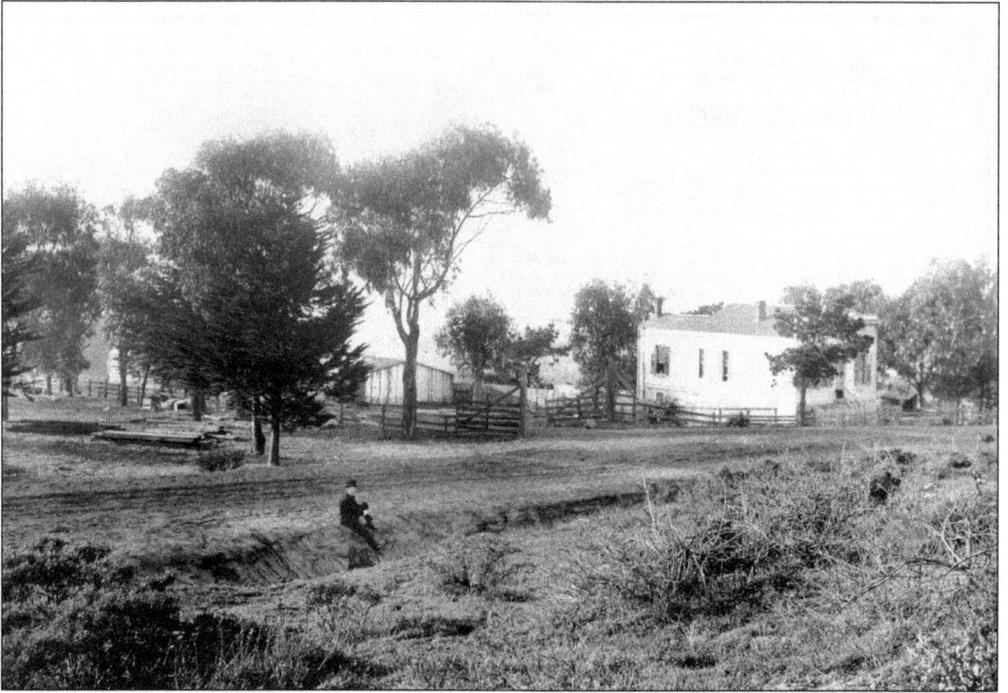

These photographs, taken around 1900, show what is now Nineteenth Avenue. The top image looks northwest. The bottom photograph, taken approximately from what is now Kirkham Street, looks north toward the growing Golden Gate Park.

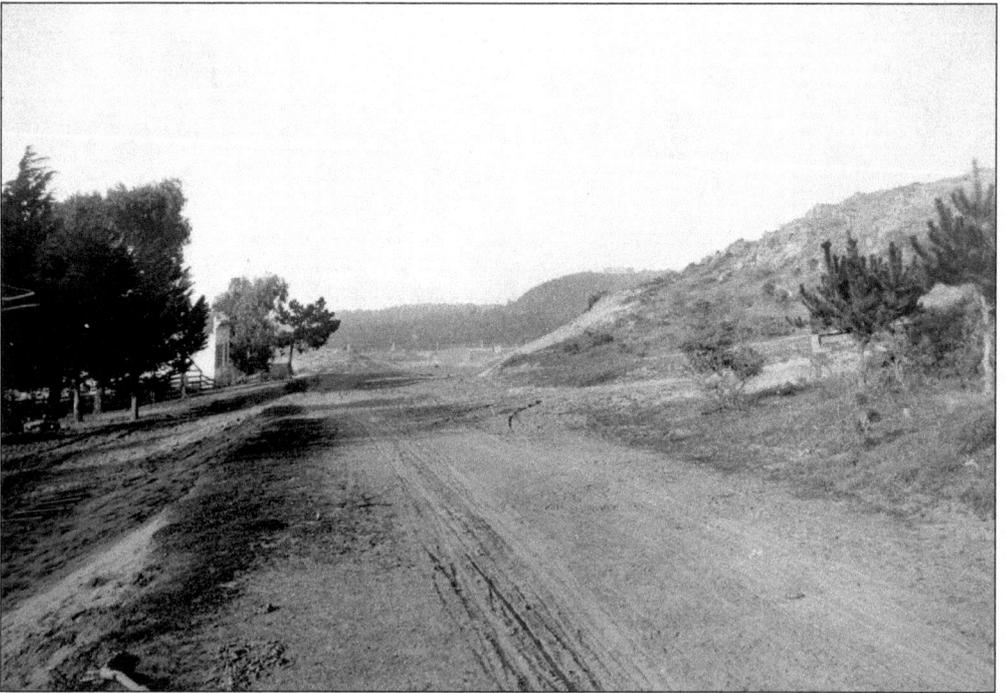

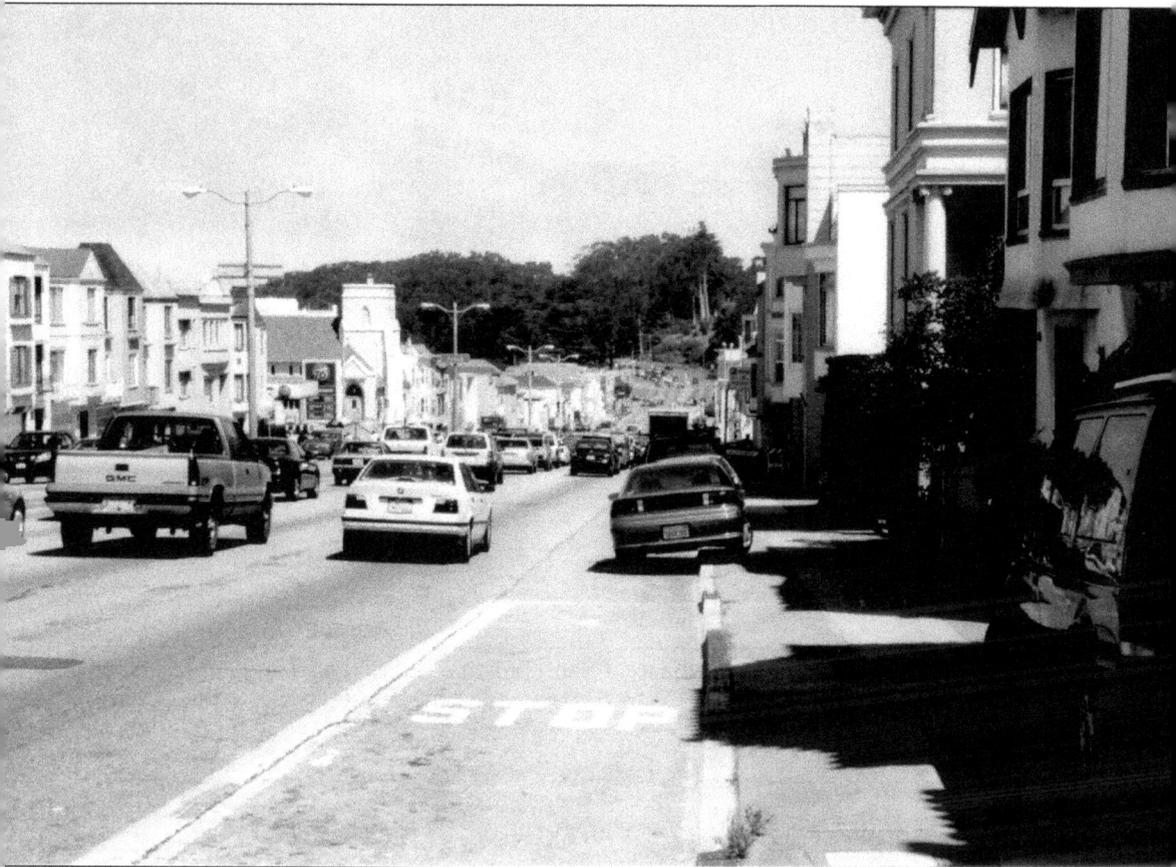

This 2003 photograph, taken from Kirkham Street, shows that Nineteenth Avenue has become a major north-south thoroughfare for drivers moving in and out of the city. (Author's collection.)

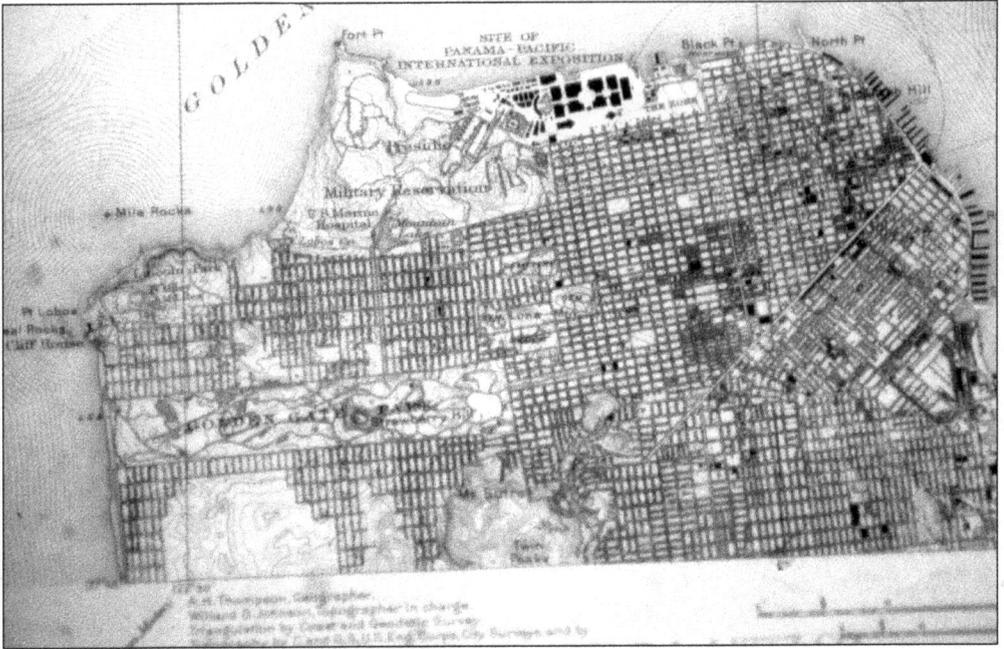

This 1915 U.S. Geological Survey map of San Francisco shows the streets in place at that time. The lower left portion of the map shows most of the Sunset as still sand. (Courtesy Katrina Coombs.)

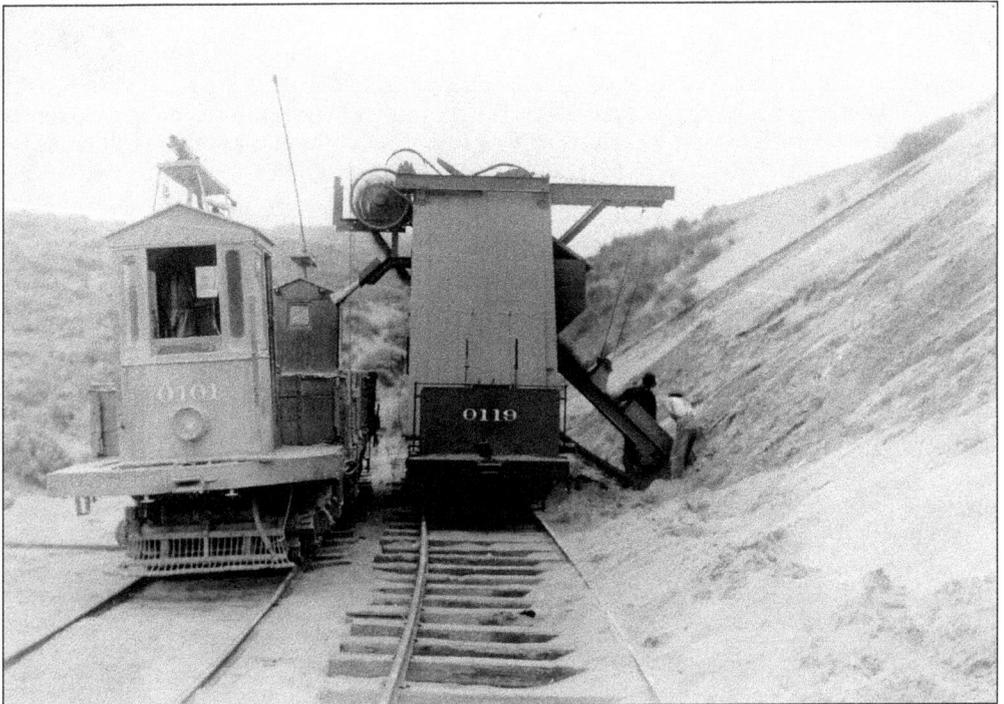

"Taming" the sand was essential to creating streets in the Sunset. This 1916 photograph shows the conveyors that removed sand so streets could be graded. (Courtesy Emiliano Echeverria.)

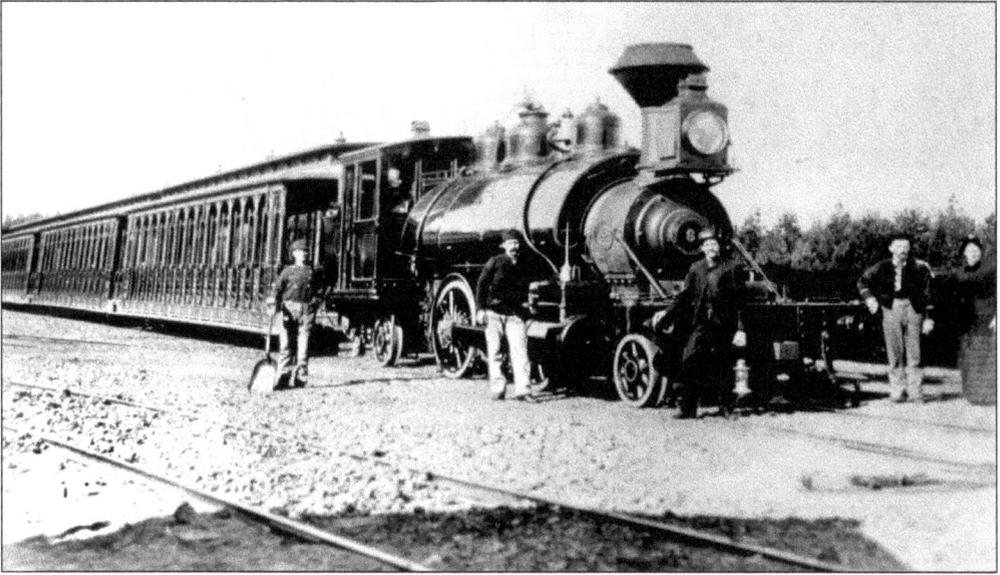

Here we see the original steam train line on H Street (now Lincoln Way), started by Leland Stanford in 1893. For 5¢ one could ride along the south border of Golden Gate Park from Stanyan Street to the beach, viewing western scenery that few San Franciscans had seen. In 1898 the steam trains were replaced by electric streetcars, and in March 1899 the streetcars were augmented with electric trains. By 1903 electric streetcars had H Street to themselves. In 1948, the streetcar line was discontinued. (Courtesy San Francisco History Center, San Francisco Public Library; photo by Roy D. Graves.)

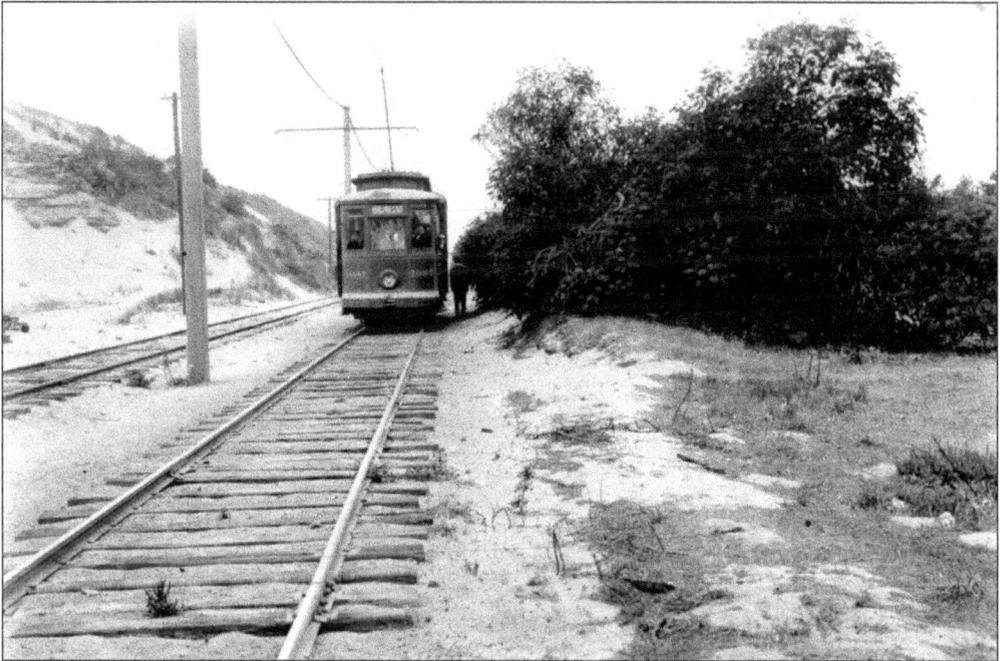

In 1907, the streetcar on H Street seemed isolated in the wilderness near Fourth Avenue. Golden Gate Park sat on the north, but only sand was visible to the south. (Courtesy Emiliano Echeverria.)

In 1916, newspapers announced the building of homes along Lincoln Way, across from Golden Gate Park. Some of these homes were built by renowned architect Fernando Nelson. "Parkway Terrace" stretched from Twenty-seventh to Thirty-second Avenues, from Lincoln to Irving. At each corner a concrete bench advertised the development. This photograph, taken around 1915, shows that the benches were built before the houses. Although the bench in this photograph no longer exists, almost all of the others remain. (Courtesy Emiliano Echeverria.)

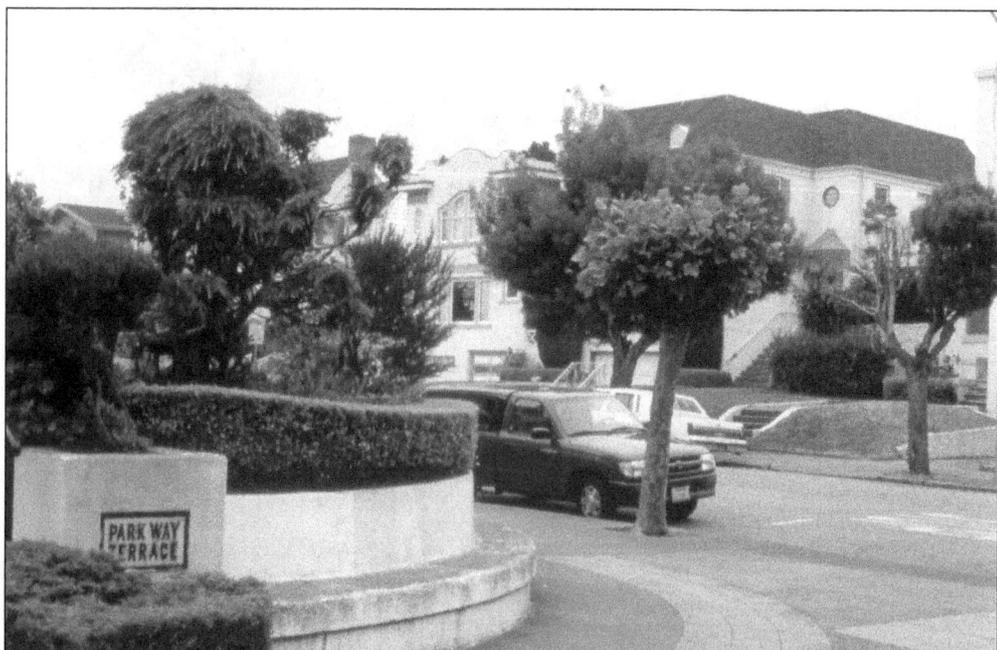

A current photograph shows the houses and landscaping at Parkway Terrace (Author's collection.)

16

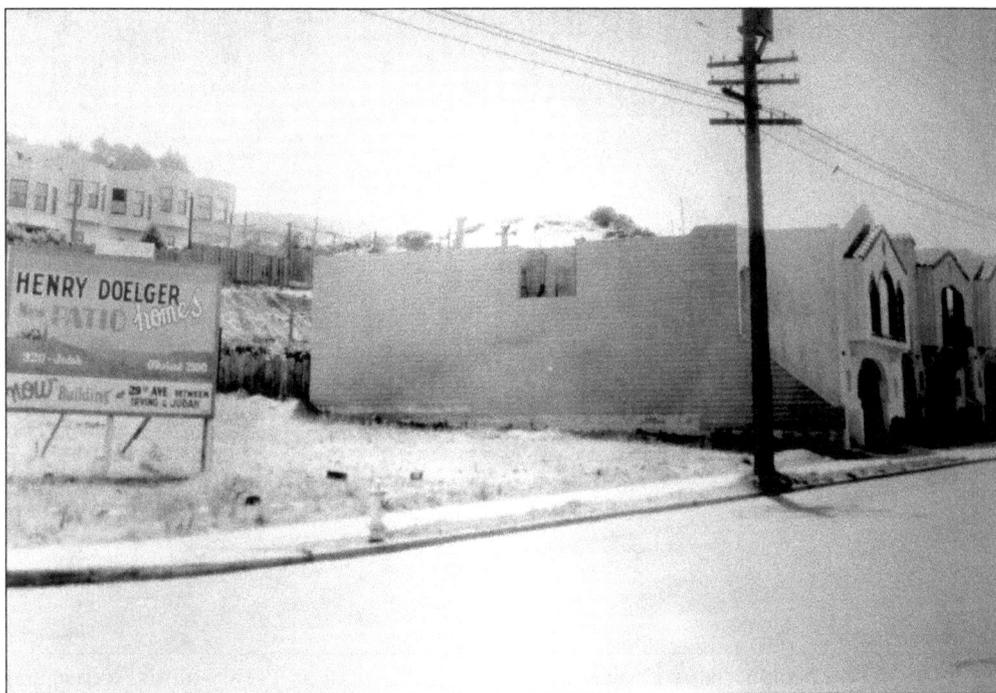

While many builders contributed to the development of the Sunset, Henry Doelger remains the most prolific. This sign on Nineteenth Avenue advertised Doelger homes. He started building houses in the 1920s but hit his stride in the 1930s when he built block after block of affordable homes. His houses stand in various parts of the Sunset, but his largest collection (sometimes called "Doelgerville") sits from approximately Twenty-seventh to Thirty-ninth Avenues between Kirkham and Quintara Streets. (Courtesy San Francisco History Center, San Francisco Public Library.)

The affordable Doelger houses had the same basic floor plan—two bedrooms and one bathroom upstairs, with a large garage downstairs. On any given block the exterior of each house was a little different from the others. Each house cost about $5,000, a reasonable amount that allowed working families to become home owners. Doelger built thousands of houses in the Sunset District before he moved south and began building in Daly City. (Author's collection.)

In this 1938 photograph Henry Doelger is standing on the right at Twenty-ninth Avenue and Noriega Street. Stories say that Doelger worked on some of his houses in coveralls, but when a prospective buyer came along, he took off the coveralls, revealing a suit, and proceeded to become a salesman. (Courtesy San Francisco History Center, San Francisco Public Library.)

This photograph shows how the houses Doelger was building at Twenty-ninth and Noriega look today. (Author's collection.)

A lesser known—and less prolific—Sunset builder was Oliver Rousseau, the son of a well-known San Francisco developer. A Rousseau home cost more than the other homes being built in the Sunset, but it had extras: a sunken living room (optional), a completed room downstairs, an I-beam supporting the second floor, carved moldings, and more. A block of Rousseau homes was often recognizable by turrets and other exterior touches that were more extravagant than those on houses built by Henry Doelger, Ray Galli, Louis Epp, and others. (Author's collection.)

In this 1930s photograph, toddler Jerry Ames played alongside new Rousseau homes. (Courtesy Jerry Ames.)

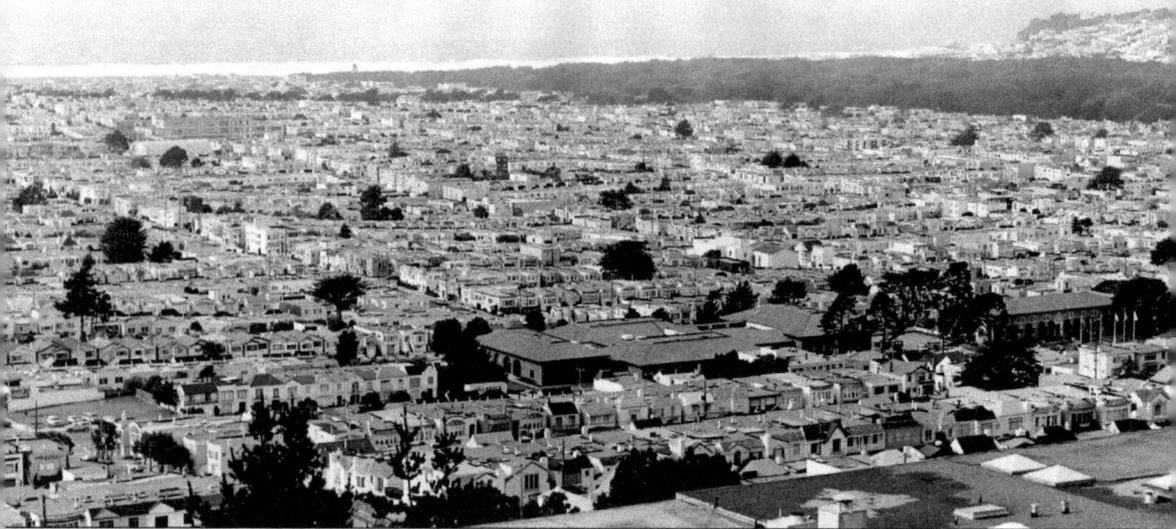

By 1990, virtually all of the Sunset District had been developed, as shown in this western view from Golden Gate Heights.

Two

THE INNER SUNSET

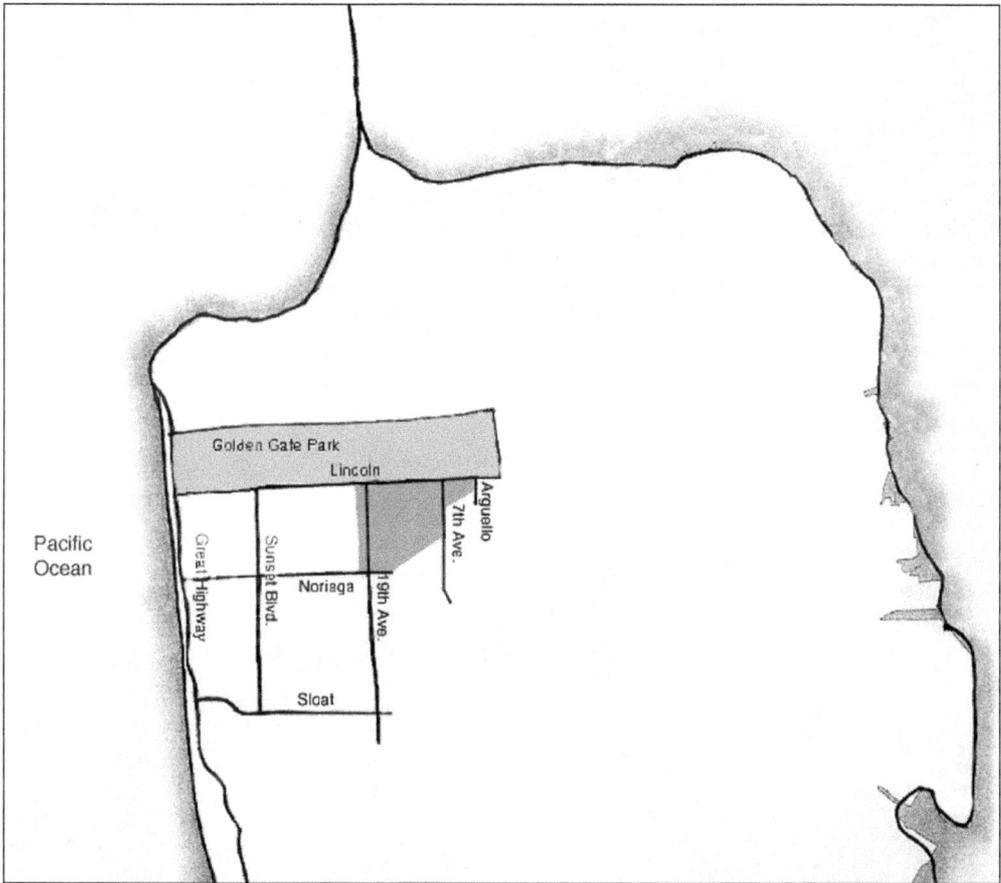

The map shows the Inner Sunset area with labels: Pacific Ocean, Golden Gate Park, Lincoln, Great Highway, Sunset Blvd., Noriega, 19th Ave., 7th Ave., Arguello, Sloat.

The Inner Sunset is roughly bounded by Lincoln Way on the north and Noriega Street on the south. It spans Arguello (First) Avenue to about Nineteenth or Twentieth Avenue but jogs around the University of California Medical Center and Sunset Heights. This area of the Sunset, along with the area along the beach, was one of the earliest areas of the Sunset to be developed. Its proximity to Golden Gate Park and to the University of California helped encourage early growth. Developer Aurelius Buckingham is credited for naming the area "The Sunset" in the 1880s. The name "Inner Sunset" came later, designating the area closest to downtown San Francisco. (Map by Christine Riley.)

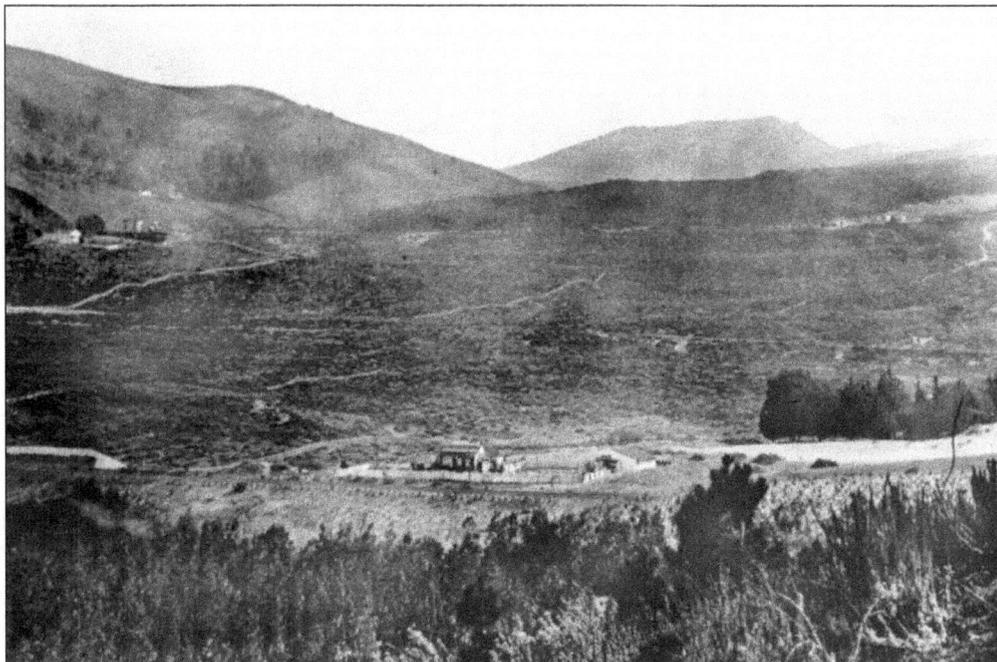

This 1886 photograph was taken from Strawberry Hill in Golden Gate Park, looking south toward the Inner Sunset. Mount Sutro is on the left and Mount Davidson on the right. This picture was taken before eucalyptus and other trees were planted on these hills, completely changing the landscape.

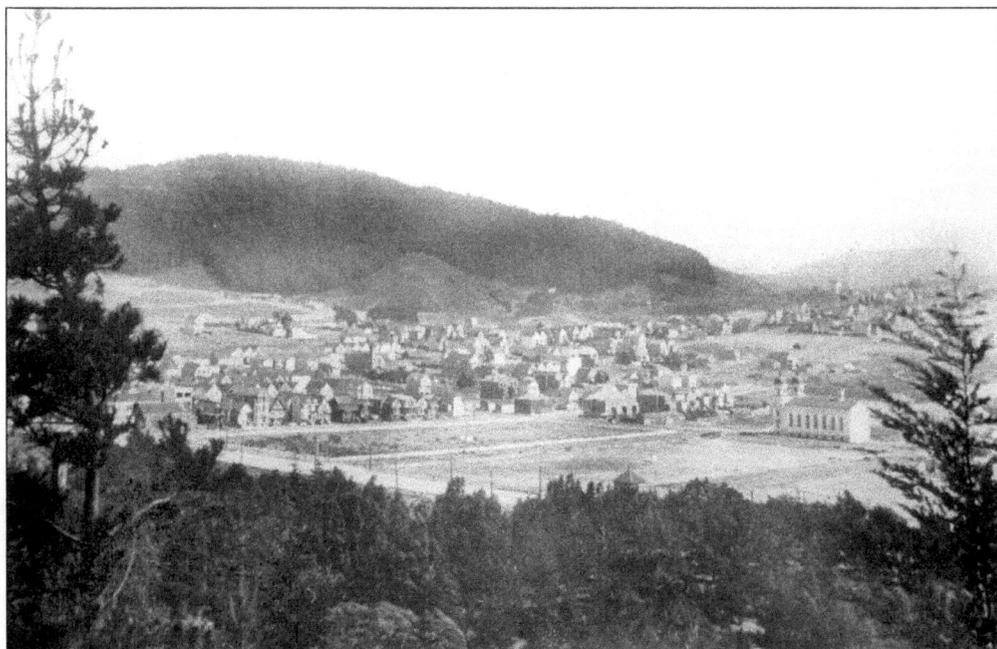

This 1908 view of the Inner Sunset shows burgeoning development. Note the trees covering Mount Sutro at the left and the original St. Anne's Church at the right. (Courtesy Kent Bach.)

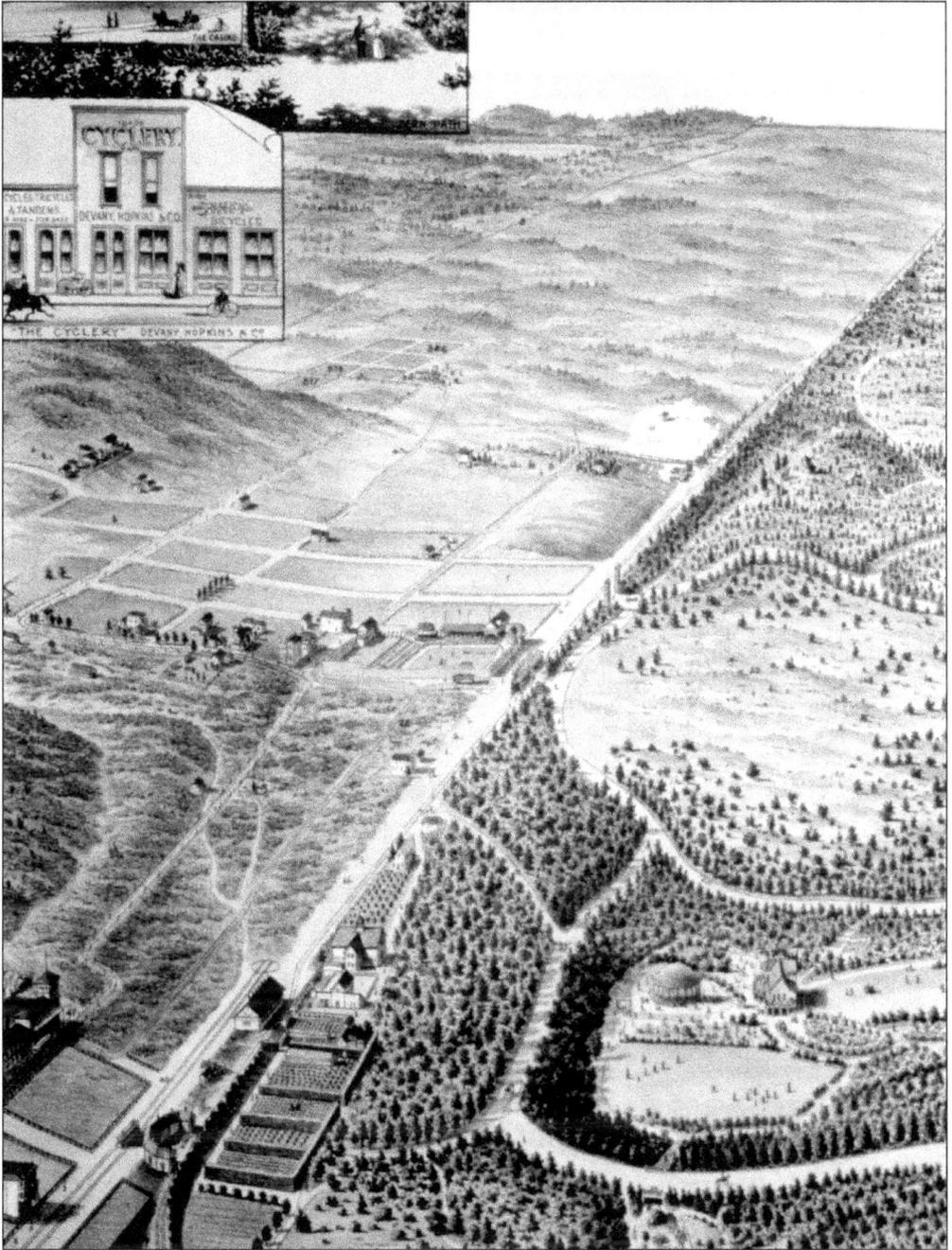

In 1894, the city sponsored a Midwinter Fair in Golden Gate Park. A lithographer created a special image to depict the park and its environs. This piece shows the park on the right and the nearly barren Sunset District on the left. (Courtesy San Francisco History Center, San Francisco Public Library.)

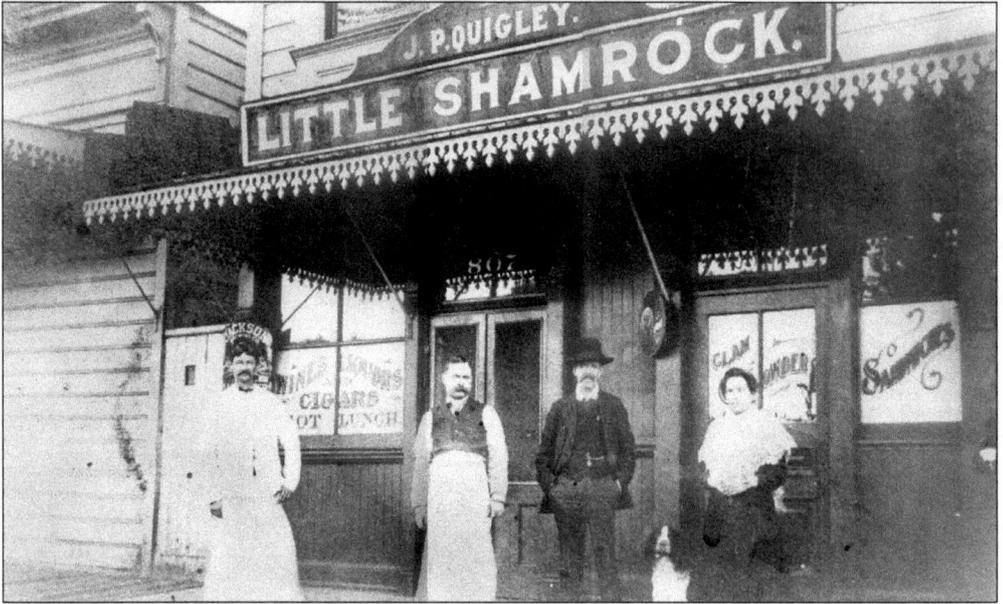

The Little Shamrock opened at Ninth and H Street (now Lincoln Way) in 1893 when the Midwinter Fair was being built. This pub stood across from Golden Gate Park, near what became the main entrance to the fair. It offered a free lunch for the purchase of a 5¢ "schooner" of beer. At the time only three buildings sat on H Street. After the 1906 earthquake, employees of the Little Shamrock brought food to the refugees living in tents in the park. Little Shamrock is still open for business today; it may be the longest continually running business in the Sunset. (Courtesy the Little Shamrock.)

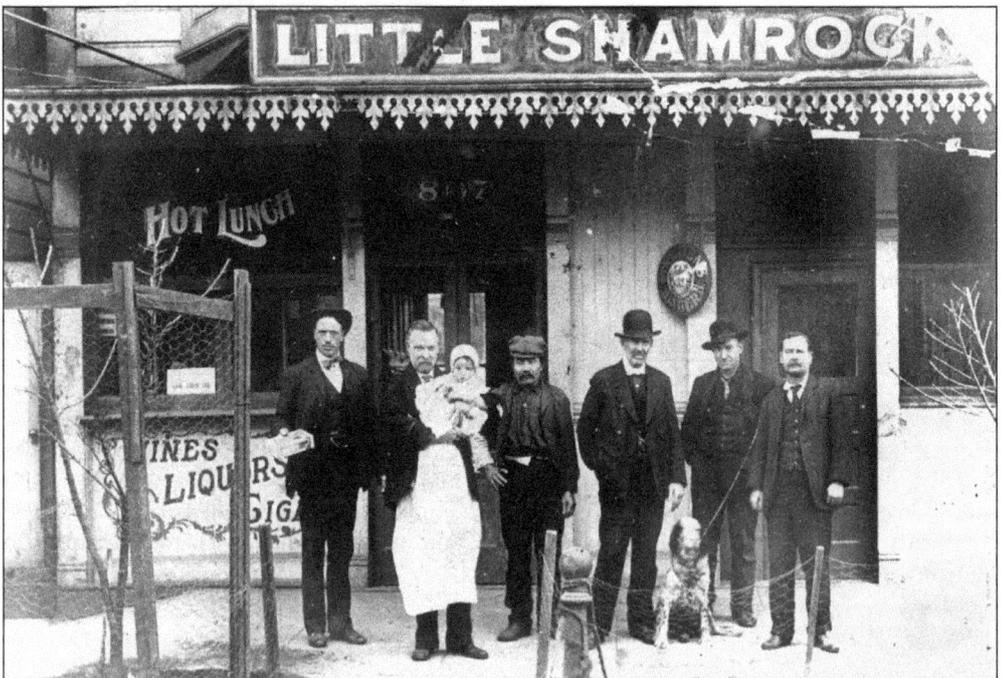

Shown above is the Engine 22 Fire House, the first fire house in the Sunset, at 1348 Tenth Avenue, built by the city in 1898. (Courtesy Hogan, Sullivan & Bianco Funeral Home.) The building shown at right was declared a San Francisco city landmark in 1970 and now houses a daycare center. (Author's collection.)

FURNISHING AND EQUIPMENT CAMPAIGN OF THE
SEVENTH AVENUE PRESBYTERIAN CHURCH

Between Irving and Judah Streets — — Opposite the Laguna Honda School

A Character Building
Community Center

A Sunset Church
For Sunset People

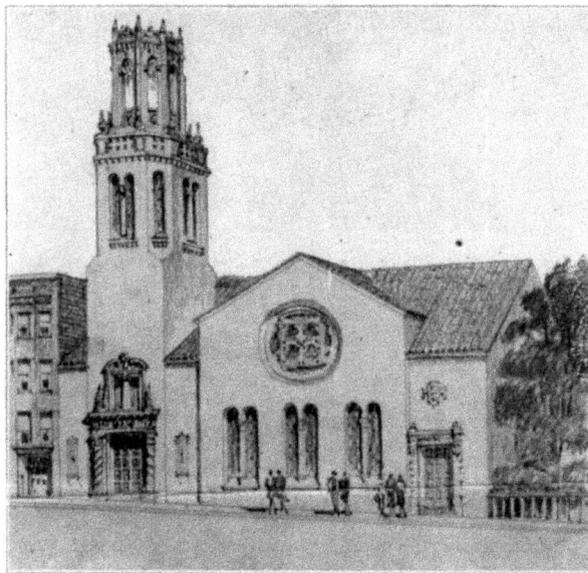

Present Church, Built in 1907

New Church—Now Under Construction

THIS BUILDING HAS BEEN FINANCED BY THE MEMBERS OF THE CHURCH AND PARENTS OF THE SUNDAY SCHOOL WHO HAVE SUBSCRIBED NEARLY $40,000—THEY ARE ASKING THE COMMUNITY FOR

$5,000

TO PROVIDE THE FOLLOWING NECESSITY EQUIPMENT

Seatings For Auditorium—Alter Furniture—Chairs and Tables for Sunday School Rooms—Lighting Fixtures and Hardware Gymnasium Equipment, Including Showers

BULLETIN NO. 2

In 1907, the Seventh Avenue Presbyterian Church opened on Seventh Avenue between Irving and Judah Streets. This 1929 flyer shows the original church in the inset, and solicits funds for the new church being built. (Courtesy Seventh Avenue Presbyterian Church.)

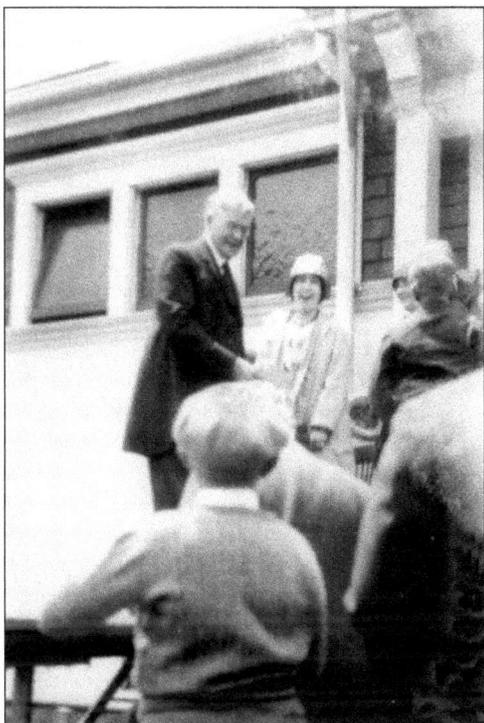

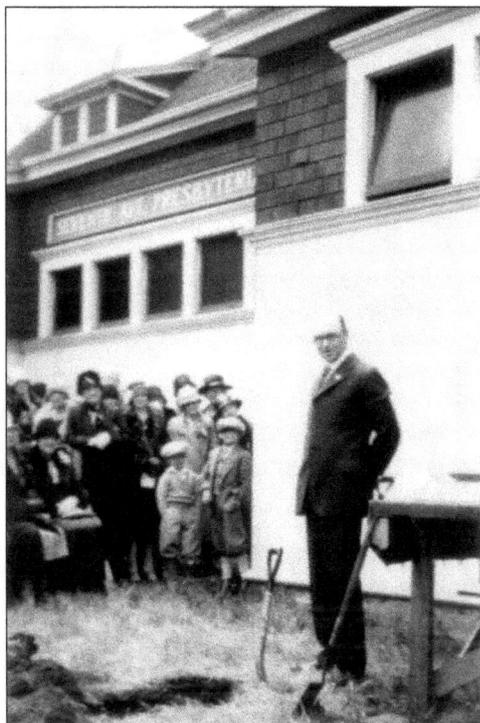

Groundbreaking ceremonies for the new Seventh Avenue Presbyterian Church were held outside the old church in 1929. The old building was retained, raised to be a second floor, and still sits behind the new church. (Courtesy Seventh Avenue Presbyterian Church.)

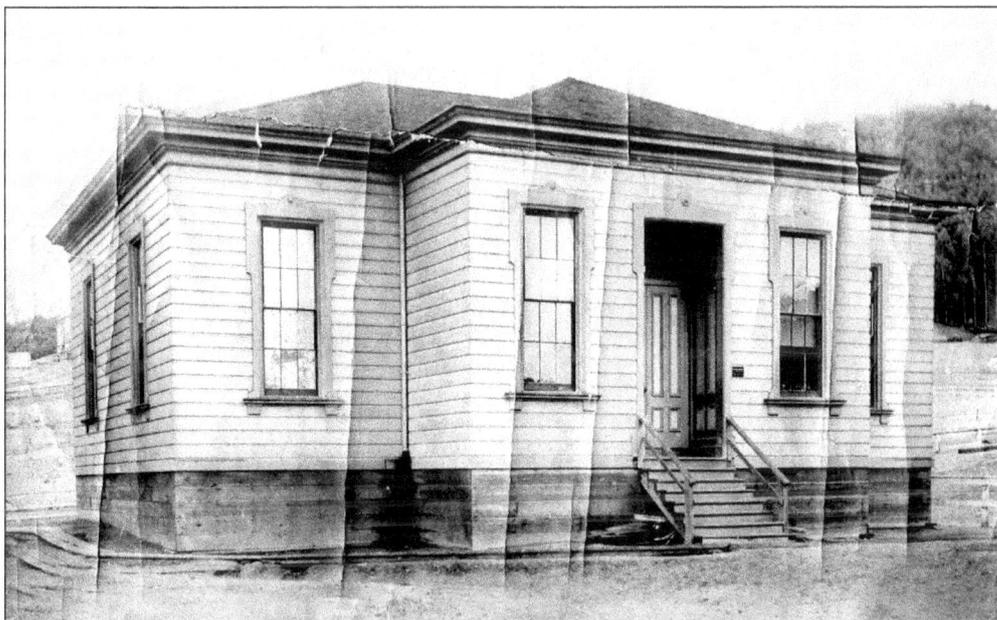

In 1900 the one-room Laguna Honda School sat on Seventh Avenue. It was later rebuilt as a brick structure that still remains on Seventh Avenue across from the Seventh Avenue Presbyterian Church. (Courtesy Jane Wiard.)

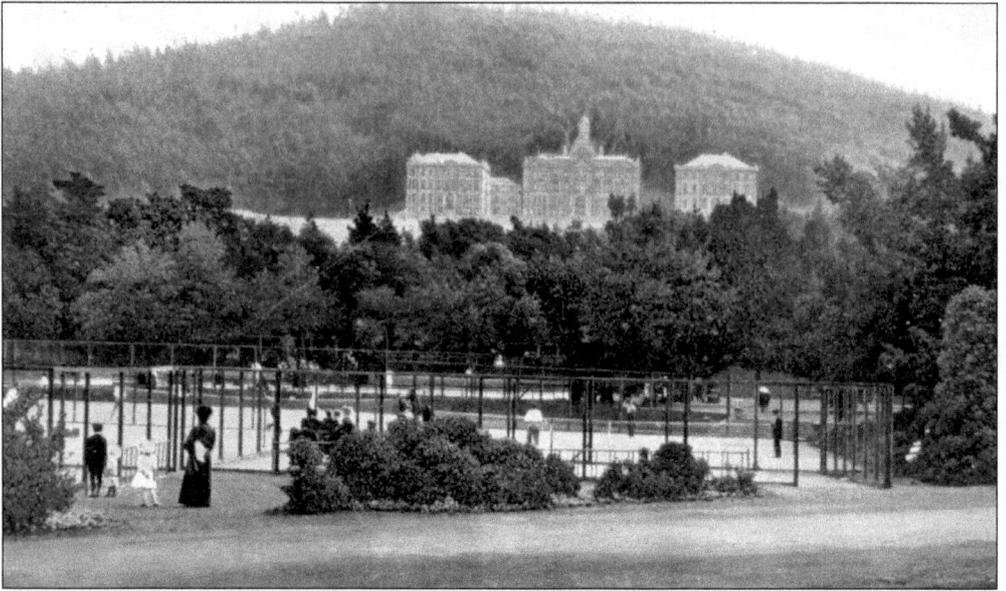

This 1908 view shows two early spurs to the Inner Sunset's population growth: Golden Gate Park, with its lawn tennis and other recreations, and the Affiliated Colleges (later University of California, San Francisco), which opened on the hill above Golden Gate Park in 1898. (Author's collection.)

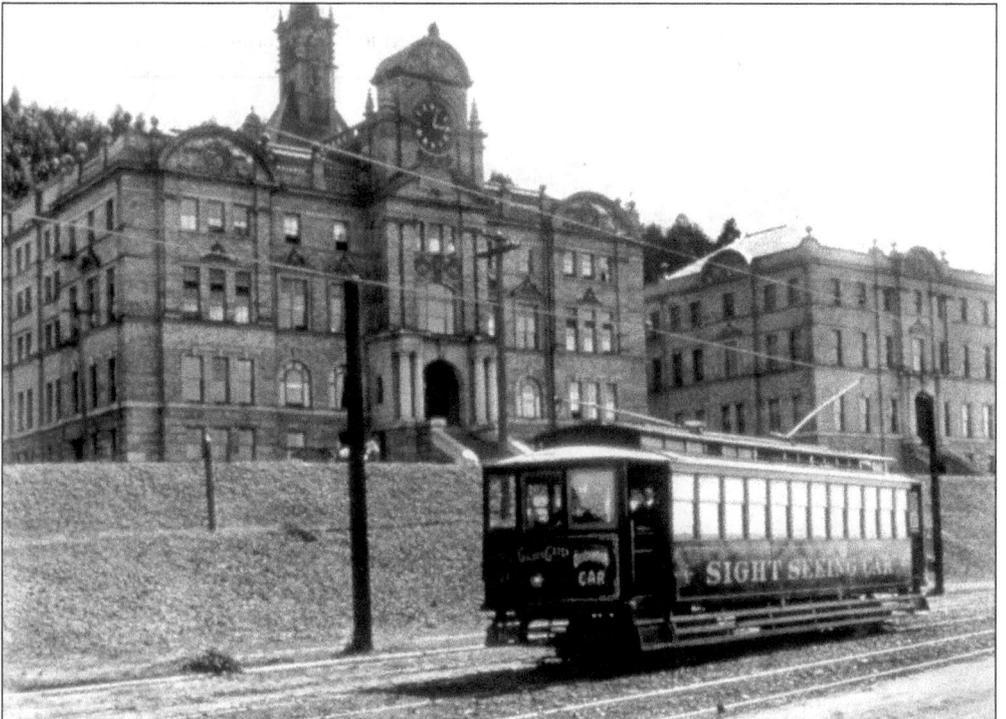

As public transportation expanded to the Inner Sunset, a streetcar ran alongside the Affiliated Colleges, bringing people from across town to study medicine. (Courtesy Emiliano Echeverria.)

The first Catholic parish in the Sunset was formed in 1903. Until St. Anne's Church, shown here, was built in 1905, mass was celebrated at the old Parkview Hotel at Ninth Avenue and Lincoln Way. Because so few people lived in the area the parish covered a large geographical area—comprising the entire Sunset District and beyond. At the time it was formed, the congregation numbered about 75 families, mostly Irish and Irish American. (Courtesy St. Anne's archives.)

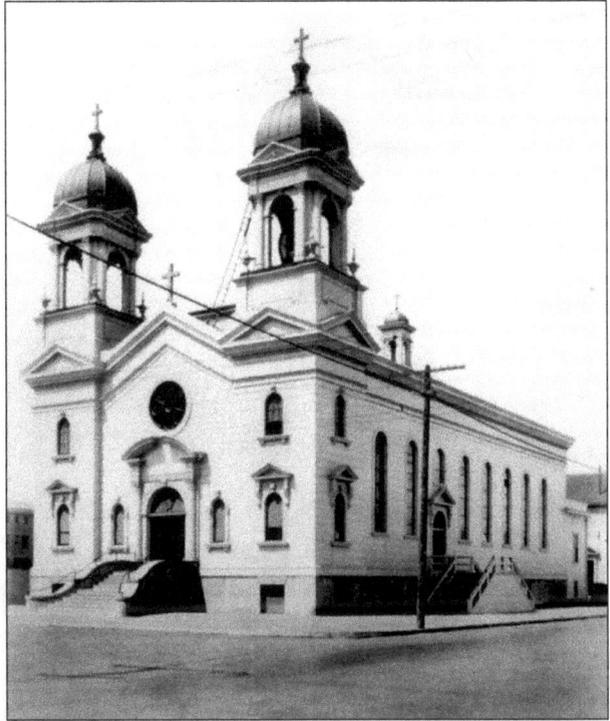

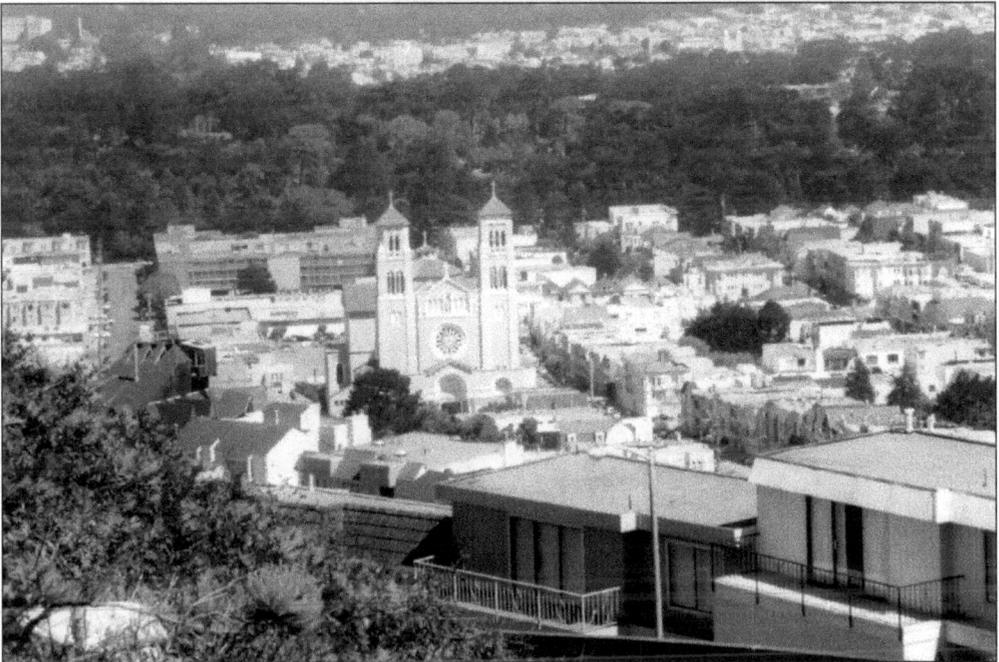

The current St. Anne's Church was built at Funston (formerly Thirteenth) Avenue and Judah Street in 1933. The church dominates the Inner Sunset skyline. As the 20th century progressed people began to move to the Sunset District, and more parishes were created. The entire Sunset District now has four Catholic parishes; St. Anne's still services the Inner Sunset. (Author's collection.)

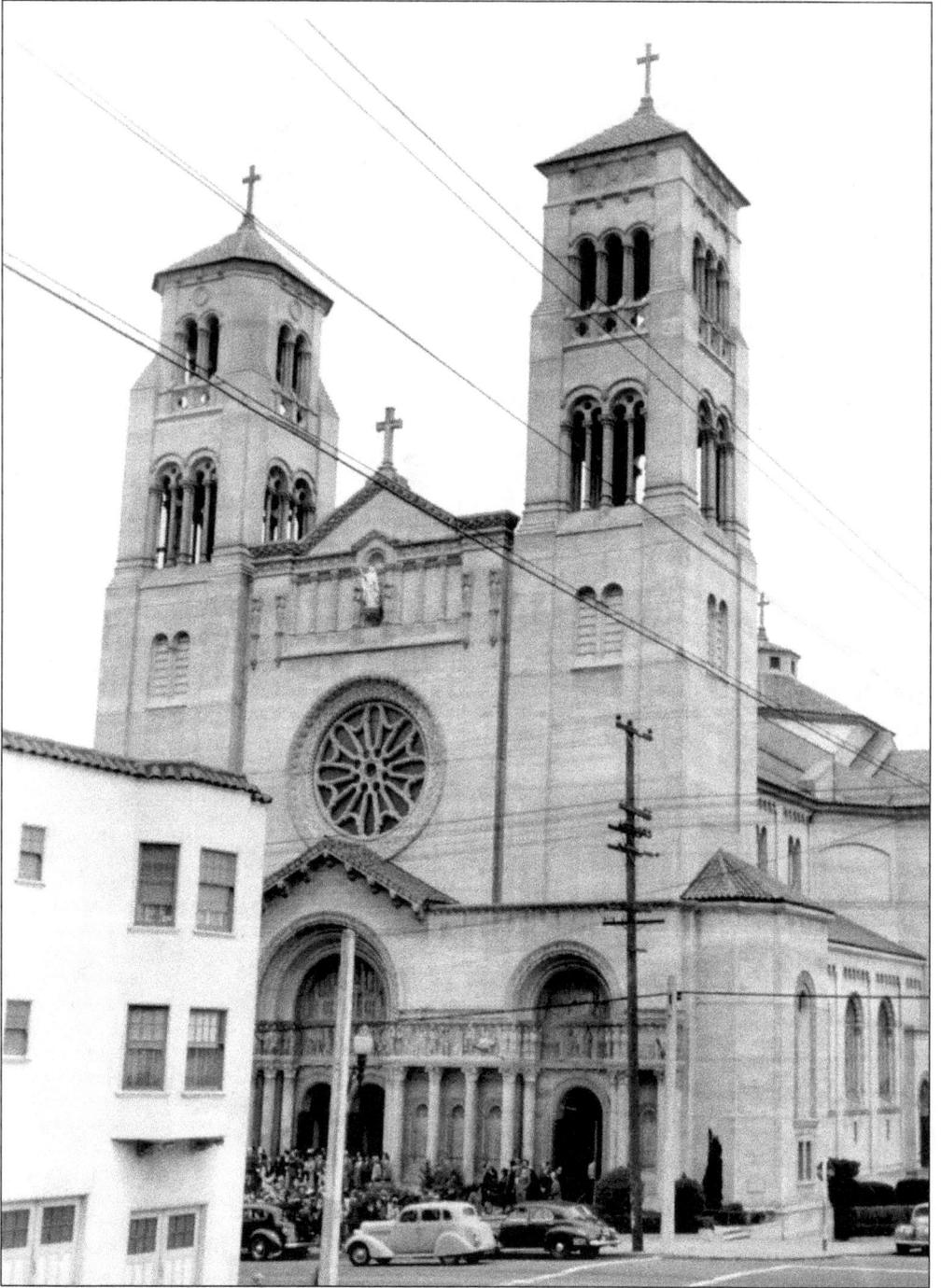

St. Anne's is a beautifully designed and detailed church. (Courtesy Cecilia and Ken Deehan.)

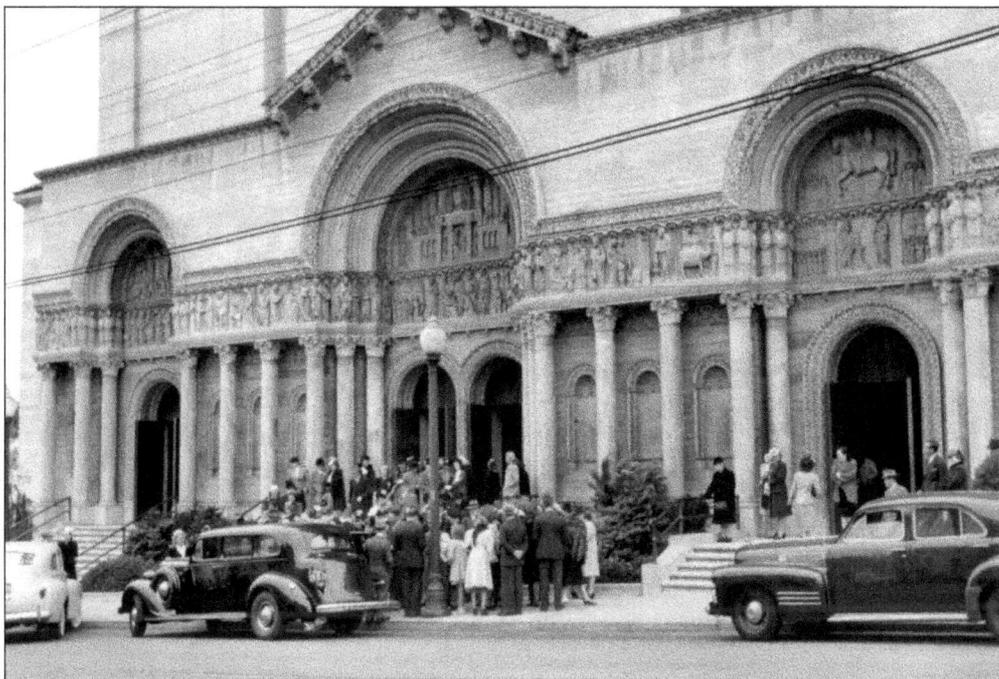

A remarkable feature of St. Anne's Church is the frieze, which was designed and sculpted by Sister Justina Niemierski, a Dominican nun, who had trained in Germany as an artist. Stationed at Mission San Jose, California, she was called upon to work on St. Anne's Church. Her figures depict biblical stories. This photo was taken at the wedding of Cecilia Murphy and Ken Deehan on May 11, 1946. (Courtesy Cecilia and Ken Deehan.)

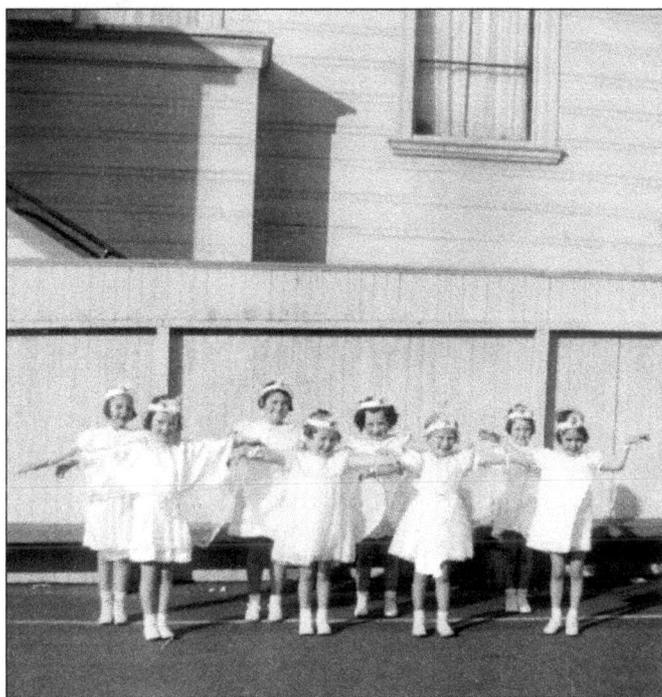

St. Anne's Church parish also supported a school. In 1939, the kindergarten class at St. Anne's School performed a Christmas play. (Courtesy Maryhelen Colling Nightingale.)

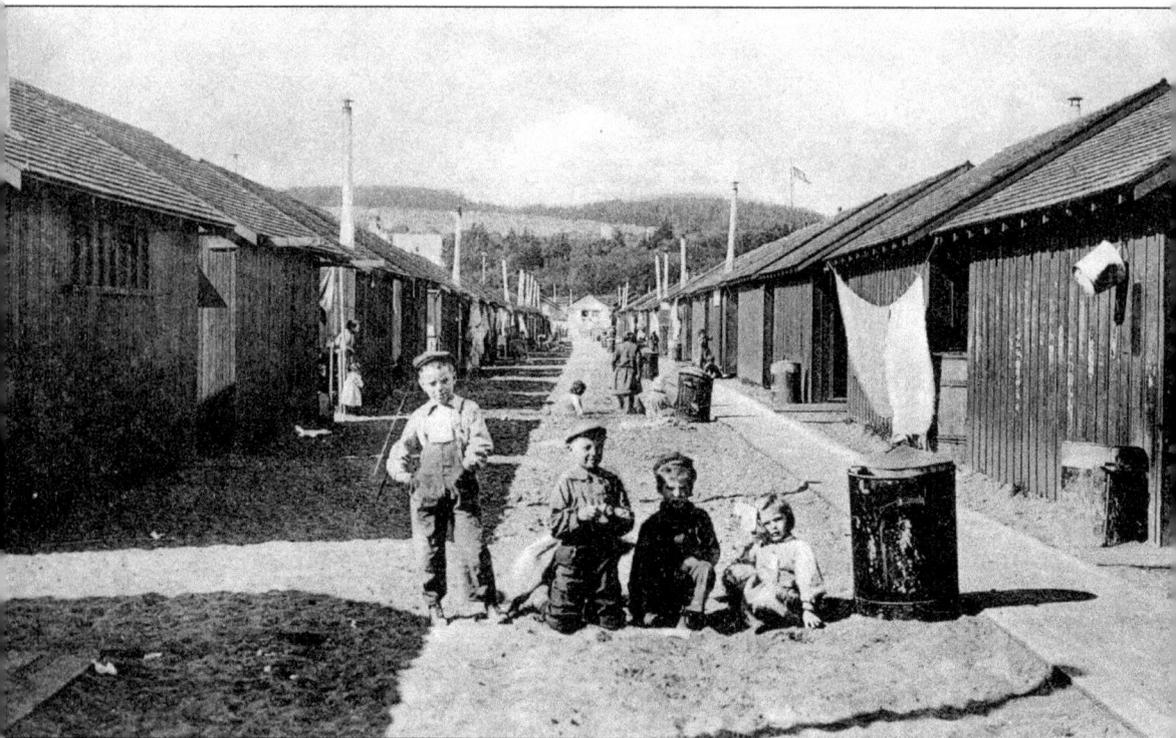

After the earthquake and fire in 1906, temporary cottages were built for the newly homeless. See facing page for more information. (Courtesy John Freeman.)

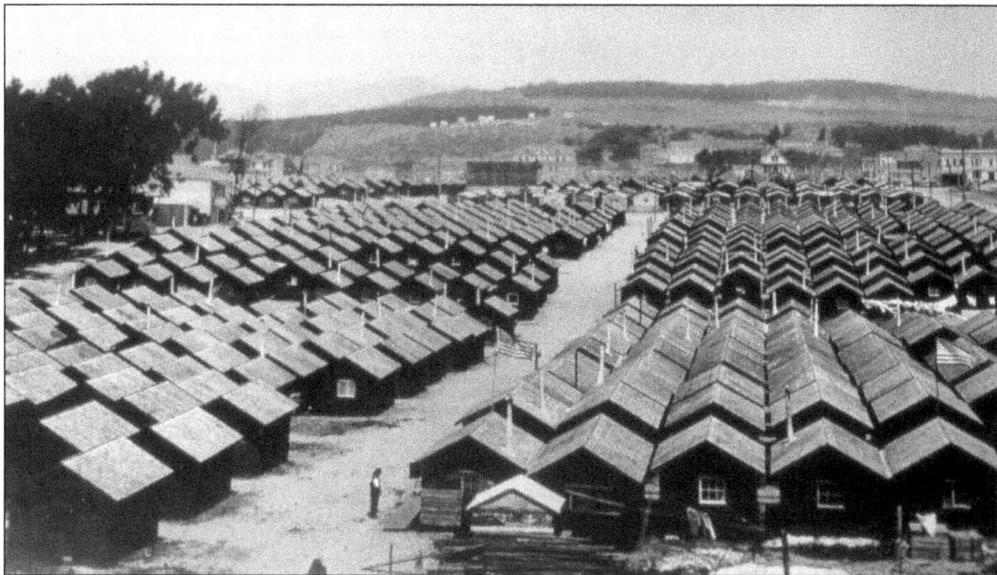

To house the newly homeless after the 1906 earthquake and fire, the city built more than 5,600 temporary cottages, called "earthquake shacks." The average shack was 14 by 18 feet and rented for $1 or $2 per month. The camp in this photograph covered park land in the Richmond District north of Golden Gate Park. Within a year, the city was encouraging camp residents to move their cottages to lots elsewhere in the city—even offering to refund all rent payments made if the cottages were moved. (Courtesy San Francisco History Center, San Francisco Public Library; photo by Charles Weidner.)

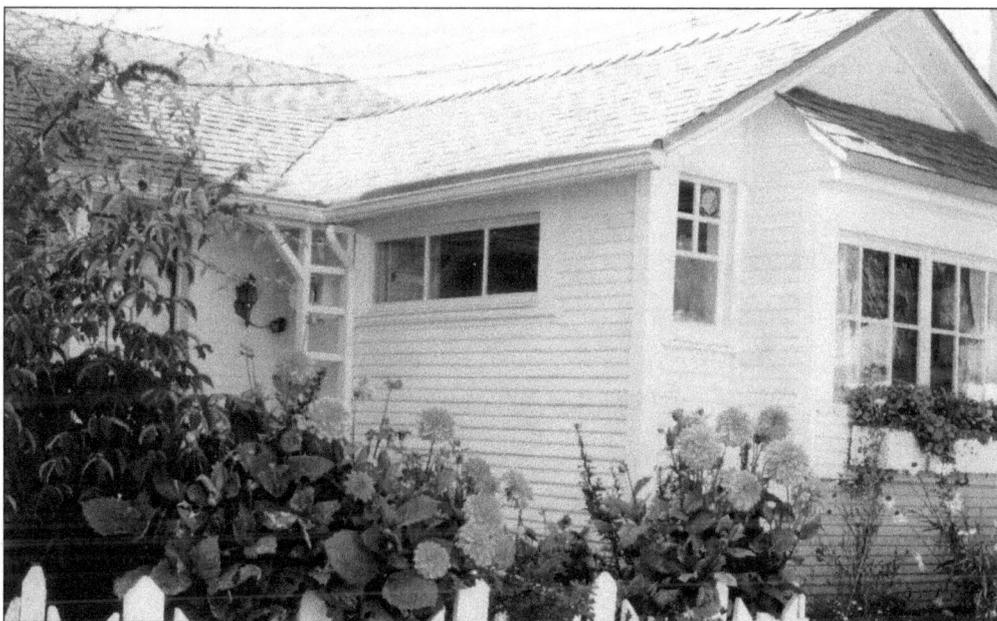

Several earthquake shacks, cobbled together to make a small house, were moved to Twenty-fourth Avenue in the Inner Sunset. In 1984 the building was named a San Francisco landmark, one of three in the Sunset District. As of this writing, only about 20 identified earthquake shacks remain standing. (Author's collection.)

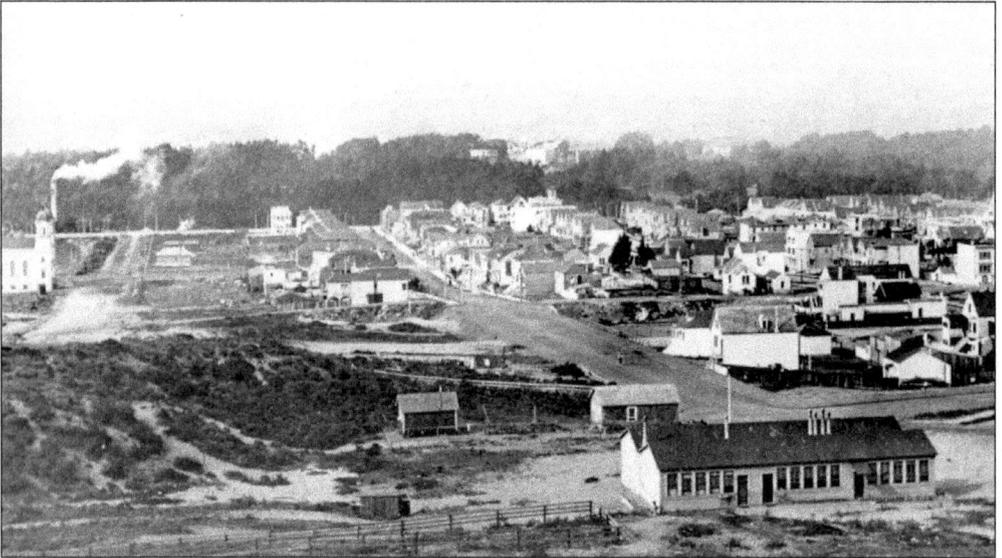

This 1908 view of the Inner Sunset looks north from about Funston Avenue and Lawton Street. The old St. Anne's Church stands at the far left and the old Columbus School at the lower right. (Courtesy Lawson-Faulkner family.)

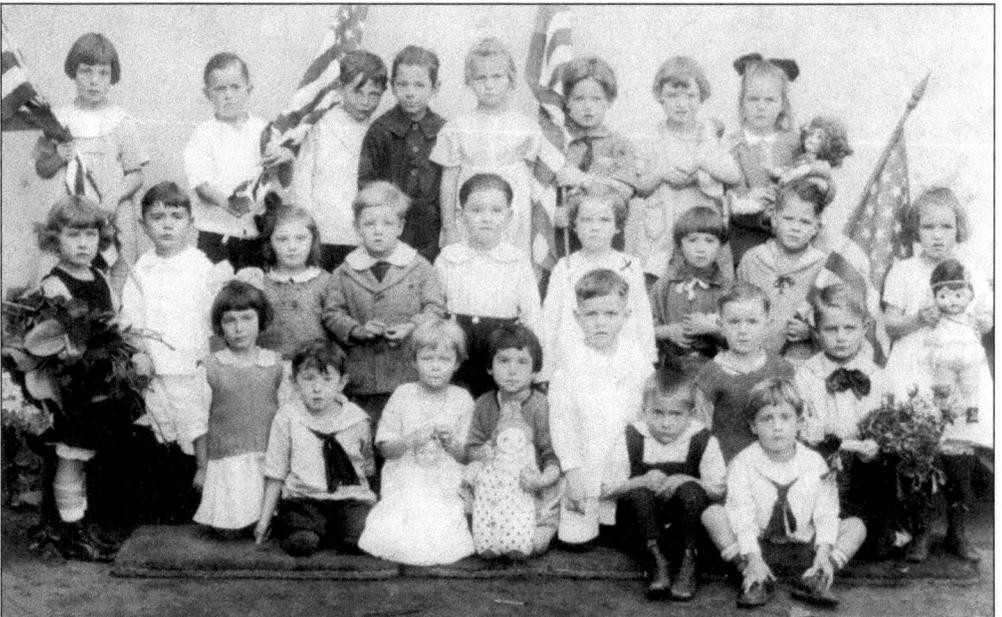

Marcella O'Connor, a student at Columbus School, marked herself with an "x" in her 1922 kindergarten class photograph. (Courtesy Marcella O'Connor Iwersen.)

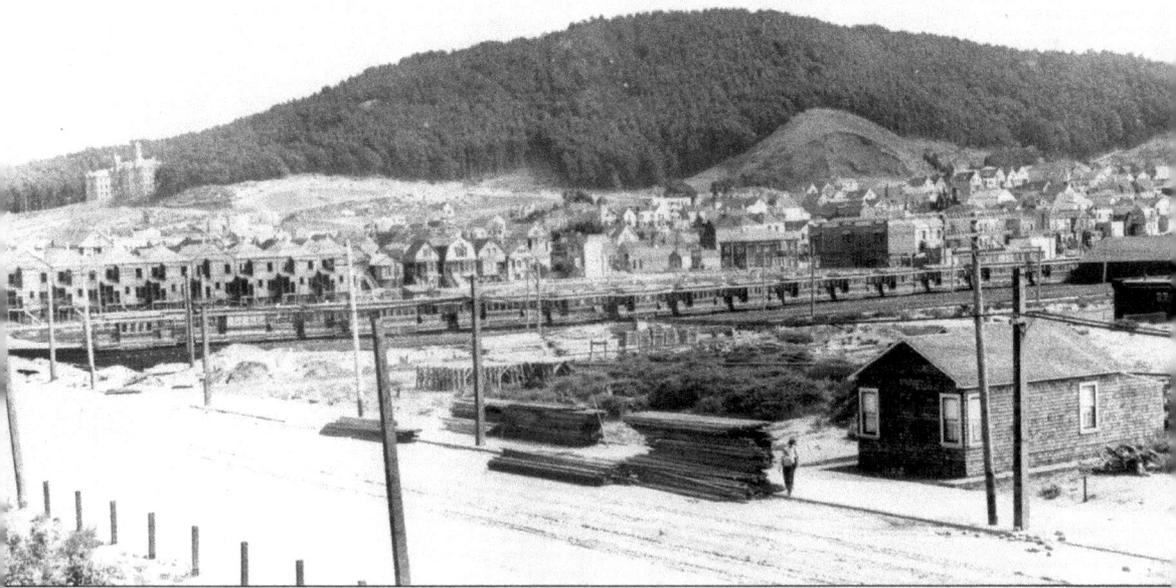

In the early 20th century a streetcar barn was planned from Lincoln to Irving between Funston and Fourteenth Avenues. However, the car barn was never built. Instead, an open yard was maintained to store functioning cars. It also became a place where damaged and "retired" cars were taken. It became known as "The Boneyard," and is now the site of Andronico's Market and an apartment complex. (Courtesy Emiliano Echeverria / San Francisco Municipal Railway.)

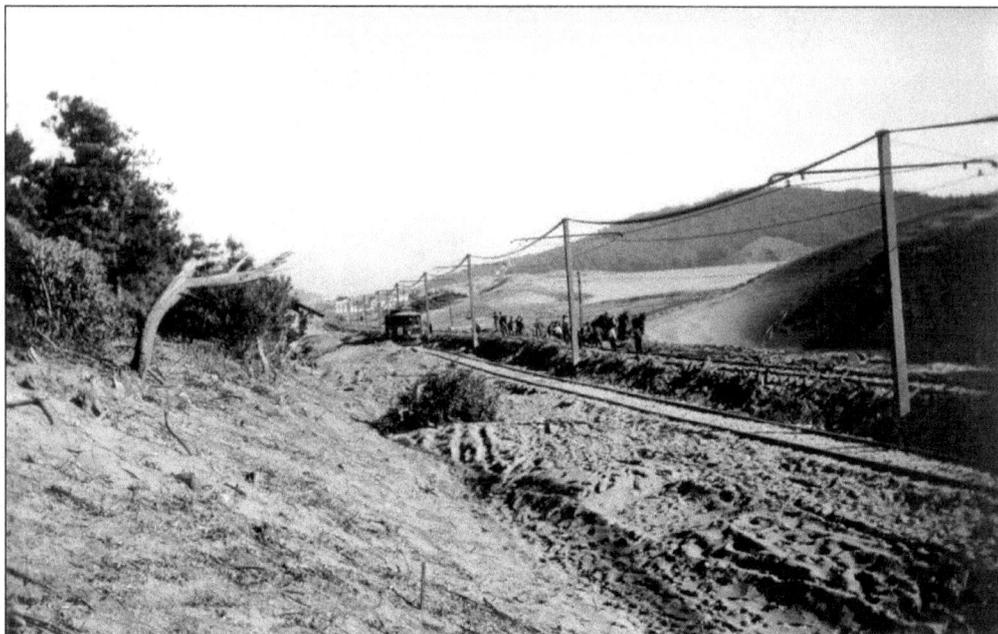

In 1909 work was done on the H Street tracks. This eastern view shows a few Golden Gate Park trees on the north, the steep sand dunes on the south, and the tree-covered Mount Sutro in the distant southeast. (Courtesy Emiliano Echeverria.)

In 1911 Bernadette O'Connor stood in front of her family's home at 1244 Twelfth Avenue, built in 1904. Note the hitching post. Bernadette's father had a horse; no one on the block had an automobile. (Courtesy Marcella O'Connor Iwersen.)

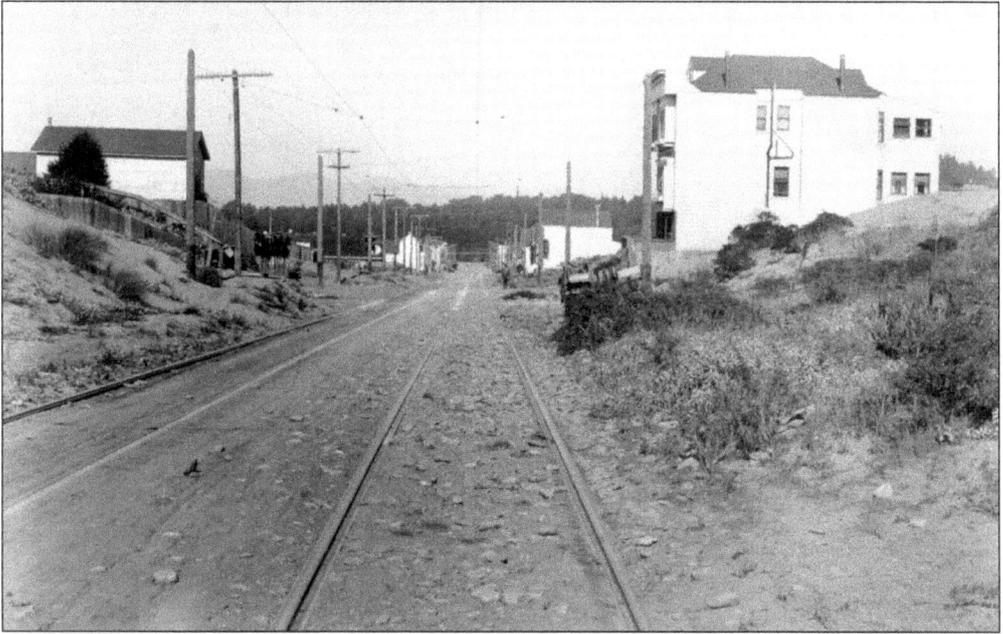

This view of Twentieth Avenue near Kirkham in 1914 shows that, although not many houses had been built on the street, a streetcar (number 17) operated on it. (Courtesy Emiliano Echeverria / San Francisco Municipal Railway.)

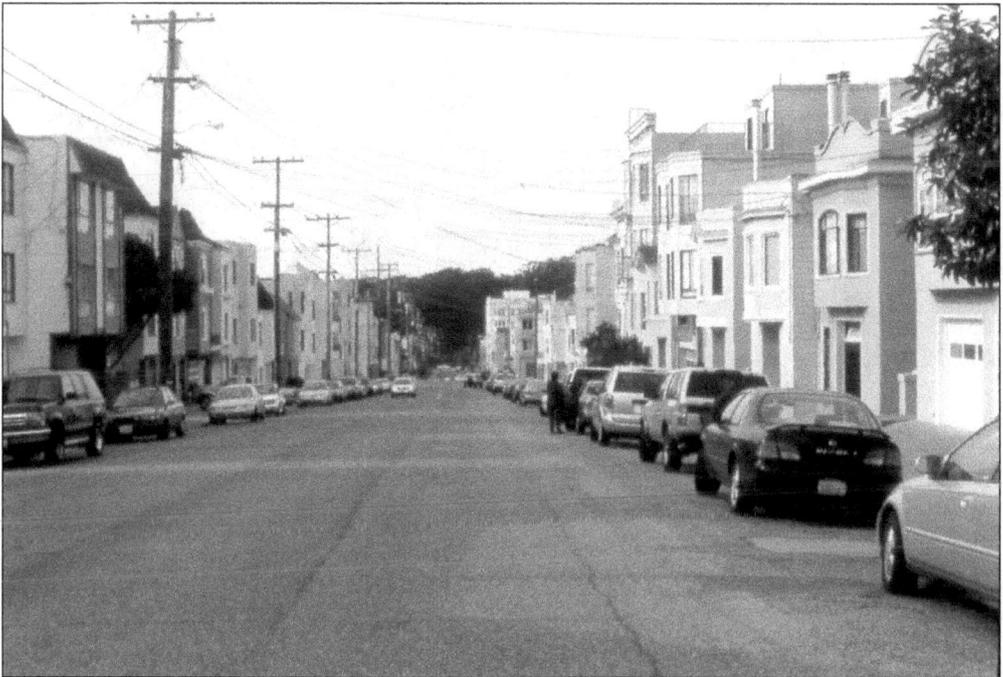

Today, no streetcar runs up Twentieth Avenue, and houses fill the lots. (Author's collection.)

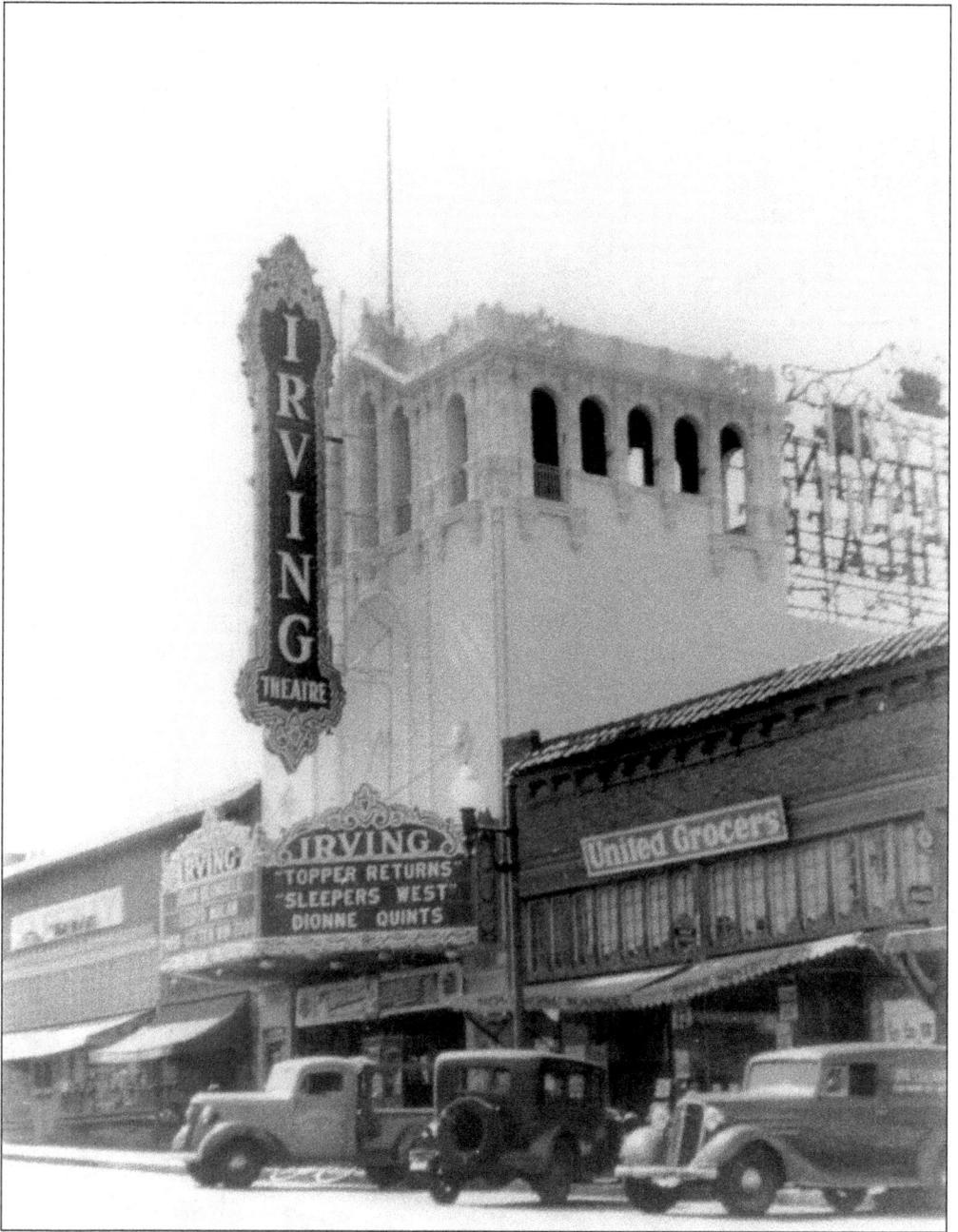

In 1926 a new movie theatre opened on Irving between Fourteenth and Fifteenth Avenues. The first large theatre in the Sunset, the Irving closed on July 8, 1962. (Courtesy Jack Tillmany.)

Program for January, 1937

SUNDAY	MONDAY	TUESDAY	WEDNESDAY	THURSDAY	FRIDAY	SATURDAY
Jan. 3	4	5	6	7	8	9
WM. POWELL · CAROLE LOMBARD **MY MAN GODFREY** HARRY HUNTER · JUDITH BARRETT **YELLOWSTONE**			Arthur Treacher **Thank You, Jeeves** Russell Hardie Ben Lyon **DOWN TO THE SEA** BANK NIGHT	JOAN CRAWFORD · ROBERT TAYLOR LIONEL BARRYMORE · FRANCHOT TONE **THE GORGEOUS HUSSY** ROSCOE KARNS · MARY BRIAN · WM. FRAWLEY **THREE MARRIED MEN** TEN-O-WIN — Saturday		
10	11	12	13	14	15	16
SIMONE SIMON · LORETTA YOUNG JANET GAYNOR **Ladies in Love** PUDDLES HANNEFORD in HERE COMES THE CIRCUS Three Ring Circus Short LEW AYRES **MURDER WITH PICTURES** $234.00 REFRIGERATOR — Tuesday			WALTER HUSTON RUTH CHATTERTON MARY ASTOR **DODSWORTH** SALLY EILERS **WITHOUT ORDERS** BANK NIGHT — Wednseday		GLADYS GEORGE **VALIANT IS THE WORD FOR CARRIE** Pete Smith's Greater Short WANTED A MASTER JACK HOLT · EVELYN VENABLE **North of Nome** TEN-O-WIN — Saturday	
17	18	19	20	21	22	23
CLARK GABLE MARION DAVIES **Cain and Mabel** OUR GANG COMEDY ROSALIND RUSSELL · JOHN BOLES **CRAIG'S WIFE**			JOEL McCREA JOAN BENNETT **Two in a Crowd** Robert Young **SWORN ENEMY** BANK NIGHT	Jack Benny · Burns & Allen **THE BIG BROADCAST OF 1937** MICKEY MOUSE VICTOR McLAGLEN · BINNIE BARNES **THE MAGNIFICENT BRUTE** TEN-O-WIN — Saturday		
24	25	26	27	28	29	30
STUART ERWIN · PATSY KELLY JACK HALEY **Pigskin Parade** MARCH OF TIME JOHNNY WEISSMULLER · MAUREEN O'SULLIVAN **TARZAN ESCAPES**			EDMUND LOWE **Girl on the Front Page** Cesar Romero **15 MAIDEN LANE** BANK NIGHT	Errol Flynn · Olivia de Havilland **THE CHARGE OF THE LIGHT BRIGADE** OUR GANG COMEDY JACK HOLT **END OF THE TRAIL** TEN-O-WIN — Saturday		
31	Feb. 1	2	3	4	5	6
NINO MARTINI · LEO CARRILLO IDA LUPINO **Gay Desperado** KATHARINE HEPBURN · HERBERT MARSHALL **A WOMAN REBELS**			EDMUND LOWE **Seven Sinners** HENRY HUNTER **LOVE LETTERS OF A STAR** BANK NIGHT	MYRNA LOY · WILLIAM POWELL JEAN HARLOW **Libeled Lady** GENE AUTRY **THE BIG SHOW** TEN-O-WIN — Saturday		

TEN-O-WIN EVERY SATURDAY
BANK NIGHT EVERY WEDNESDAY

This January 1937 flyer lists the movies coming to the Irving Theatre. At the bottom, the flyer advertises "Bank Night Every Wednesday" and "Free Tuesday Night, January 12—A $234.50 Sparton De Luxe Refrigerator." (Courtesy Wilma Zari.)

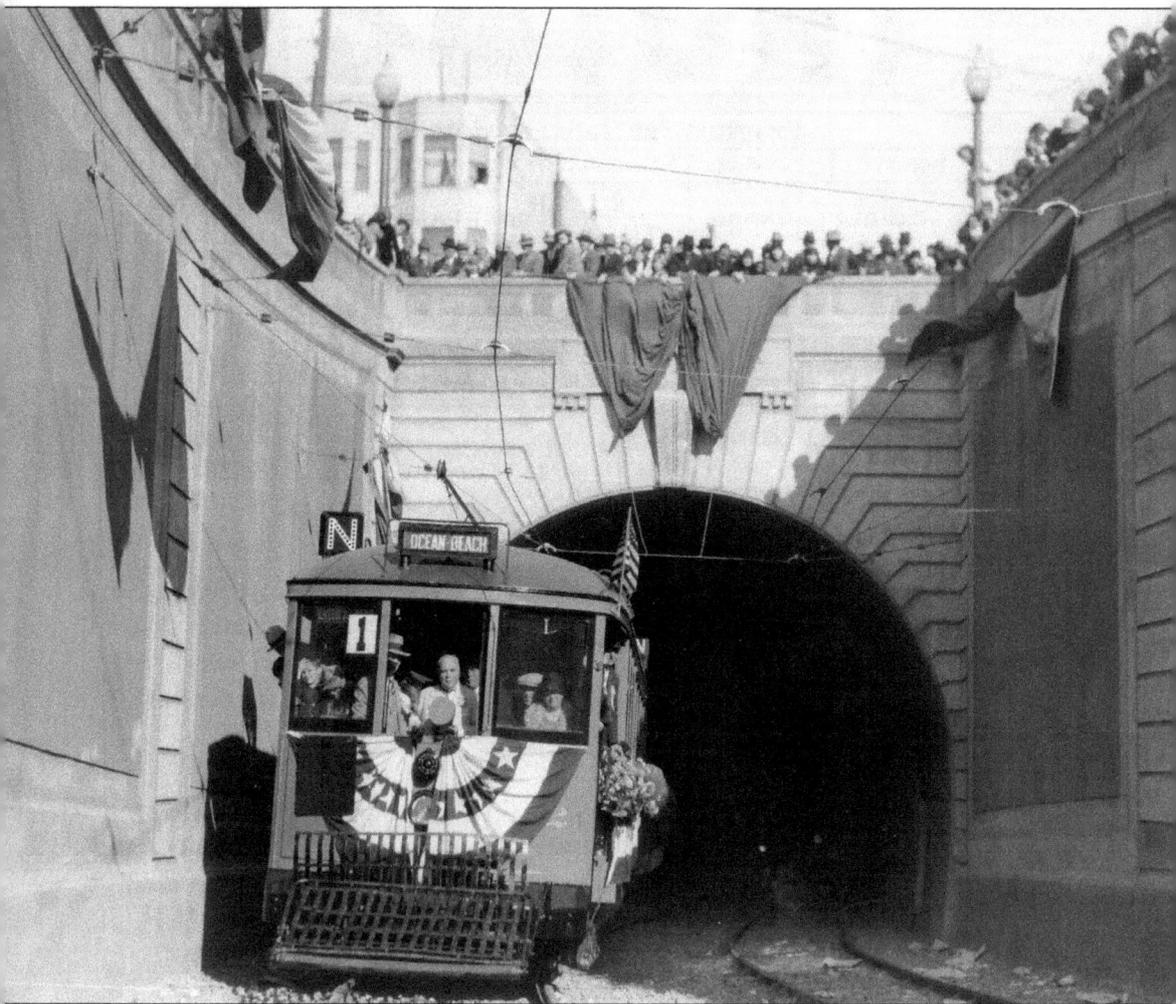

On October 21, 1928 the Sunset Tunnel opened with great fanfare, ushering in a new streetcar line, the N Judah, to connect the Inner and Outer Sunset with downtown. As part of the celebration, the city's mayor, "Sunny Jim" Rolph, drove the new N Judah car from downtown through the tunnel and down Judah Street to the beach. (Courtesy Emiliano Echeverria / San Francisco Municipal Railway.)

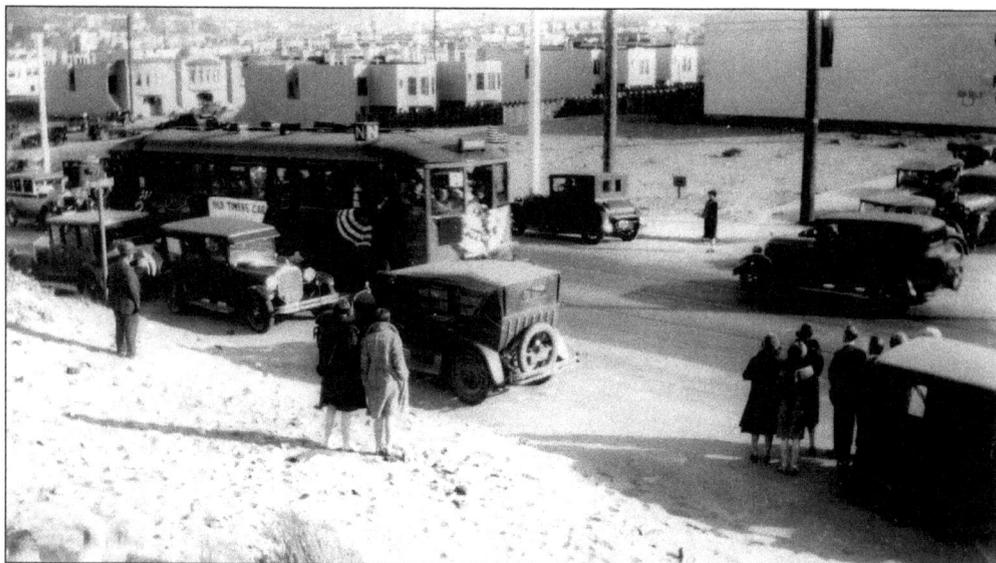

Thousands of people lined the route of the first N Judah streetcar on opening day in 1928, although by the time it reached the Outer Sunset, fewer people had made the trek. Note the finished houses alongside empty sand lots. (Courtesy Emiliano Echeverria.)

The N Judah loop, built in 1926, provided a way for the streetcar to turn around and return downtown when it reached the end of the line near the beach. The N Judah is one of two streetcar lines that still run in the Sunset; the other is the L Taraval line.

In 1940 Maryhelen Colling and her friend won first place as Scarlett O'Hara and Rhett Butler at an Irving Street festival. She remembers that their prize was about 50¢ each. (Courtesy Maryhelen Colling Nightingale.)

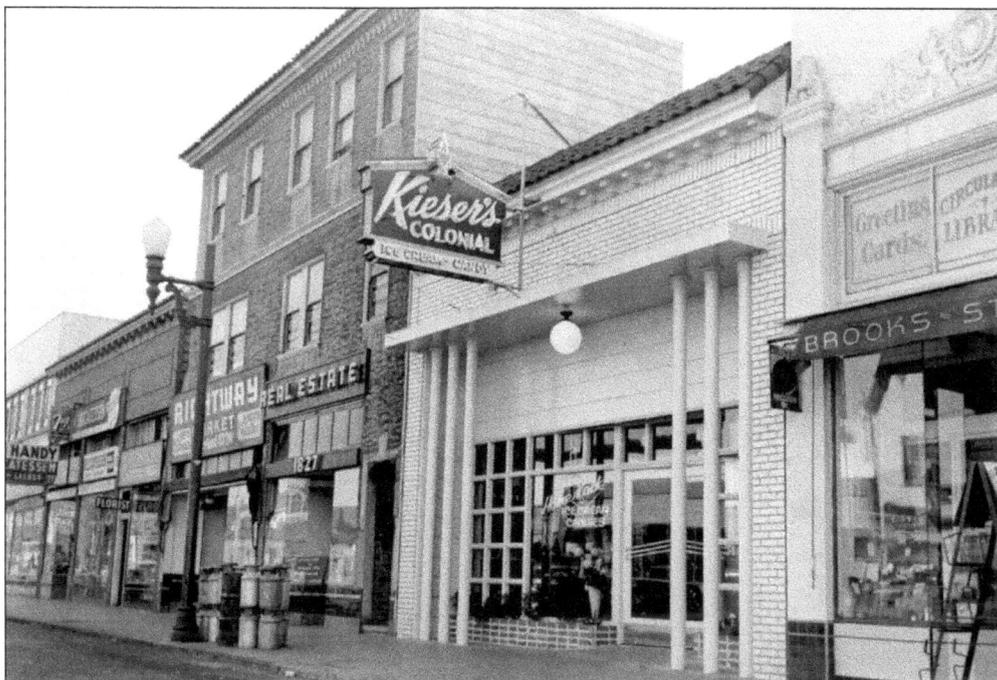

In 1946 Ellen Kieser's family opened Kieser's Colonial Creamery on Irving Street near Nineteenth Avenue. Ellen made the ice cream, which was delivered to Sunset customers. She remembers, "Sometimes a driver was sure that he could make it across a sand dune but would get stuck on the way to a delivery." (Courtesy Ellen Kieser.).

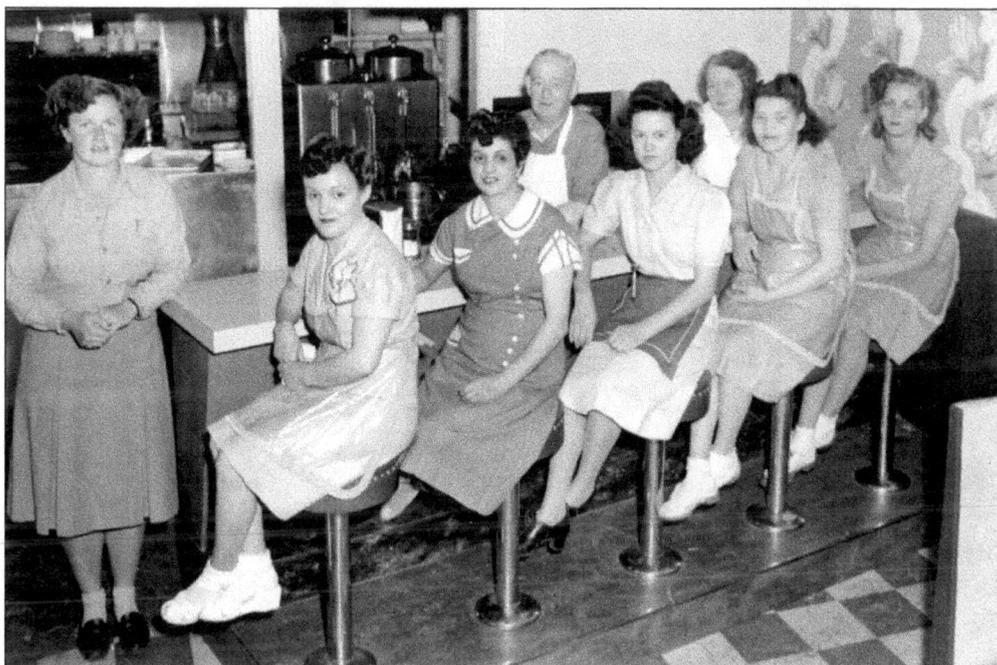

Ellen Kieser (left) and her staff posed inside the Colonial Creamery in 1946. (Courtesy Ellen Kieser.)

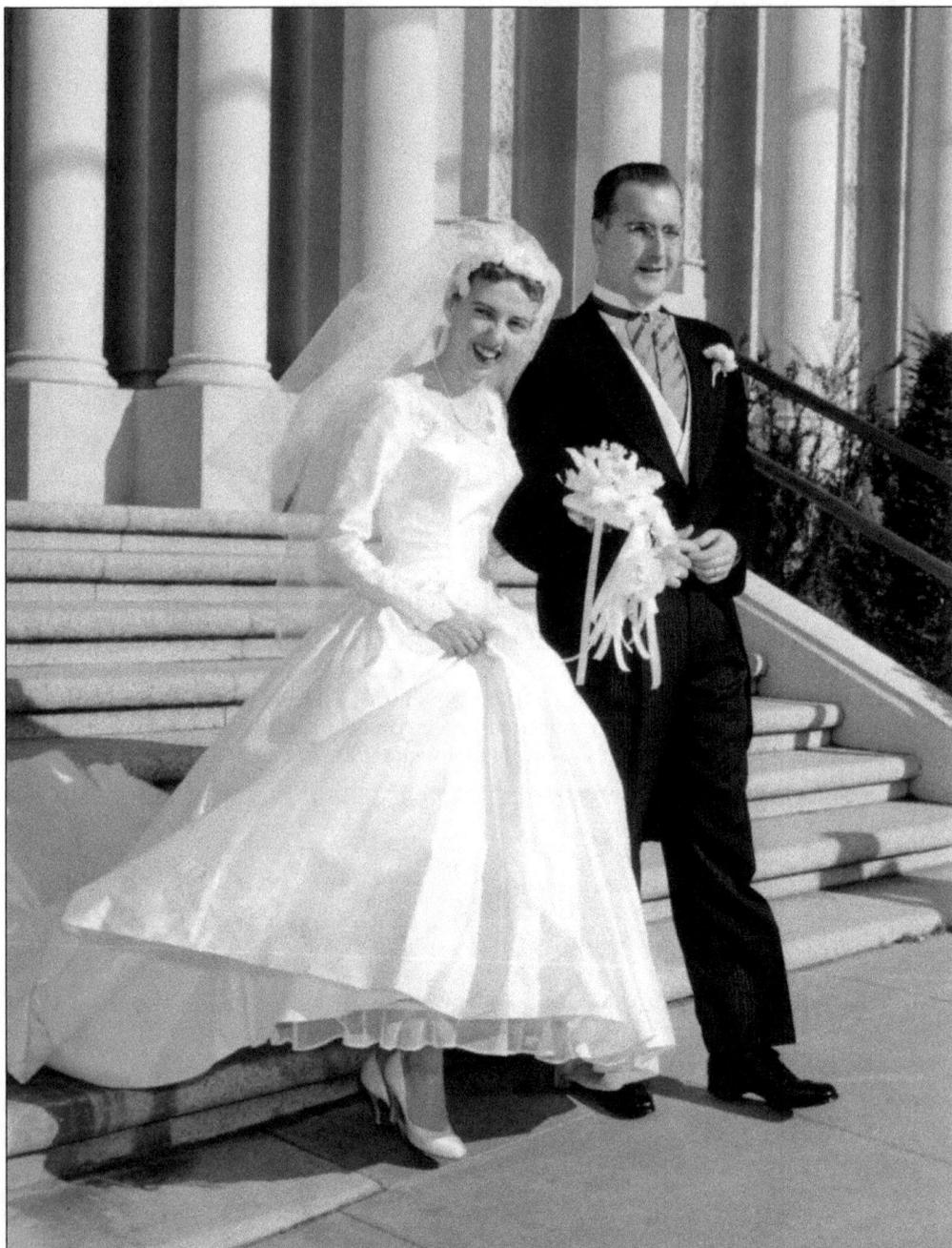

In 1956 Maryhelen Colling and Raymond Nightingale were married at St. Anne's Church. (Courtesy Maryhelen Colling Nightingale.)

Three

THE PARKSIDE

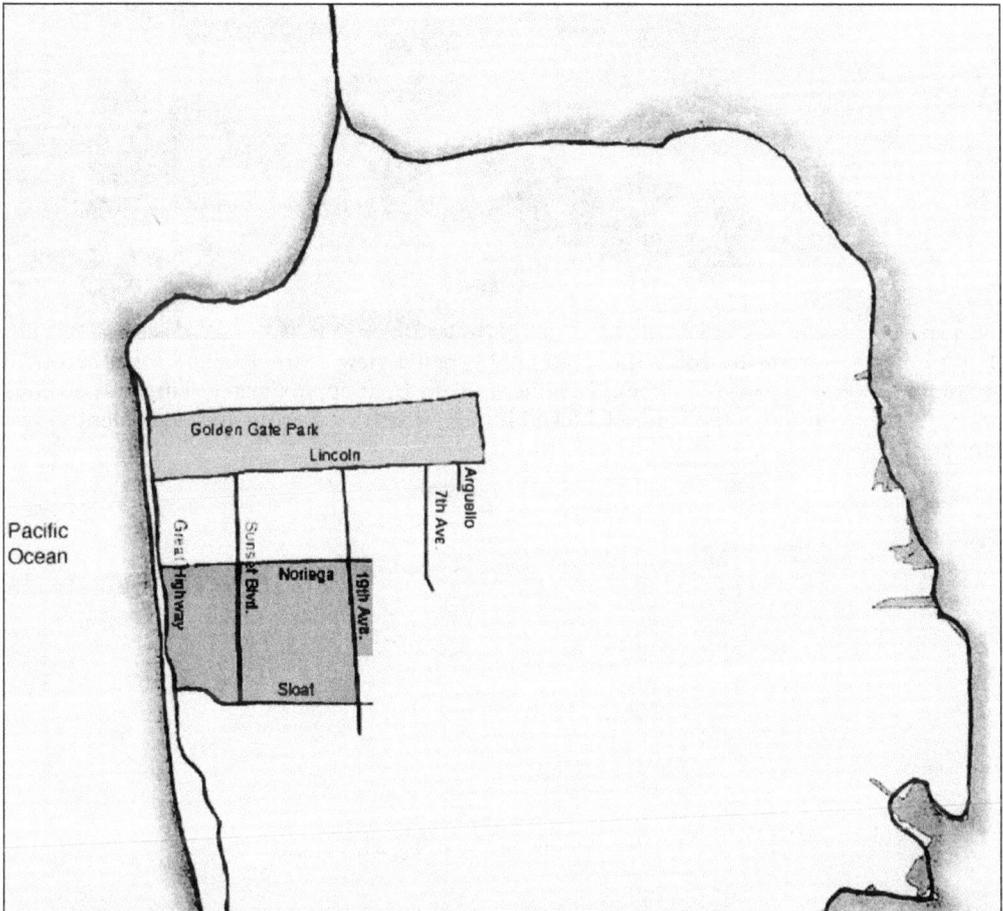

The Parkside comprises the southern section of the Sunset. The Parkside's approximate boundaries are from Noriega Street on the north to Sloat Boulevard on the south, from approximately Nineteenth or Twentieth Avenue on the east to the Great Highway on the west. (Map by Christine Riley.)

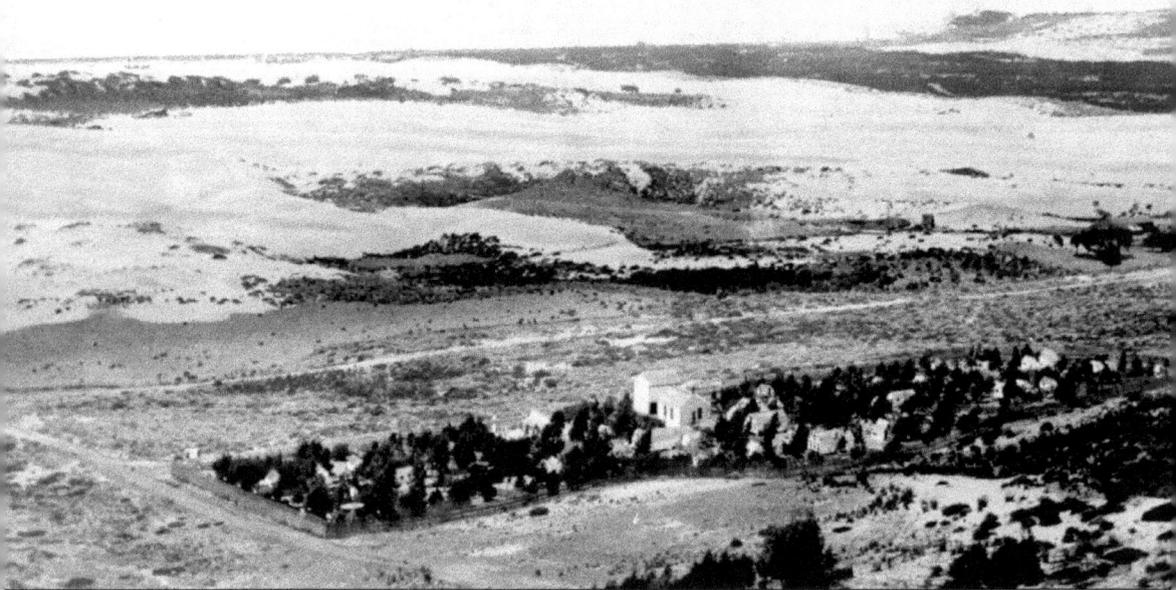

This photograph from the 1880s shows an unobstructed view of the Pacific Ocean beyond a seemingly endless expanse of dunes. This view, taken from approximately Fifteenth Avenue and Ortega Street, shows the Larsen Chicken Ranch, which took up an area equivalent to two city blocks.

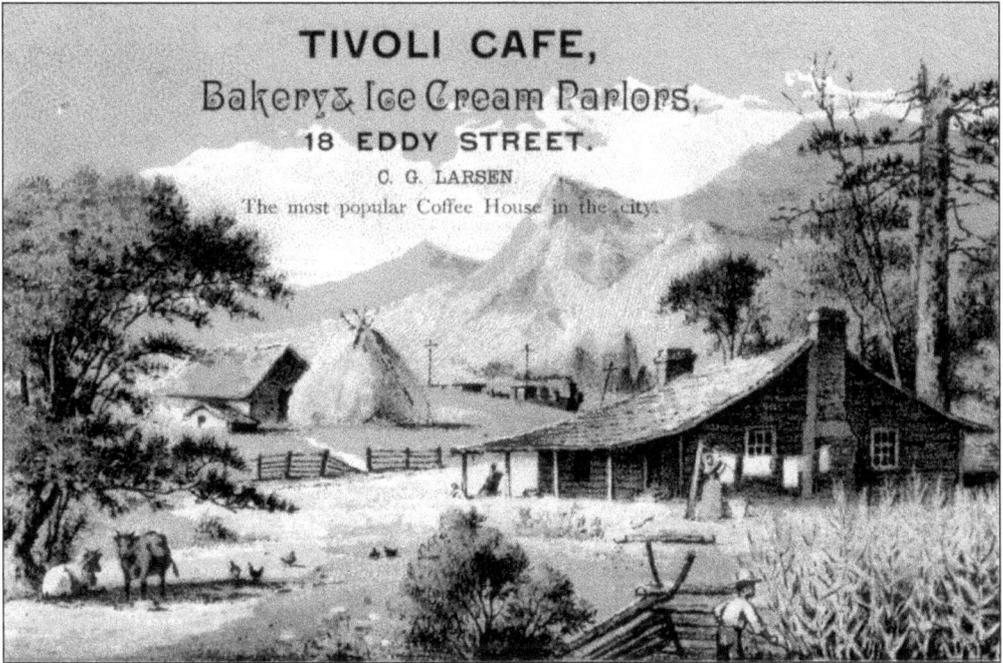

TIVOLI CAFE,
Bakery & Ice Cream Parlors,
18 EDDY STREET.
C. G. LARSEN
The most popular Coffee House in the city.

Carl Larsen (1844–1928) moved to San Francisco from Denmark in 1873. He never lived in the Sunset District, but he bought the equivalent of 30 blocks of undeveloped sand dunes. Larsen owned the Tivoli Café in downtown San Francisco on Eddy Street, and every day a horse-drawn wagon carried fresh eggs from the Larsen Chicken Ranch to the Tivoli. Above is an advertisement for the Tivoli Café. (Author's collection.) To the right is a photograph of the actual café. (Courtesy San Francisco History Center, San Francisco Public Library.)

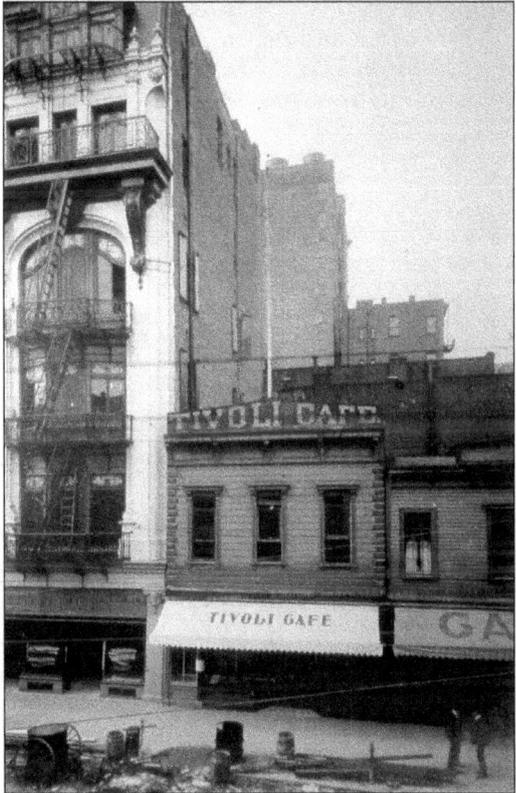

47

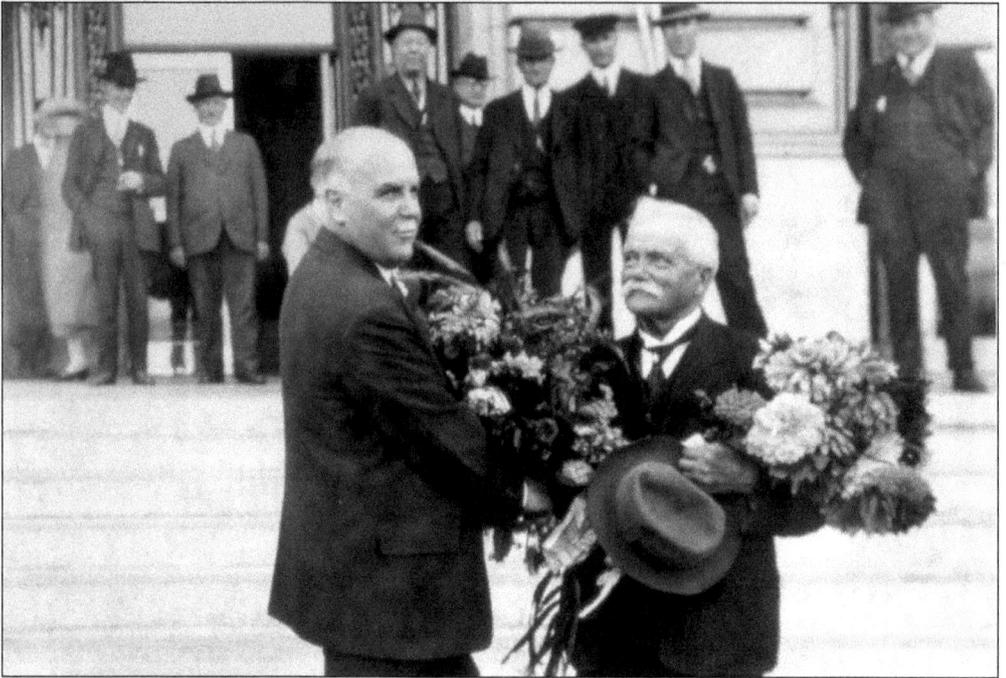

Carl Larsen is shown here (at right) in 1926 with Mayor "Sunny Jim" Rolph, who is thanking Larsen for donating land to San Francisco. This donation, later named Carl G. Larsen Park, covers two square blocks from Nineteenth to Twentieth Avenues, from Ulloa to Wawona Streets. This was Larsen's second donation; in 1924 he gave six acres of his ranch land to the city for a park. Note that Larsen is holding a bouquet of dahlias; the dahlia had recently been named the city flower of San Francisco. (Courtesy San Francisco History Center, San Francisco Public Library.)

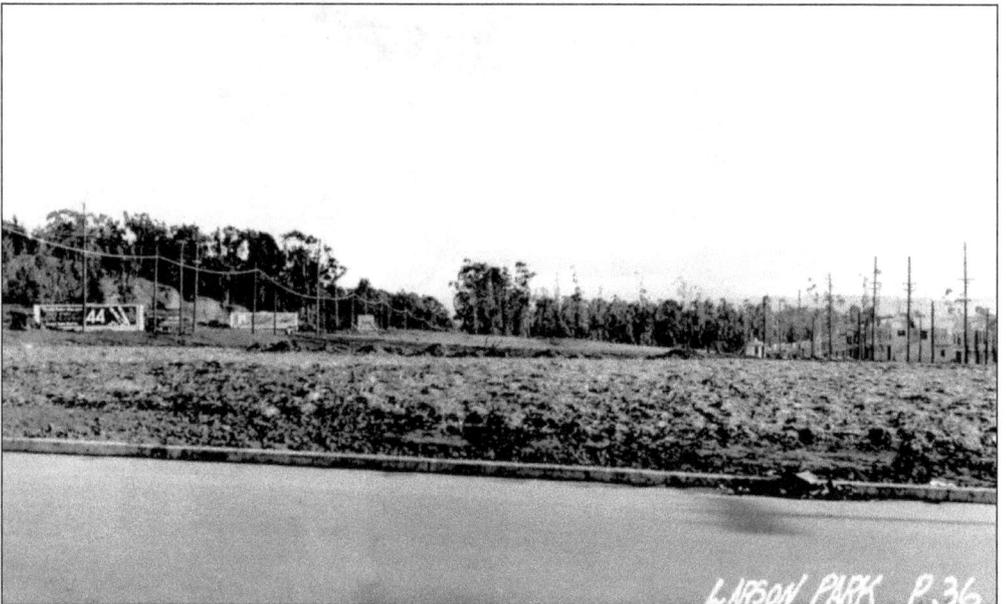

This photograph shows the untamed plot of land donated for the Carl G. Larsen Park on Nineteenth Avenue.

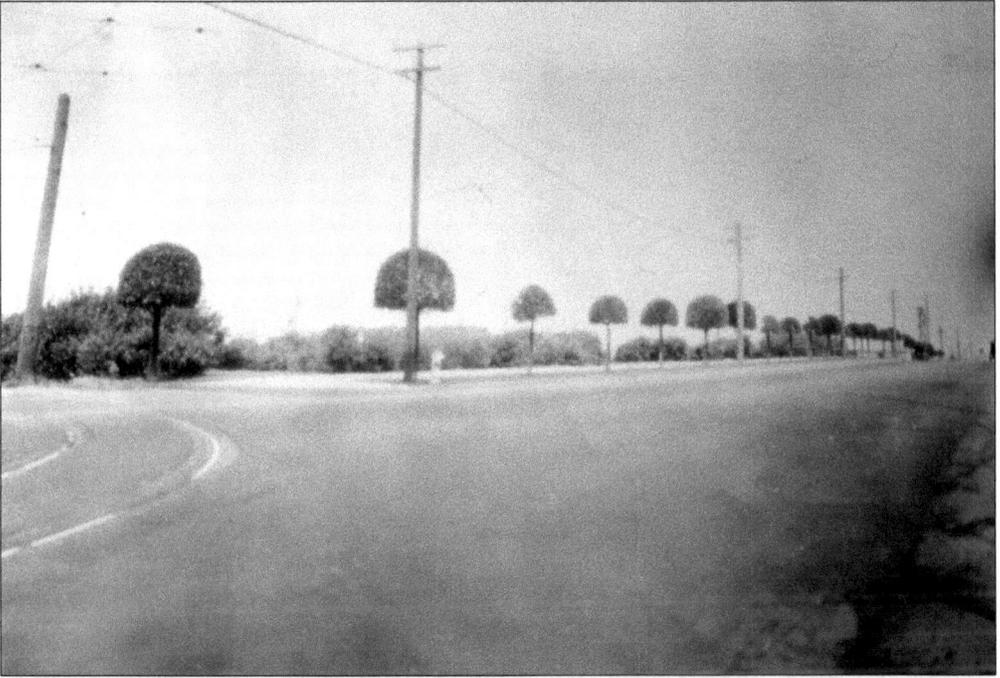

In 1934, manicured trees lined Larsen Park. The streetcar tracks shown here along Wawona Street turned onto Nineteenth Avenue, where the photographer was standing. (Courtesy San Francisco History Center, San Francisco Public Library.)

A unique feature of Larsen Park was the jet installed for children. Over the years several different jets delighted climbing children. (Courtesy San Francisco History Center, San Francisco Public Library; photo by Bob Jones.)

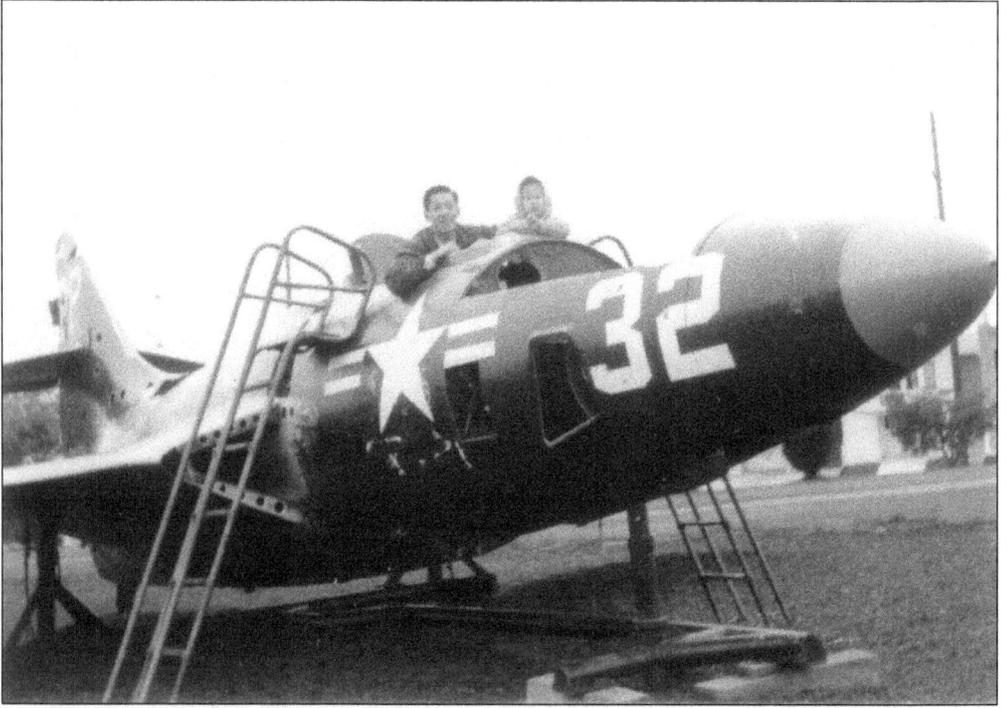

In 1966, Richard Lim sat in the cockpit with his son. Later, the jet was removed; hazardous levels of lead had leached into the surrounding soil. (Courtesy Richard Lim.)

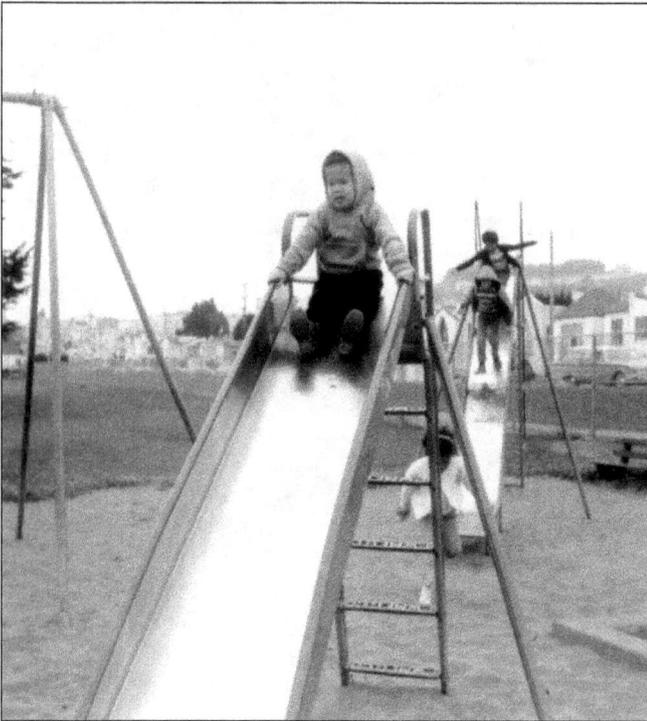

This 1966 photograph shows the playground at Larsen Park. Other features of the park include a baseball diamond and the Charlie Sava Pool, named after a popular swimming instructor. Houses line Nineteenth Avenue across from the park. (Courtesy Richard Lim.)

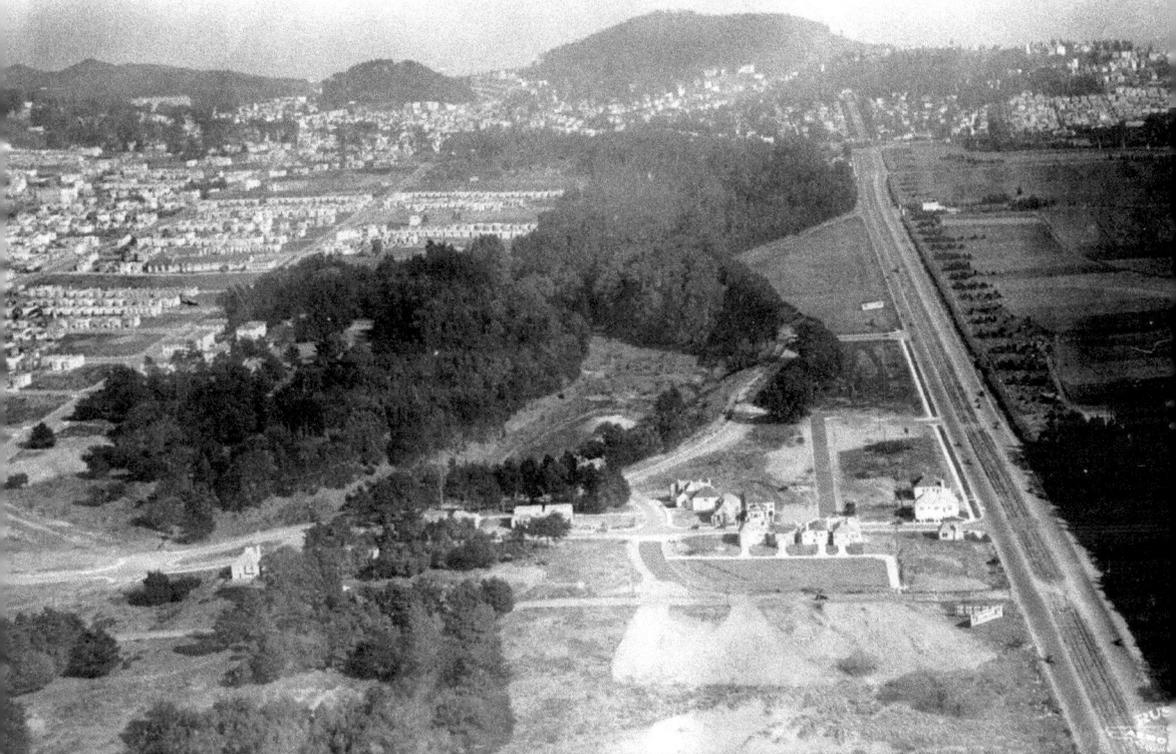

Another immigrant to the Parkside was George M. Greene, who brought his family to San Francisco from Maine in 1847. This aerial photograph from the 20th century shows some of the land the Greenes settled, identifiable by the line of trees that Greene's son, George M. Greene Jr., and his family planted. Note Mud Lake (now known as Pine Lake), the small body of water in the clearing near the center of the photo.

In 1892 George M. Greene Jr. built the Victorian-style Trocadero Inn, a popular roadhouse that offered weekend visitors food, music, and entertainment. It became famous in 1906 when, during the graft trials of city officials, political boss and attorney Abe Ruef "hid out" at the Trocadero, where he was arrested. The roadhouse closed in 1916, but the Trocadero building still stands in Sigmund Stern Grove and is used for weddings and parties. (Author's collection.)

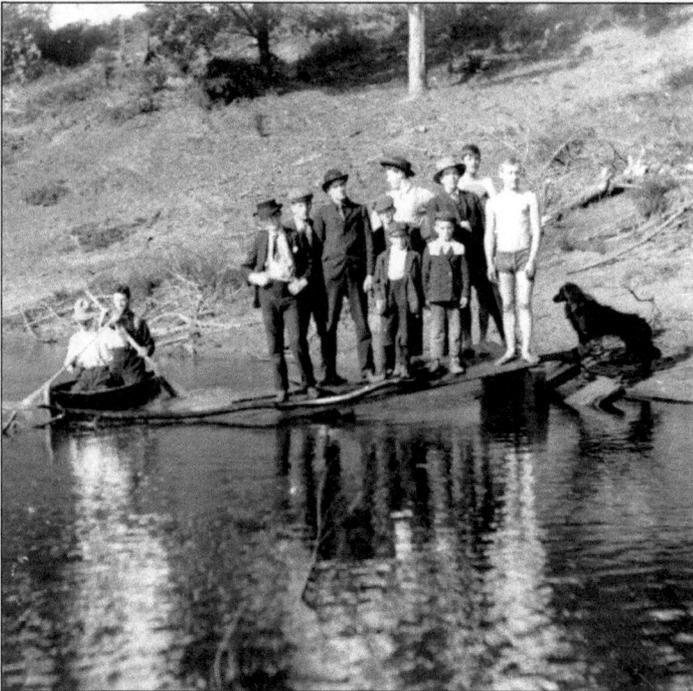

In the early 1900s Mud Lake was a favorite swimming and boating spot for Parkside residents.

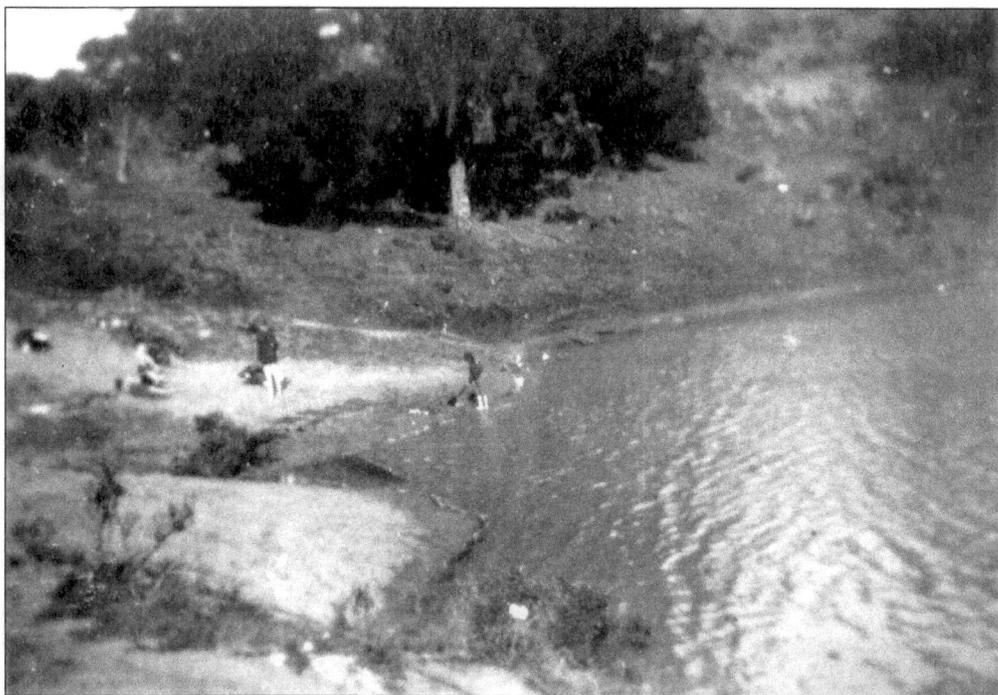

Chas Williams and his buddies often spent time at Mud Lake. (Courtesy family of Ada and Chas Williams.)

Cows also enjoyed roaming around Mud Lake.

After the 1906 earthquake, people began moving to the new neighborhoods on the western side of San Francisco. The Parkside was a popular area in which to settle. This 1910 view of the Parkside shows scruffy empty lots alongside the houses that were beginning to appear.

In the early 1900s, a member of the Williams family took this picture of "Rivera Street between Thirty-first and Thirty-second Avenues showing the springs leading to the pond." The people in the background give a sense of how large this pond was before it was filled in and completely covered with streets and houses. (Courtesy family of Ada and Chas Williams.)

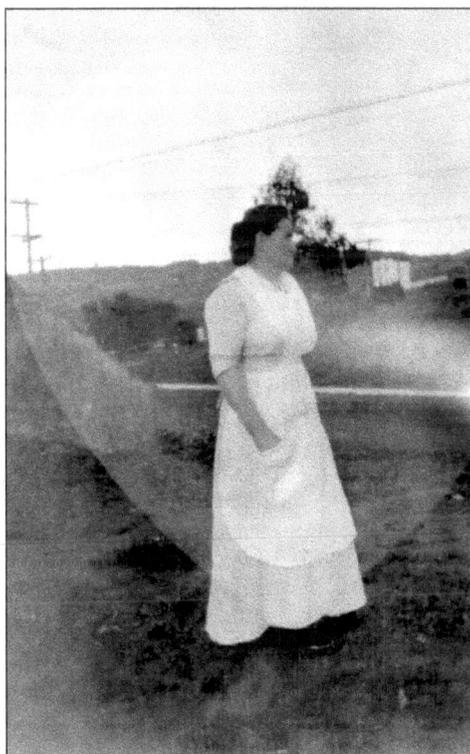

This woman in the dunes, photographed around 1910, shows how isolated the area may have felt to its new residents. (Courtesy family of Ada and Chas Williams.)

In about 1910 the Penrose family posed for this picture. It isn't clear where they were living at the time, but within four years, they had built their home in the Parkside (see facing page). Dorothy Penrose is the young girl in front. (Courtesy Roy C. Thomas.)

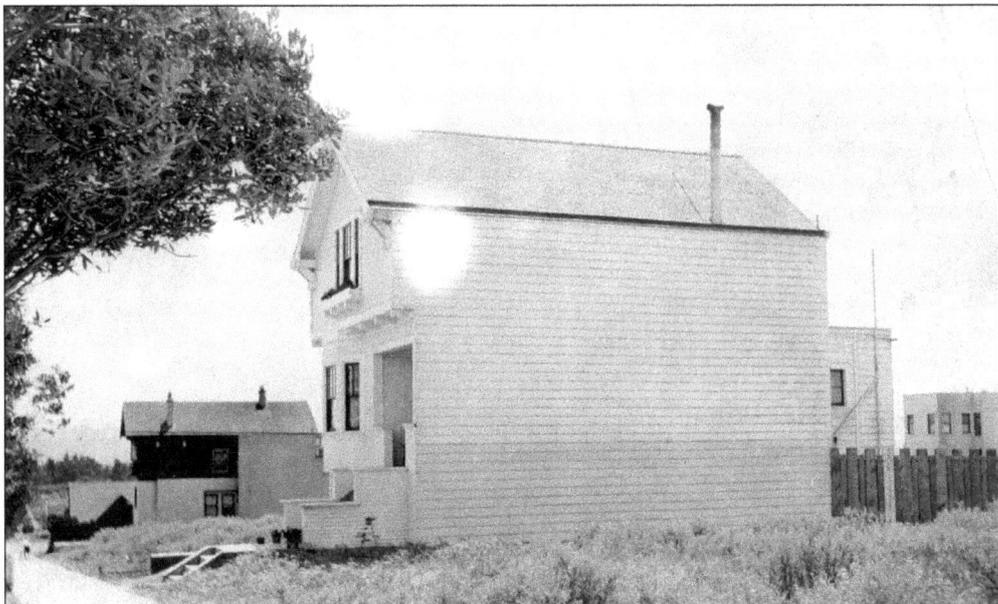

The above photograph shows the Penrose house, built in 1914 at 2443 Twenty-eighth Avenue. At the time it was only the third house on the block. Shown below in 1921, Dorothy Penrose, then age 18, posed with her dog in front of her family home. (Courtesy Roy C. Thomas.)

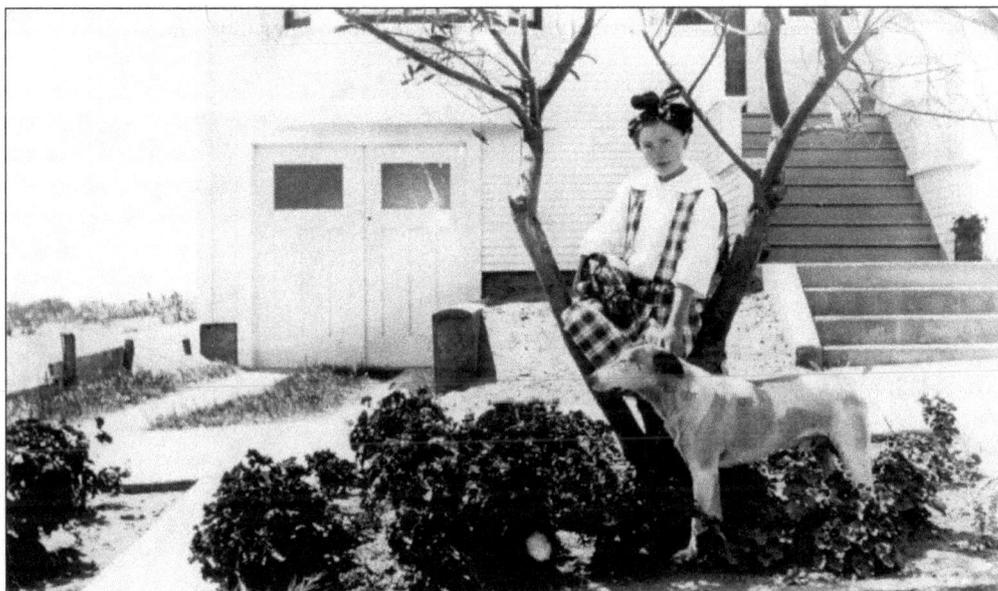

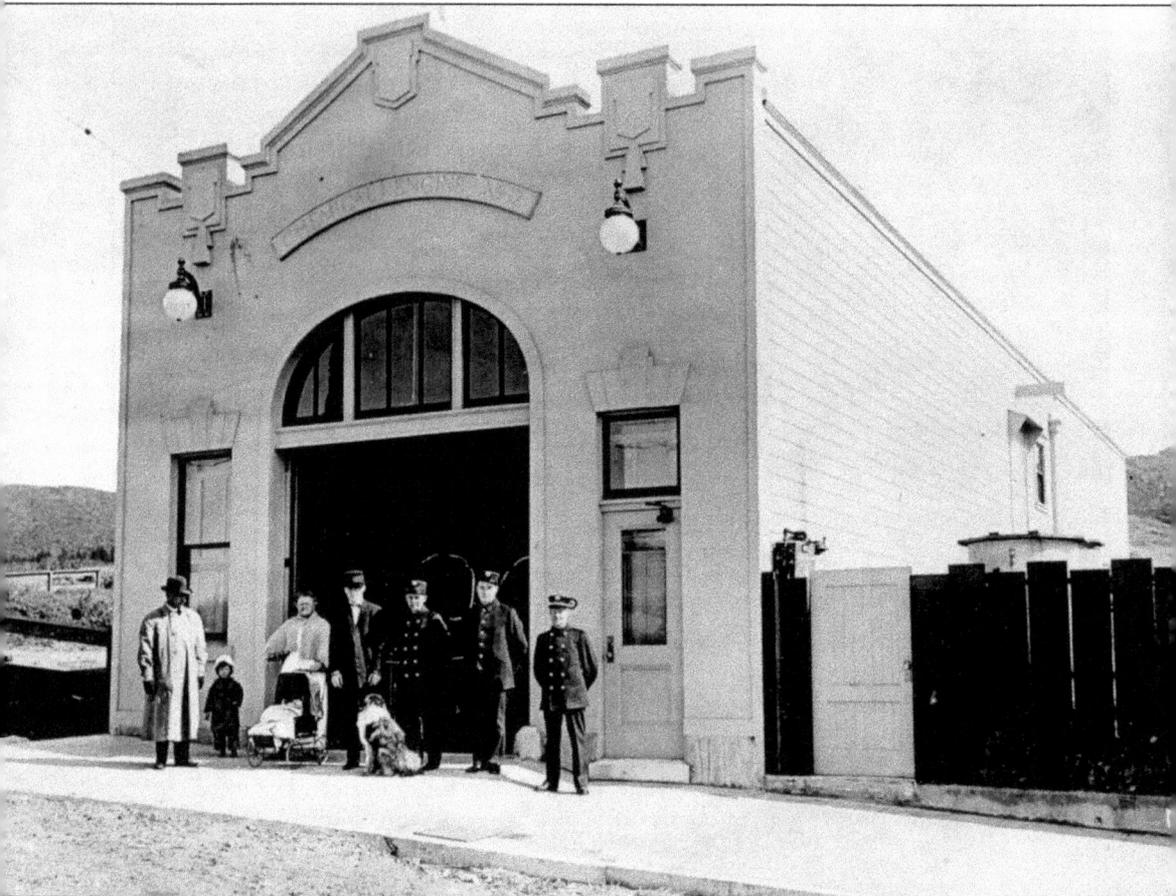

This 1913 photograph shows the neighbors and firemen of Chemical Engine #12 at 2155 Eighteenth Avenue. Note the dunes in the background. Jerian Reidy Crosby, who lived nearby during the 1950s, remembers the firemen decorating this building for Christmas each year. A firehouse still stands on the site.

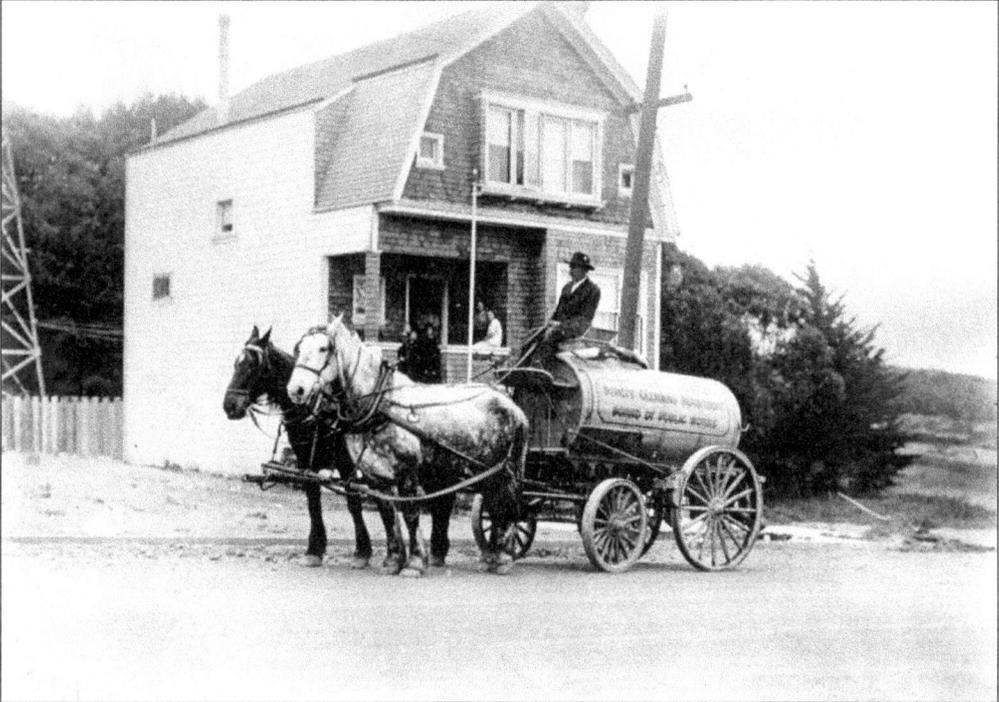

In 1915 this house stood alone on Seventeenth Avenue, surrounded by dunes and serviced by the city's "Street Cleaning" carriage. Shown below: The house remains today, flanked by "modern" buildings, paved streets, and overhead wires. (Author's collection.)

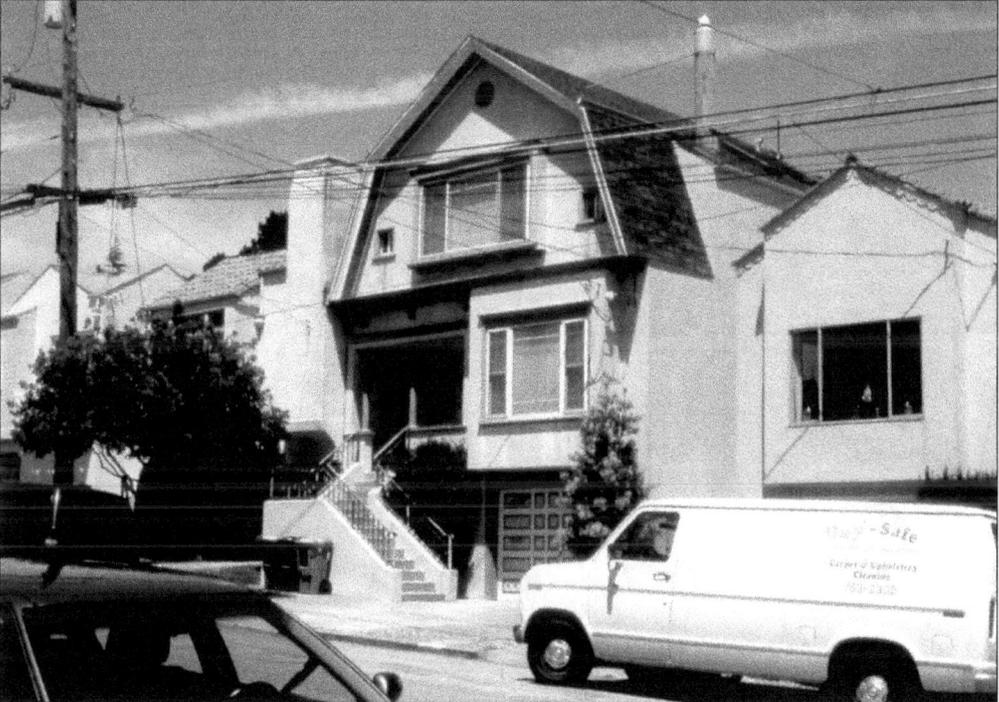

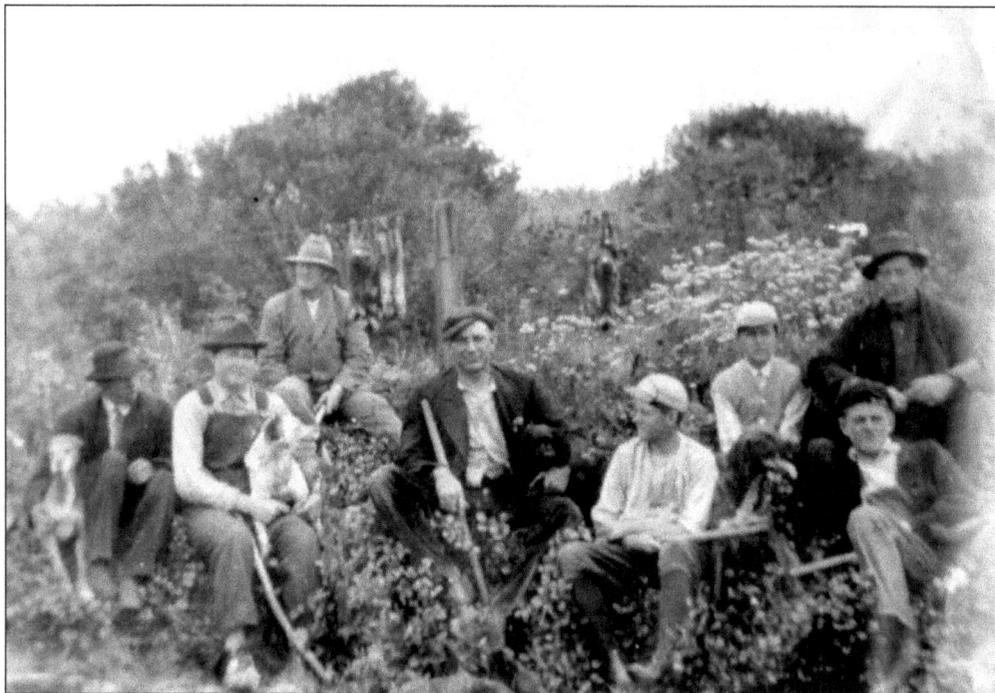

In 1915 Chas Williams and his friends often made a day of hunting the rabbits that roamed the Parkside. From left to right we find Tom Whaley, Chas Williams with dog Jack, Eugene Williams Sr., Bill Stanton Sr., Bill Henning, Bill Stanton Jr., "Mr. Henning," and George Stanton (below). (Courtesy family of Ada and Chas Williams.)

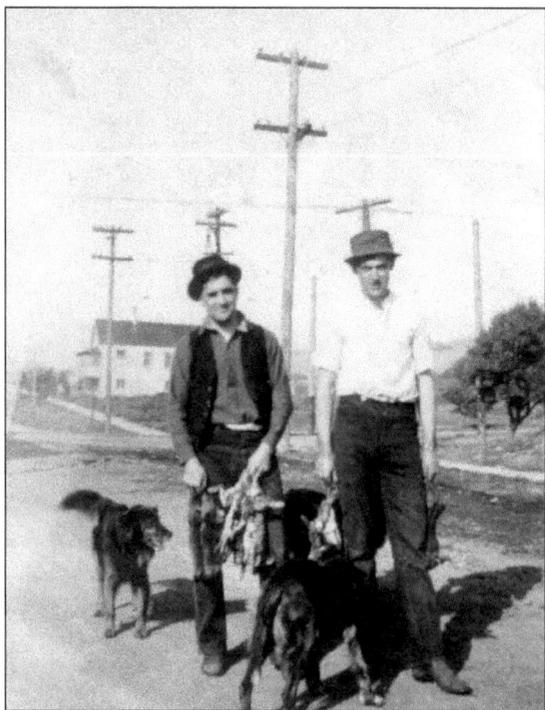

Two Parkside area hunters made their way home in 1916. (Courtesy family of Ada and Chas Williams.)

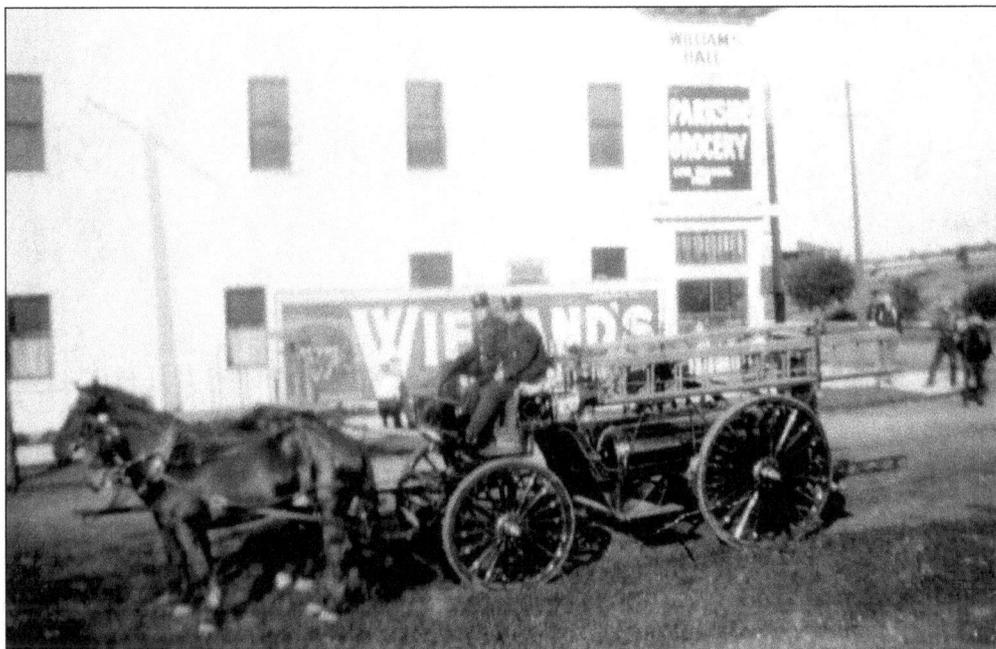

The Williams' Parkside Grocery on Thirty-second Avenue and Taraval was a popular spot for firemen and policemen to stop for snacks and supplies. Community meetings were held upstairs in Williams Hall. (Courtesy family of Ada and Chas Williams.)

The Williams family decorated their store for special occasions. (Courtesy family of Ada and Chas Williams.)

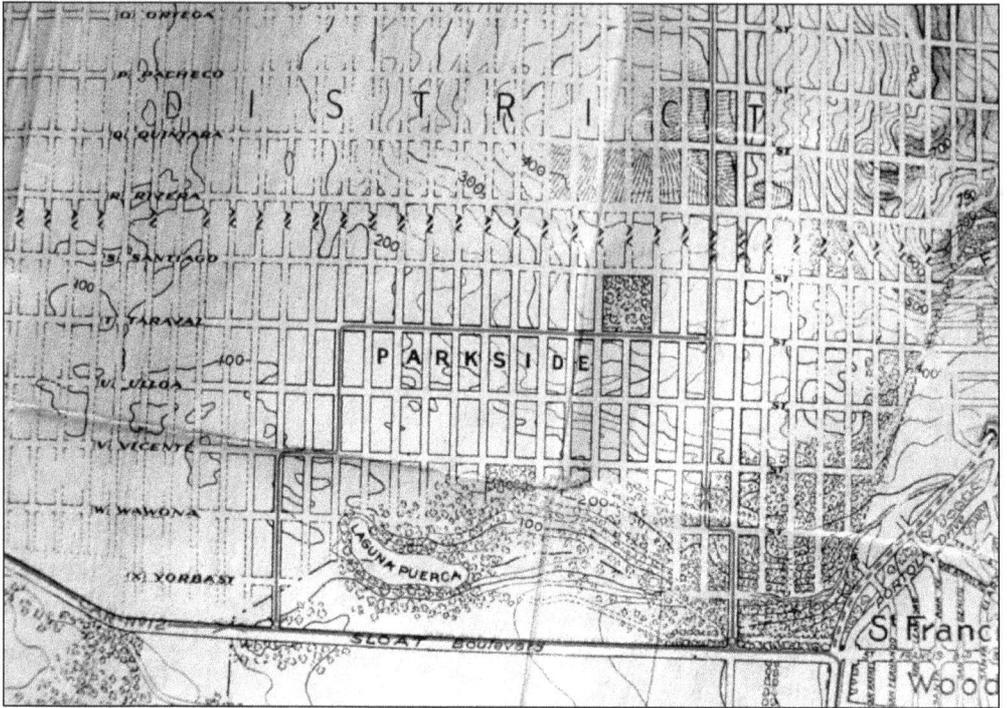

This 1915 Chevalier map designates the Parkside. Most of the area was still sand dunes. The map indicated where streets were planned, but many of the streets had not been created yet. The wavy lines indicated sand, and the thick rules marked the transit lines in the area. (Courtesy Dennis Minnick.)

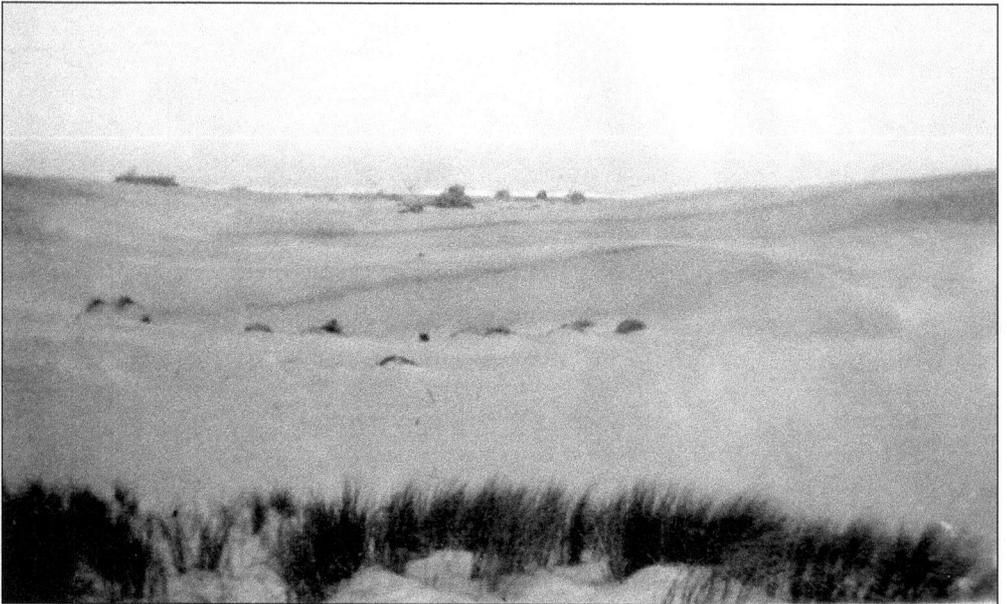

While Taraval was to become a major street in the Parkside, getting around the area was difficult before public transportation arrived. This 1916 photograph shows the view from Thirty-seventh Avenue and Taraval looking toward the ocean. (Courtesy family of Ada and Chas Williams.)

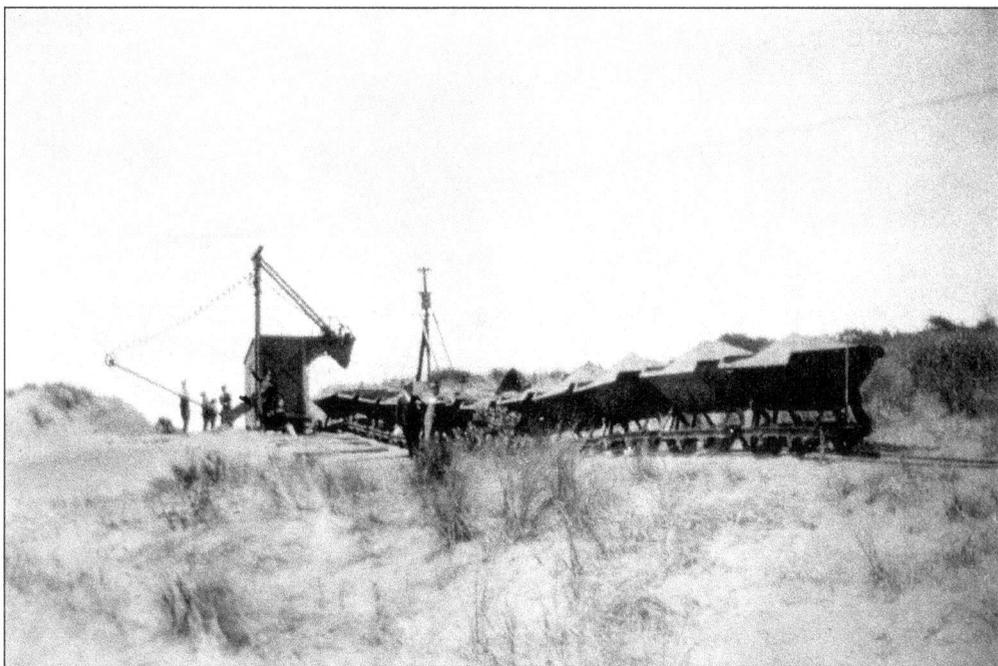

According to photographer Chas Williams, "The work of opening Taraval Street to the beach is started April 15, 1916. Pictures taken April 17, 1916." As always, sand had to be removed during construction in the dunes. This picture shows the Taraval Street sand dredger and filled sand cars. (Courtesy family of Ada and Chas Williams.)

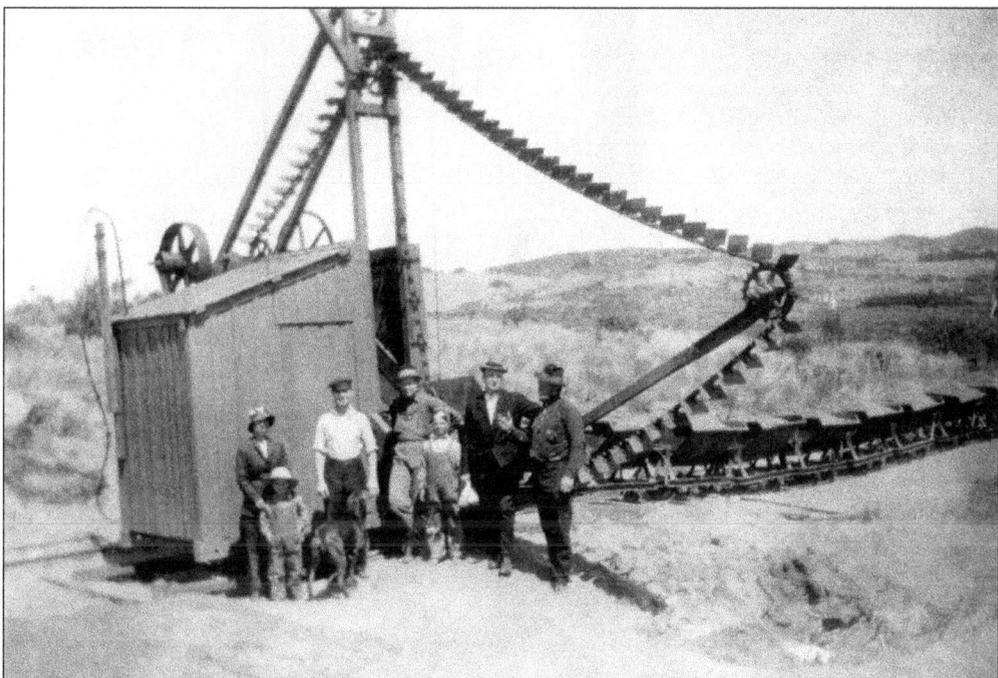

Parkside residents posed in front of the sand dredger and sand cars. (Courtesy family of Ada and Chas Williams.)

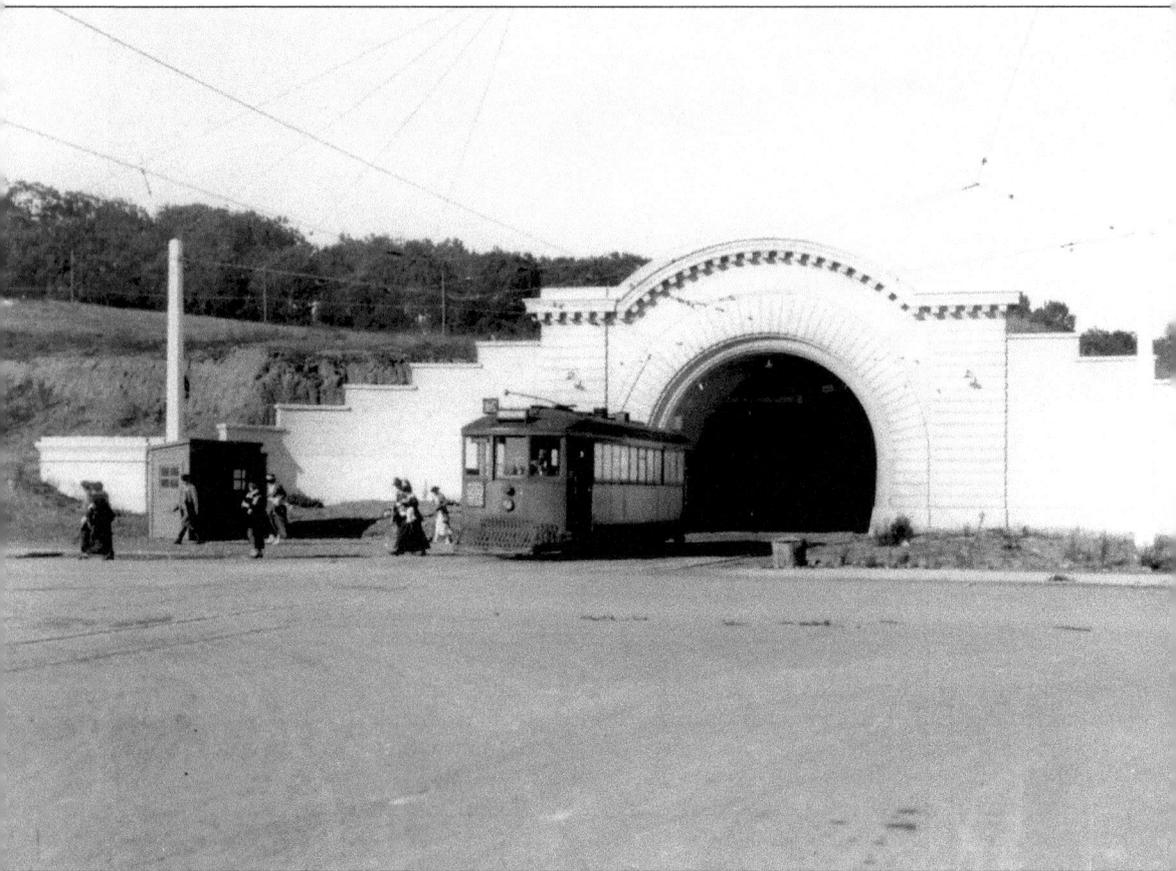

The Twin Peaks Tunnel, connecting downtown with the western side of the city, was completed in 1917 and opened in early 1918. The L Taraval line, which began the following year, ran from the West Portal side of the tunnel down Taraval Street to Thirty-third Avenue. The easier commute downtown spurred growth in the Parkside area. (Courtesy Tom Gray.)

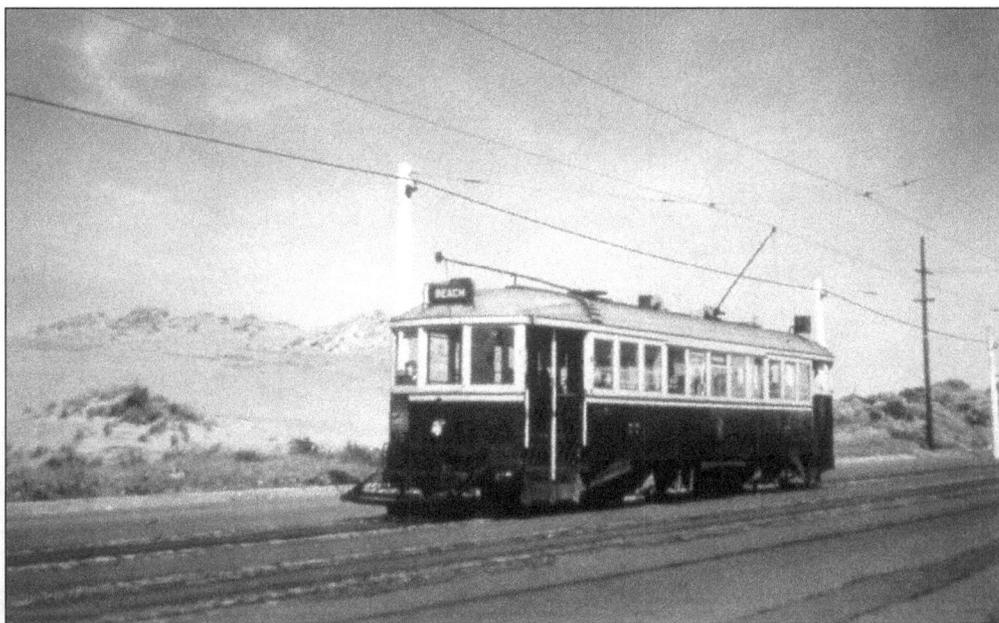

While the Parkside continued to grow with the advent of the L Taraval line, sand dunes still remained along the streetcar route in the 1940s. (Courtesy Western Neighborhoods Project.)

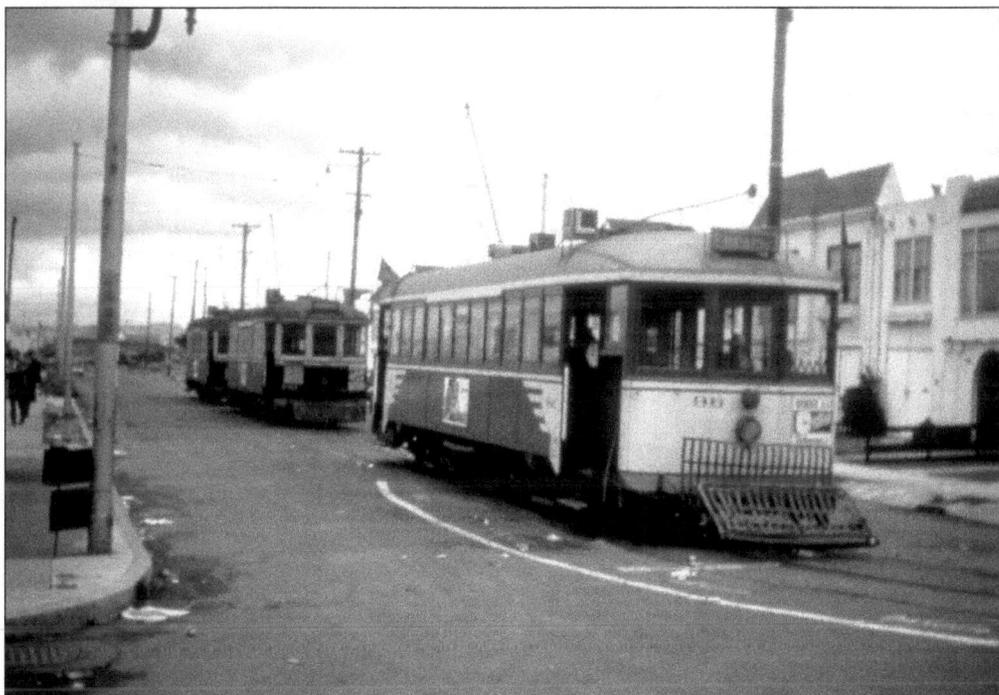

In 1937 the L line was extended to its present terminal on Sloat Boulevard near the beach. In this picture, two streetcar models are running at the same time. The one behind was one of the San Francisco Municipal Railway's early cars, soon to be discontinued in favor of the more "modern" type of streetcar, seen in the foreground. The L Taraval line is one of two streetcar lines that still run in the Sunset; the other is the N Judah. (Courtesy Emiliano Echeverria.)

In the 1940s streetcar tracks were a familiar part of Taraval Street. This picture was taken looking west near Twenty-first Avenue. (Courtesy San Francisco History Center, San Francisco Public Library.) In the 1980s composer Frank Levin captured the sounds and busyness of the street in his "Taraval Street Rag," one of several piano pieces about the Parkside and the Sunset. Levin continues to compose music about his neighborhood today.

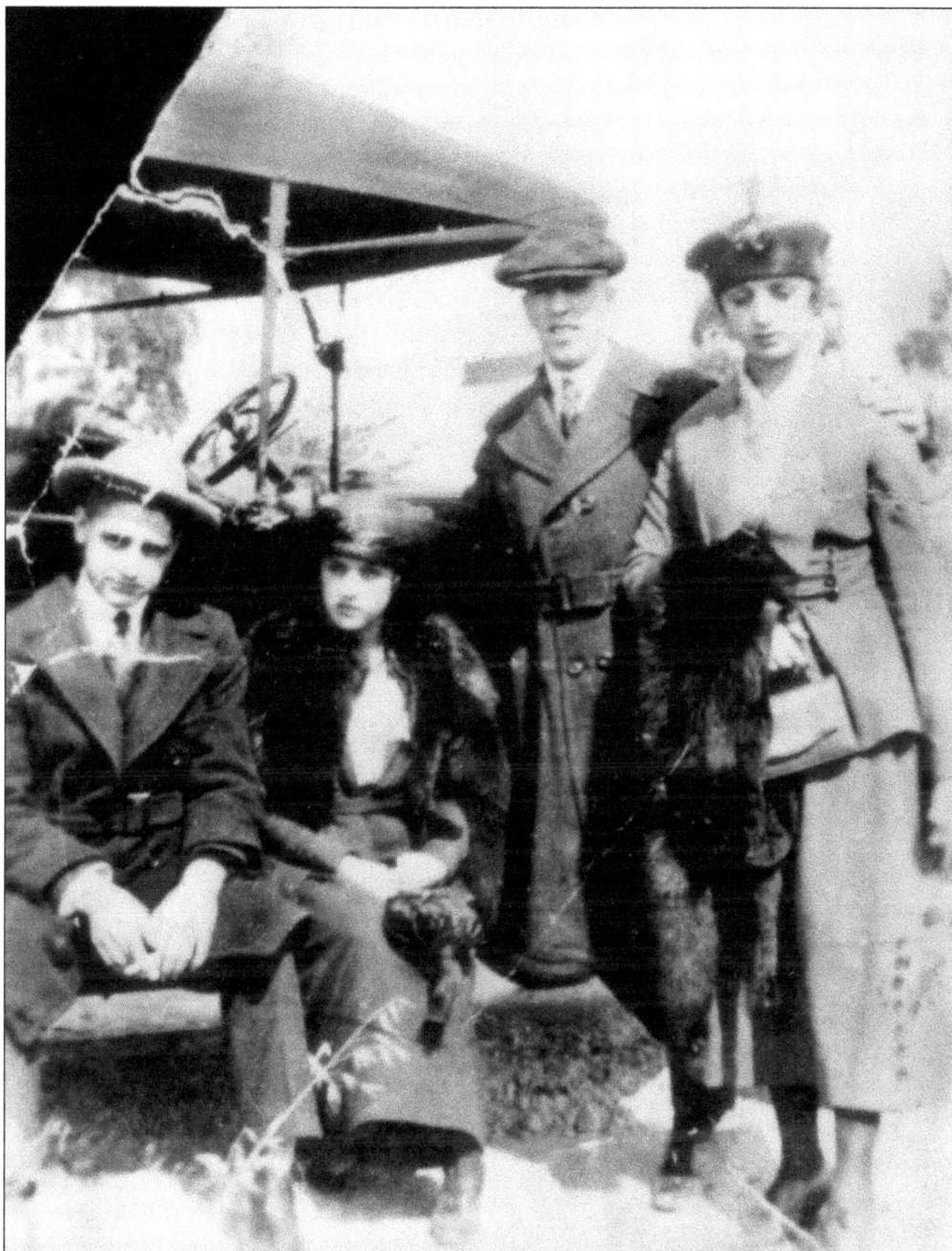

Thor Nielsen (third from the left) immigrated from Denmark with his family when he was a child. As an adult, he was a plasterer who worked on many Sunset houses built in the 1920s and 1930s. He lived with his family on Twenty-eighth Avenue between Rivera and Santiago. According to a memoir by Thor's son, William Walter Nielsen, his father tried to predict the weather each night: "He judged by the sound of the surf a mile down the slope. He waited for the lions' roar. The misplaced beasts of the Veldt were right down the hill at Fleishhacker Zoo. When there was an inversion layer, the surf and the lions seemed to come close to the house at that hour: It would be dry out on the job." (Courtesy Joan Juster.)

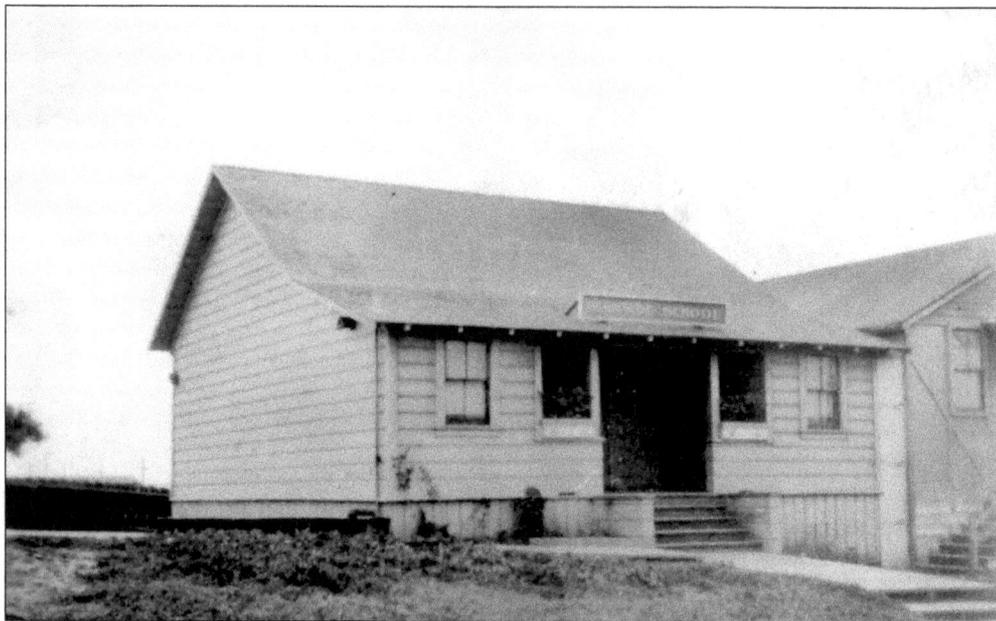

In 1917 the new St. Cecilia's parish celebrated its first mass in a house on Taraval Street. Later that year, the mayor of San Francisco donated the Parkside School building, shown here at Thirty-first and Taraval, to the archdiocese. The building was moved to Fifteenth and Taraval, where it became the first church in the St. Cecilia's parish. Over the years, the community built replacement churches and schools to serve the Catholic neighborhood. (Courtesy family of Ada and Chas Williams.)

This group of girls celebrated their eighth-grade graduation from St. Cecilia's School in 1956. (Courtesy Jerian Reidy Crosby.)

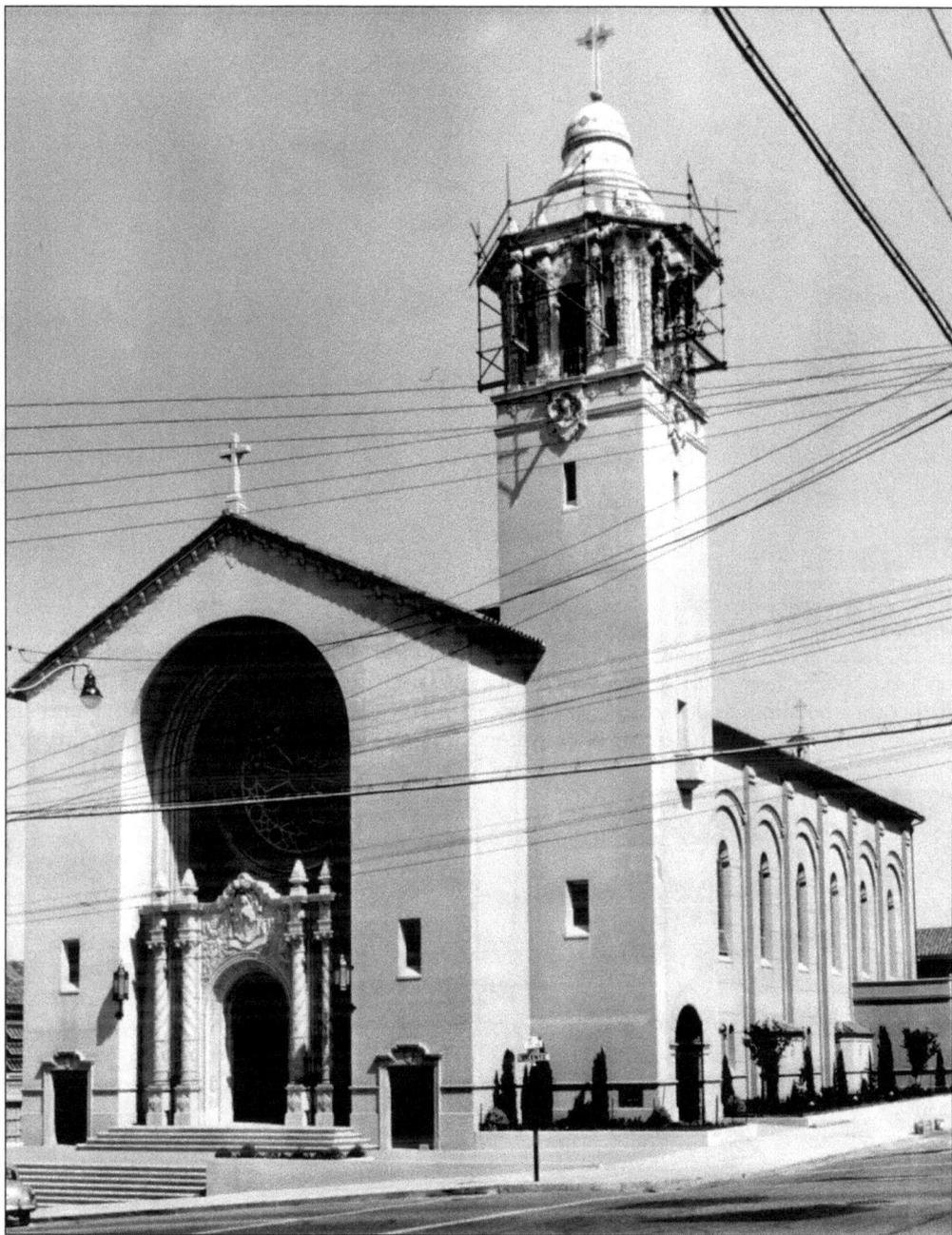

The current St. Cecilia's Church on Seventeenth Avenue at Vicente Street was under construction when this photograph was taken in 1956. (Courtesy Archives of the Archdiocese of San Francisco.)

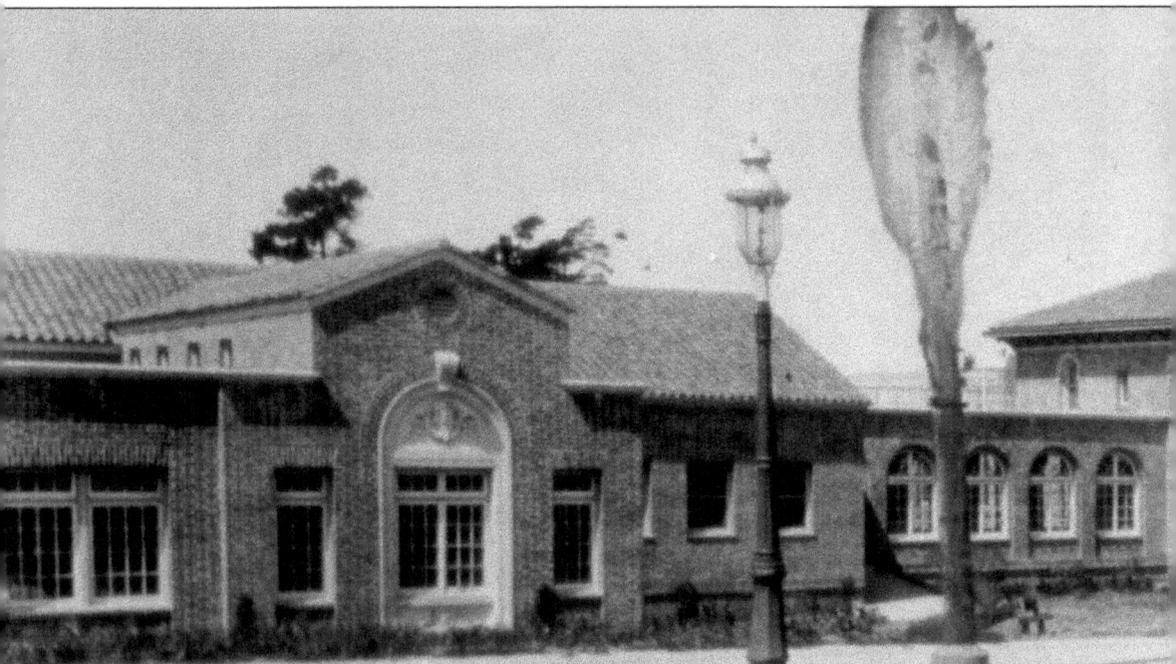

In 1923 the Shriner's Hospital for Crippled Children was built at 1701 Nineteenth Avenue, on land bought from Carl G. Larsen (see page 47). Over the years, the hospital expanded with other buildings added to the site. In the 1990s, the land was sold for condominium development. Through the efforts of neighbors and preservation groups, the original Shriner's

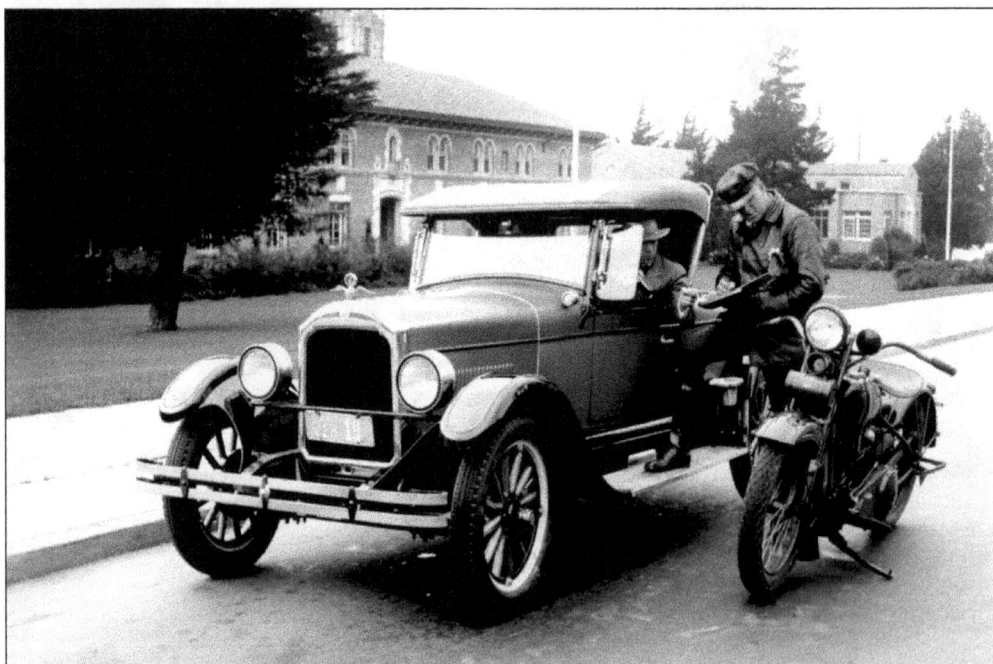

In this 1926 photograph, a policeman is giving a driver a ticket on Nineteenth Avenue. Note the original Shriner's Hospital building in the background.

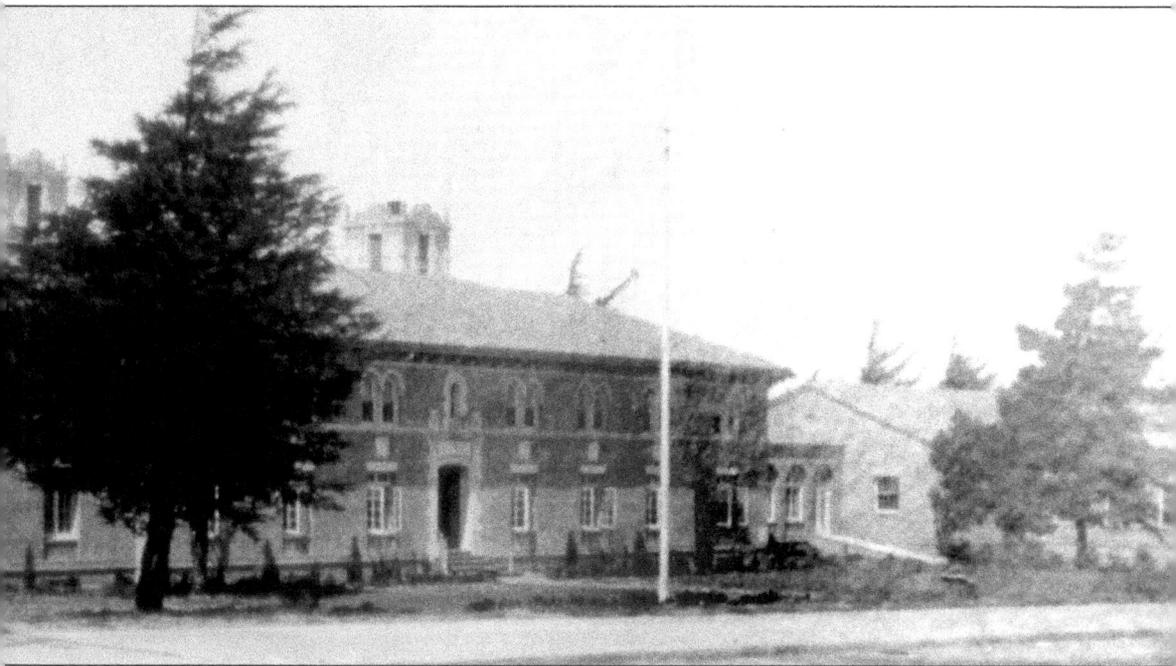

building was declared a San Francisco landmark in 1998. The condominium development excluded the original hospital building, which now serves as an assisted-care facility. (Courtesy San Francisco History Center, San Francisco Public Library.)

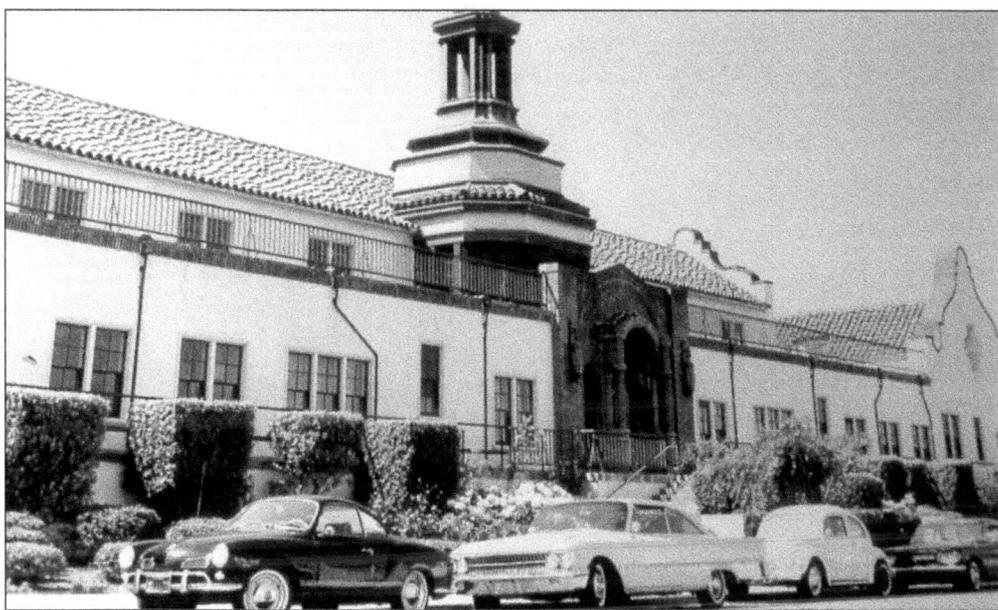

In 1928–1929 the Infant Shelter, an orphanage, was built at 1201 Ortega Street. In 1957 the San Francisco Conservatory of Music moved into the building. This picture was taken in 1964 before a south wing was added. The original building was named a city landmark in 2004. (Courtesy San Francisco History Center, San Francisco Public Library; photo by Alan J. Canterbury.)

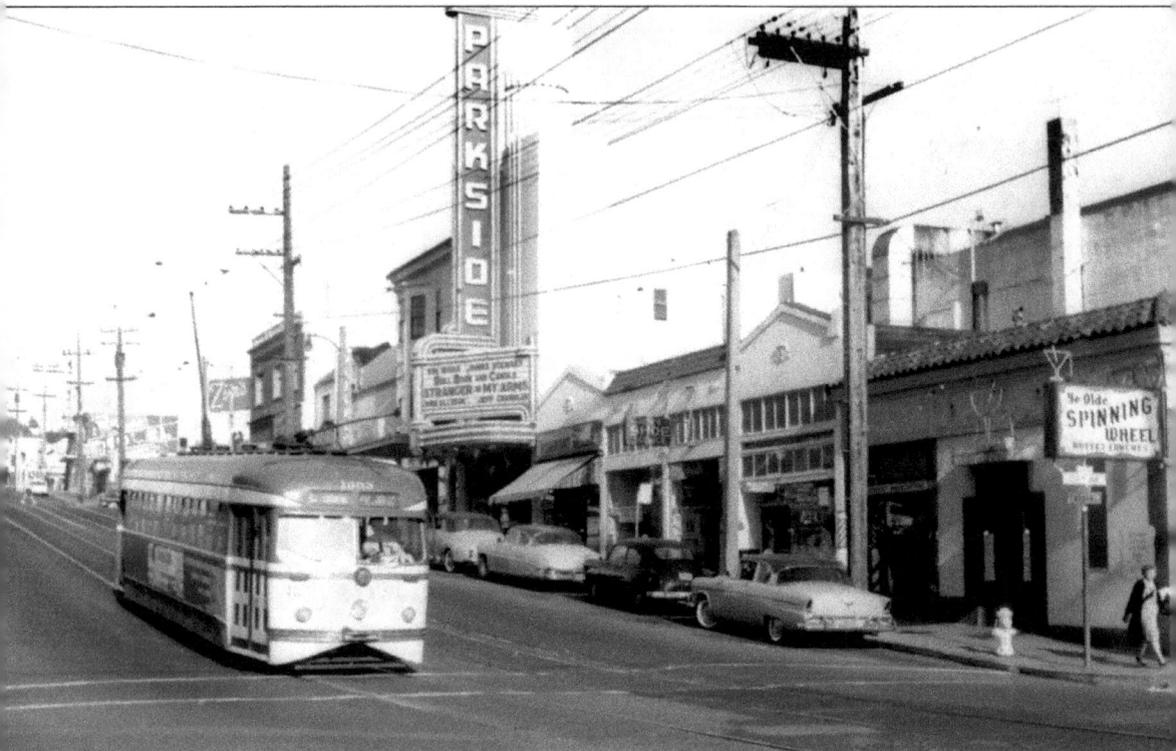

In 1928 the Parkside Theatre opened on Taraval Street between Nineteenth and Twentieth Avenues. The movie theatre was especially popular among children in the 1950s and early 1960s, as it showed special summer matinee movies at discounted prices. The theatre is shown here in 1958. It closed in July 1988. (Courtesy Tom Gray.)

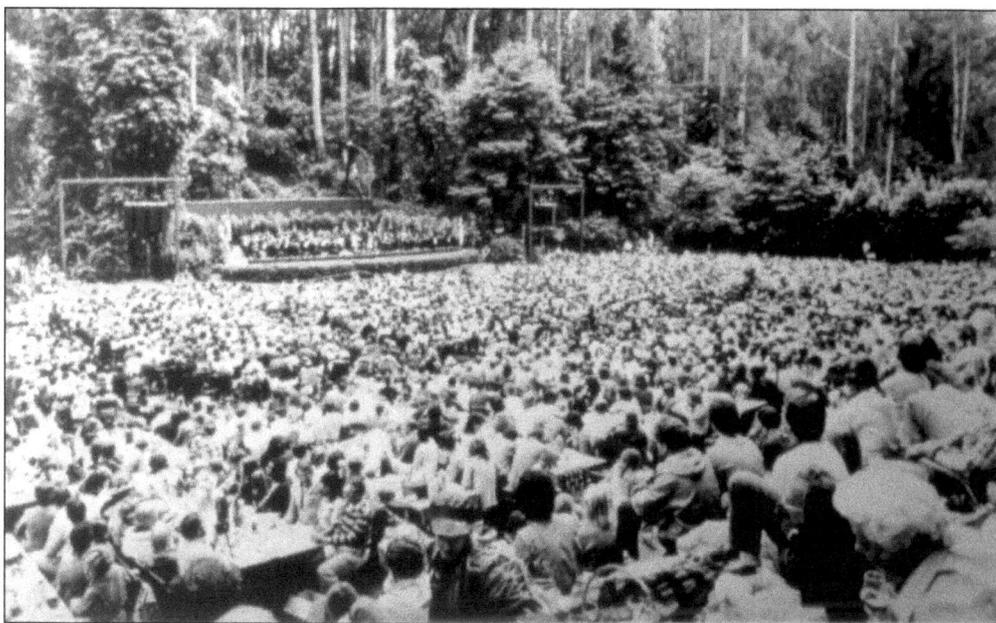

In 1931, to memorialize her late husband, civic leader Sigmund Stern, Rosalie Stern searched for a plot of land to donate to the city of San Francisco. John McLaren, superintendent of Golden Gate Park, suggested that she buy some of the land owned by the Greene family (see page 51) at Nineteenth Avenue and Sloat Boulevard. Mrs. Stern bought the land and deeded it to the city with the stipulation that it be used only for public recreation. Sigmund Stern Grove was dedicated on June 4, 1932, and free public concerts began shortly thereafter. The park included groves, walking paths, picnic tables, an open-air concert area, and the Trocadero—a Victorian roadhouse built by the Greenes. (Courtesy San Francisco History Center, San Francisco Public Library.)

Over the years, Sigmund Stern Grove has become larger, thanks to additional purchases by the city of San Francisco. The park now includes Mud/Pine Lake. The free Sunday programs continue each summer with symphony, jazz, ballet, and opera performances. (Author's collection.)

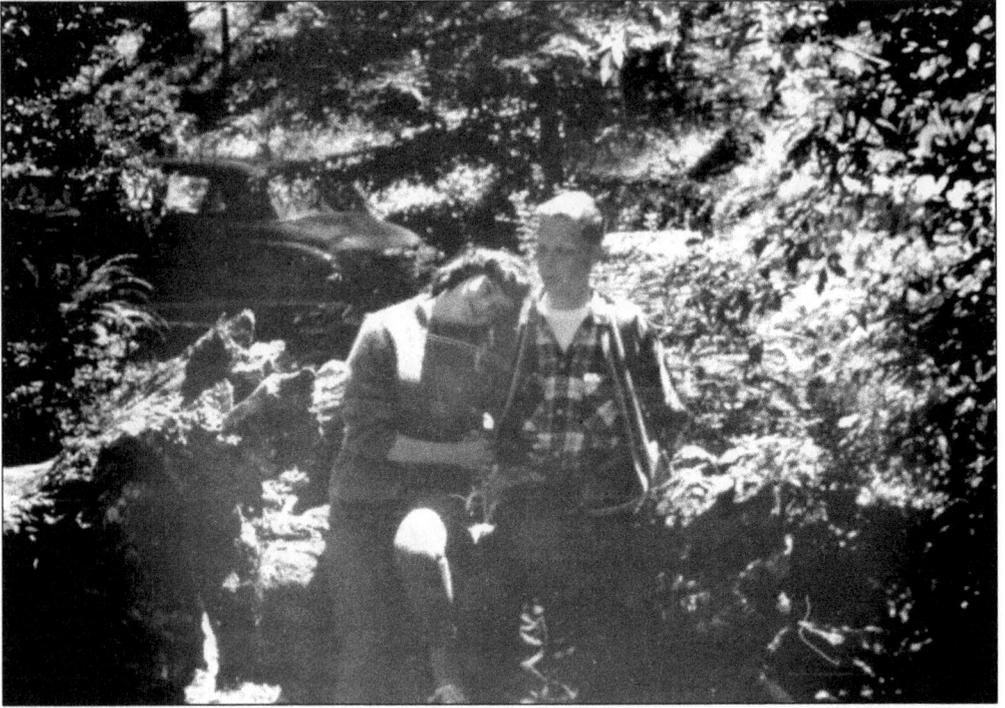

This couple found Stern Grove a great place for romance in 1960. (Courtesy Robert Menist/ Pamela LeBeau.)

It snowed in San Francisco in 1962. Neighborhood children realized that Stern Grove would be a wonderful place to play in the snow. (Courtesy Dr. Richard Koch.)

74

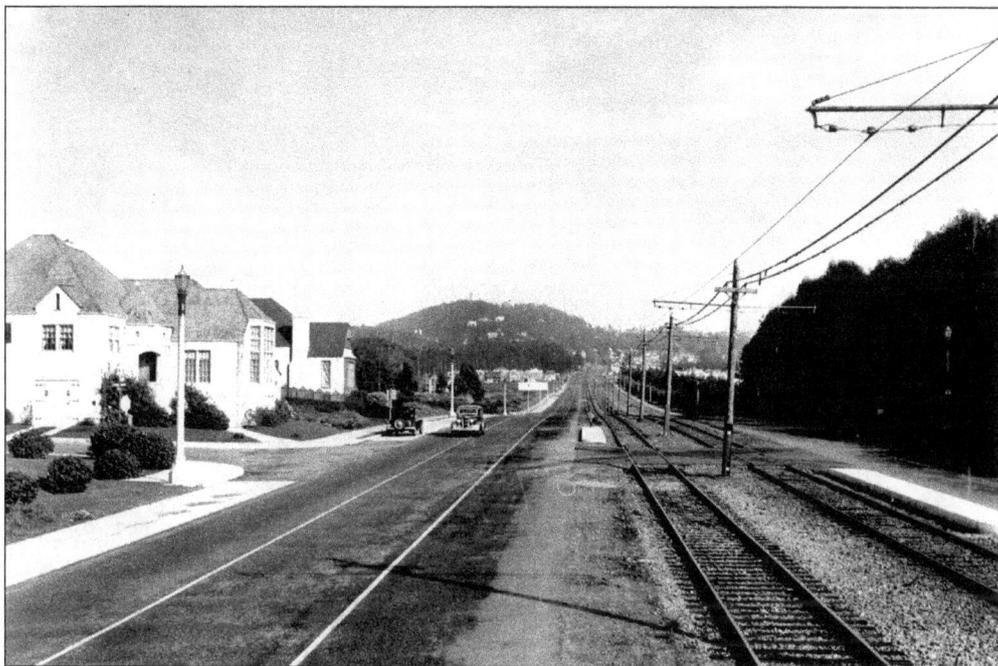

The 12 line had begun running along Sloat Boulevard to the beach in 1909 and was the longest streetcar line within the city limits. (Photo by Randolph Brant.)

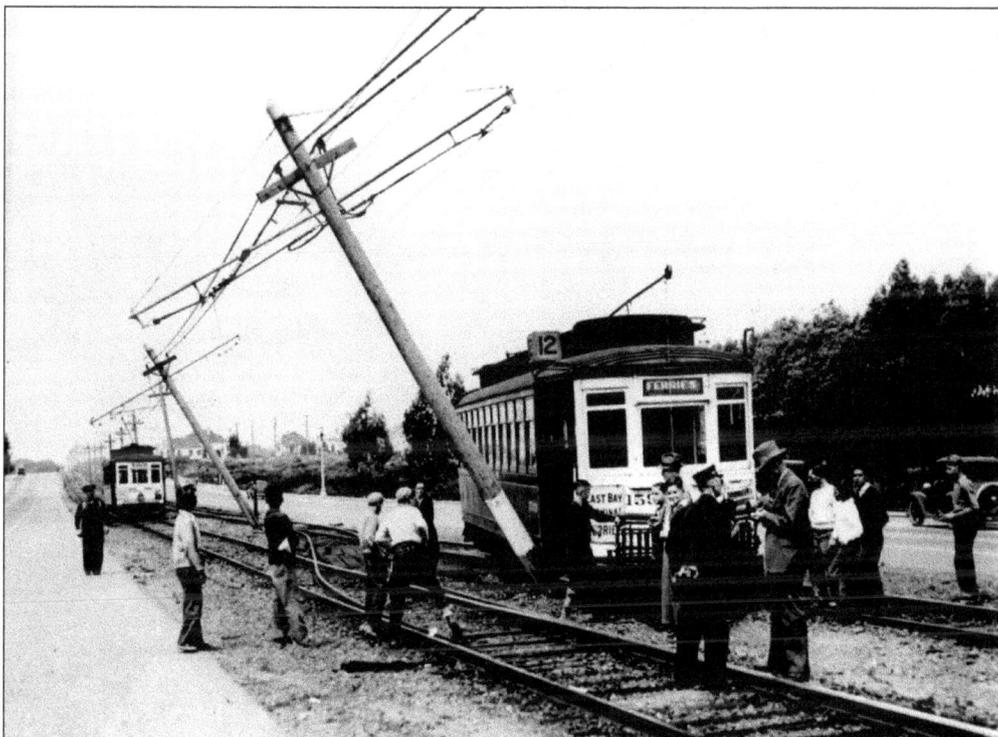

In 1938 the 12 streetcar along Sloat Boulevard derailed, affecting westbound and eastbound service. (Courtesy Emiliano Echeverria; photo by Randolph Brant.)

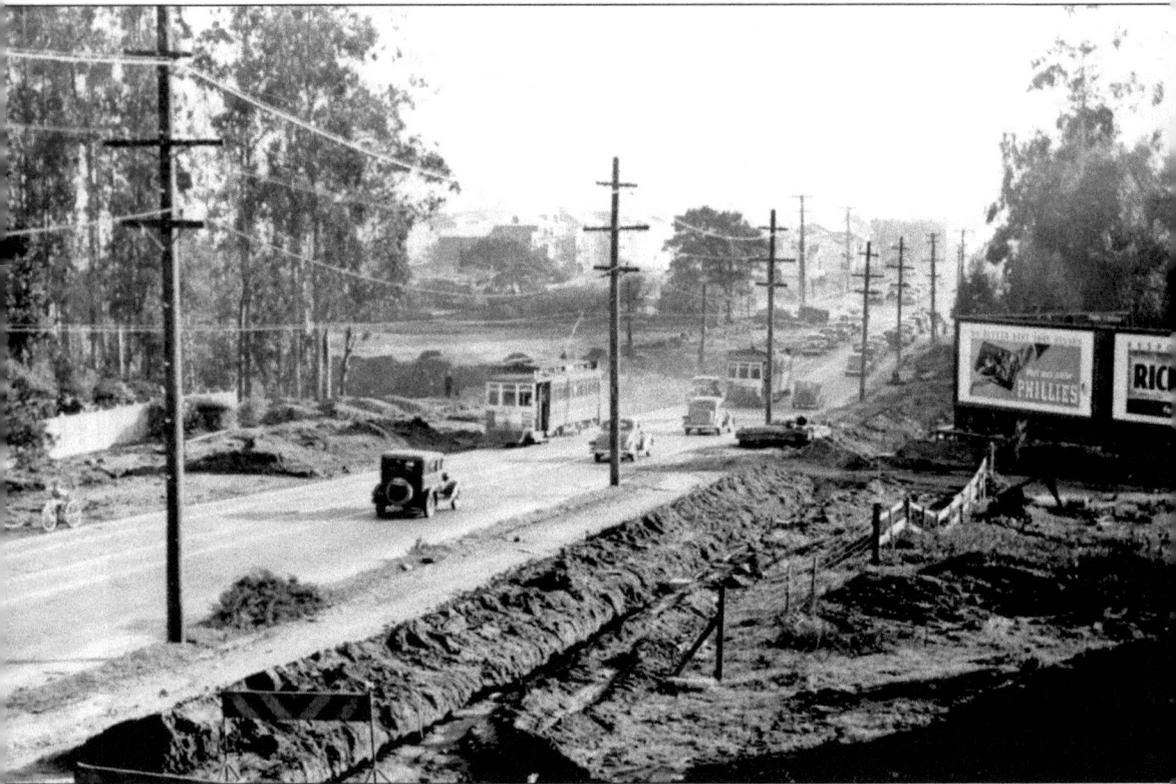

This 1937 picture was taken on Nineteenth Avenue looking south near Wawona Street during the last days of streetcar tracks along Nineteenth Avenue. The tracks carried the 17 streetcar, which ran from downtown to Lincoln Way, then to Twentieth Avenue to Wawona, where it crossed over to Nineteenth Avenue and ran two blocks to Sloat. On Sundays and holidays these cars continued to the zoo and the beach. When Nineteenth Avenue was widened in 1937 the streetcar tracks were removed. (Courtesy Tom Gray.)

By the end of 1937 workers had widened Nineteenth Avenue and removed the overhead wires.

In the early 1930s the Hauser family bought a house on Nineteenth Avenue just south of Santiago. This photograph shows the front sidewalk, much of which was lost when the street was widened. A shadow of a telephone pole also appears in the photo. All electrical wiring was put underground during the street widening. (Courtesy Bob Barnhouse.)

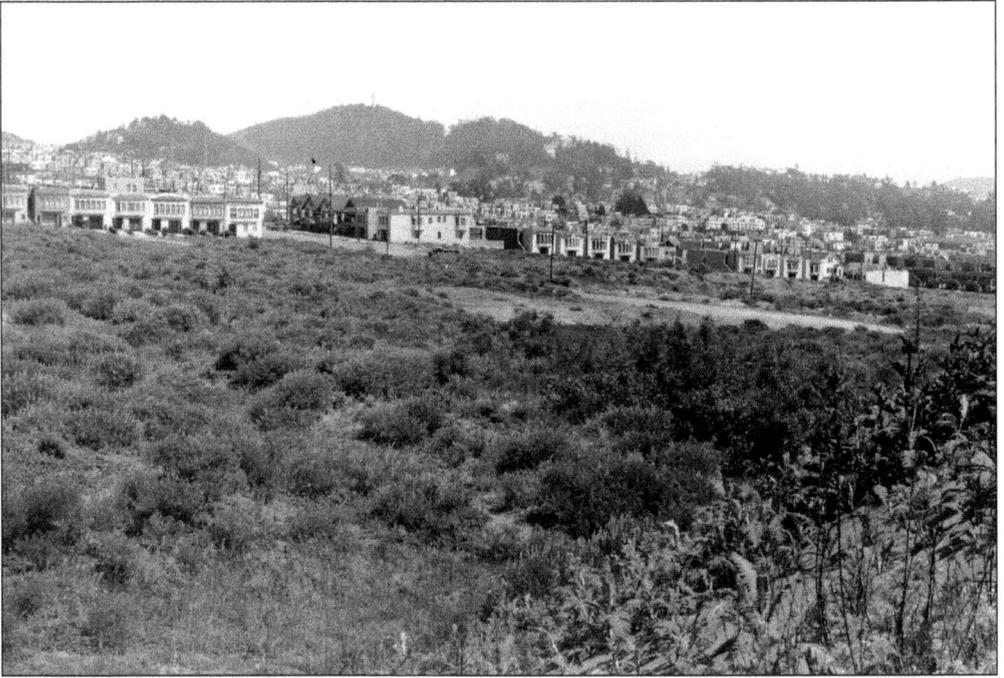

By the 1930s Sunset District residents were clamoring for a public high school to service the many children living in the area. The Parkside District Improvement Club was probably the most influential neighborhood group, and it pushed hard for Abraham Lincoln High School to be built on a city-owned lot. In the 1930s the site was selected: a four-square block area bordered on the east by Twenty-second Avenue (shown here), on the south by Santiago Street, on the west by Twenty-fourth Avenue, and on the north by Quintara Street.

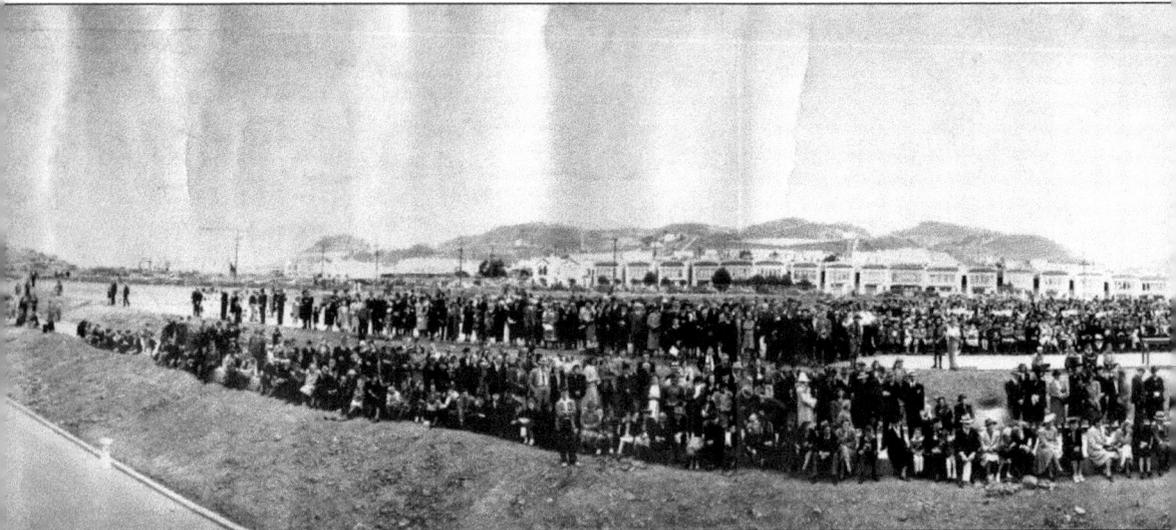

Abraham Lincoln High School, the only public high school ever built in the Sunset, was dedicated on September 22, 1940, with this special celebration on the east side of the school.

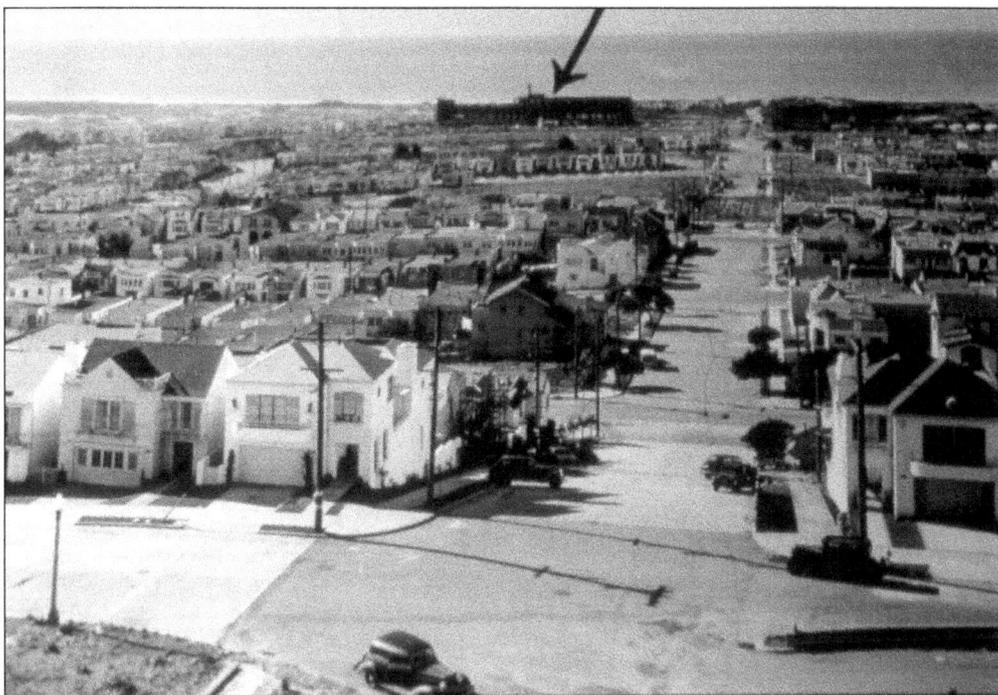

This 1940 view looking west from Golden Gate Heights shows Lincoln High School under construction (see arrow). Much of the area had been developed, but empty lots remained. (Courtesy San Francisco History Center, San Francisco Public Library.)

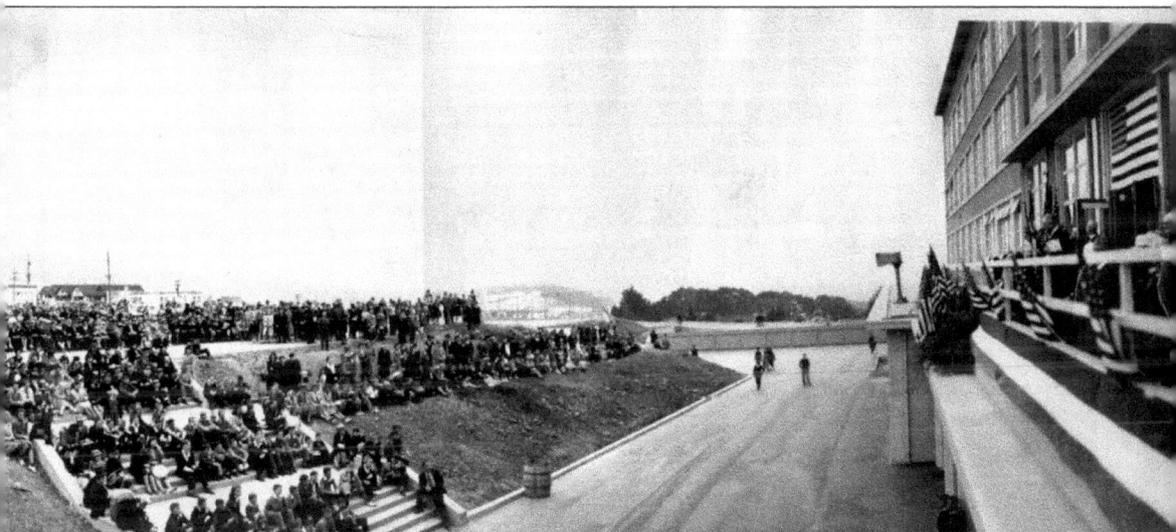

(Courtesy Western Neighborhoods Project.)

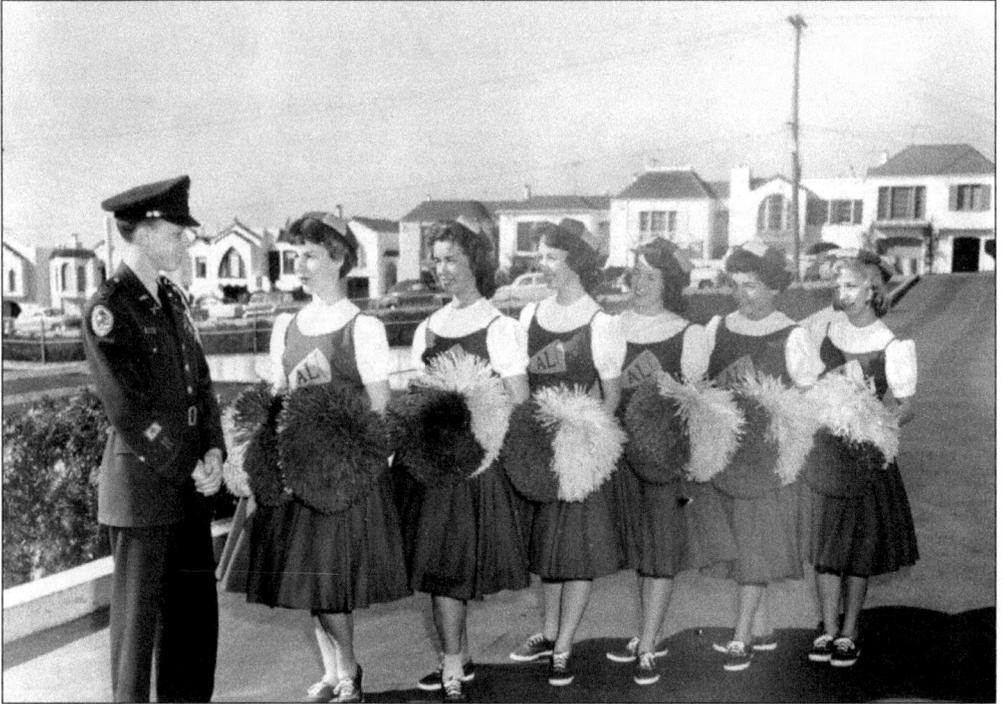

In 1960 ROTC and cheerleading were popular extra-curricular activities at Lincoln High School. (Courtesy Robert Menist.)

For many years the gates to the extensive school yards at Lincoln High School were left open, providing large play spaces for the baby boomer children in the neighborhood. This picture was taken in 1960. Now all gates are locked after school hours. (Author's collection.)

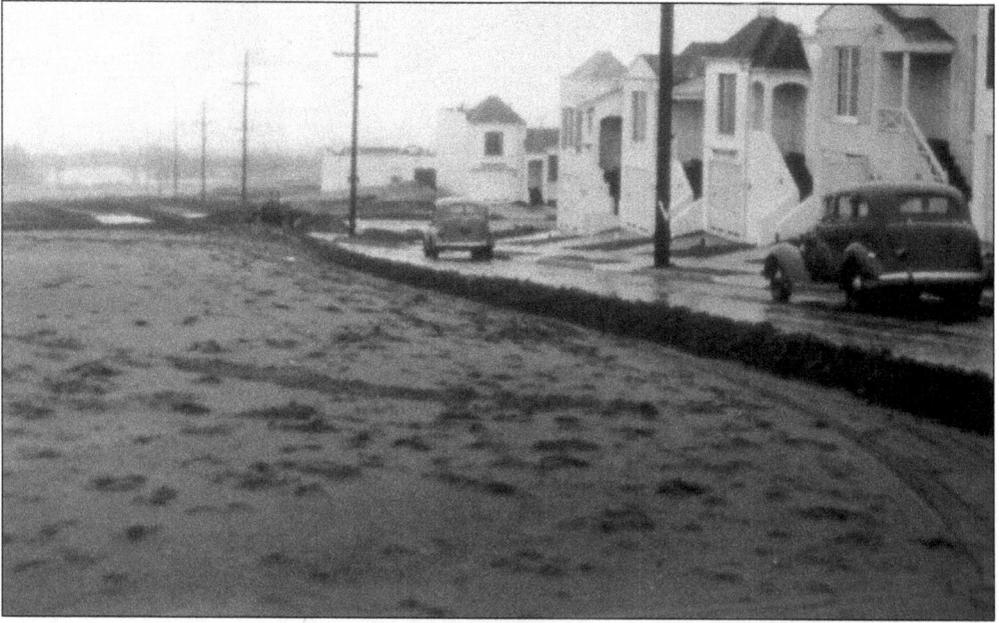

Despite increasing growth in the Sunset, sand was still a problem in the 1940s. This 1943 photograph appeared in a local newspaper accompanied by the following: "In a pinch one lane will carry all the auto traffic on a street, but it's not good, is it? That's the way it is, though, on Pacheco Street at Thirty-second Avenue, where the works department has opened one lane to traffic, but the rest of the street is covered with sand. Shifting sand is covering many of the outlying streets in the Sunset District." (Courtesy San Francisco History Center, San Francisco Public Library.)

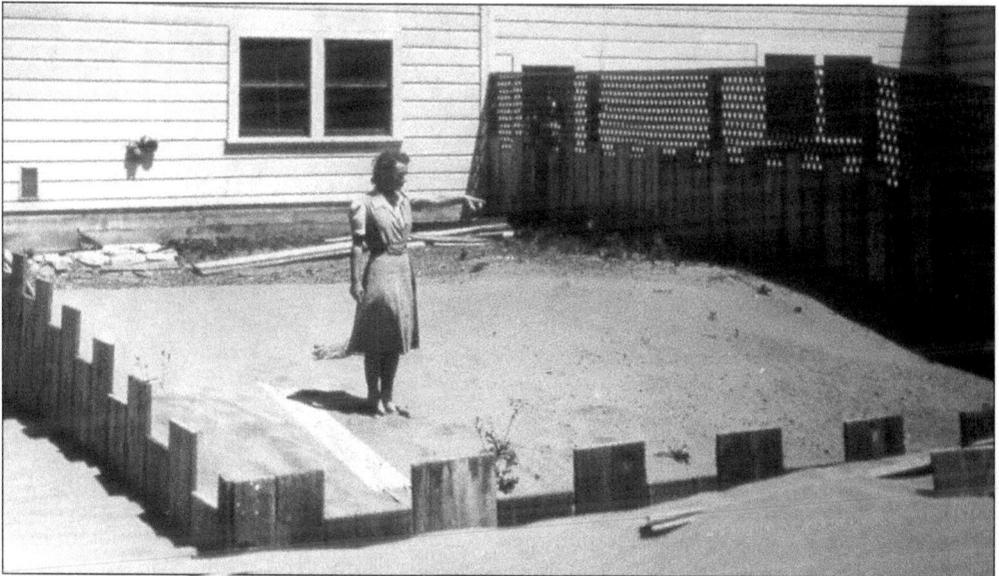

In 1942 Mrs. R.L. Anderson, who lived in the 2100 block of Thirty-second Avenue, complained "We were never able to put in a garden. The back fence has been almost buried in the daily sandstorms." A resident at that time remembers that as a child he did not need to climb over fences in the neighborhood, as they were often buried by the sand. (Courtesy San Francisco History Center, San Francisco Public Library.)

In 1932 playtime (or Halloween?) was serious among these cowboys, Indians, and football players on Thirty-eighth Avenue. (Courtesy Al Williams.)

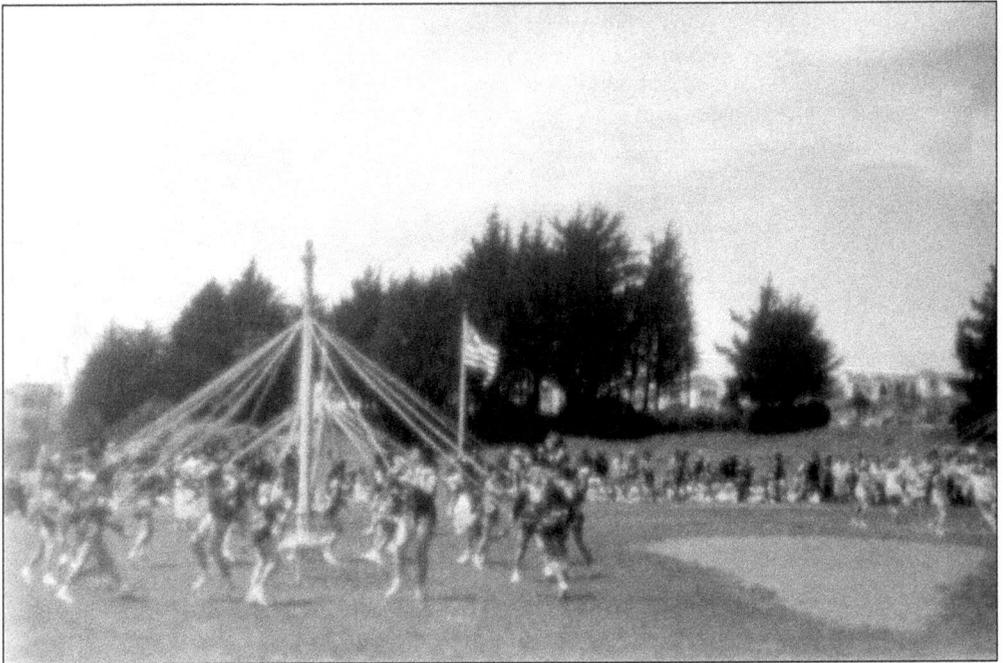

Beginning in 1939 Parkside residents sponsored an annual May Day celebration. Different from the worldwide celebration of labor, these May Day festivals involved children dressing up and usually dancing around a "maypole." Each year, a young girl was proclaimed May Day Queen (originally "Queen of the May"). The first festivals were in McCoppin Square (shown here) at Twenty-second Avenue and Santiago Street. In 1962, the May Day celebration moved to Parkside Playground at Twenty-eighth and Vicente. (Courtesy San Francisco History Center, San Francisco Public Library; Parkside District Improvement Club.)

During World War II the city encouraged people to plant "victory gardens" with fruit and vegetables. This award-winning victory garden was planted close to Sloat Boulevard, which ran behind it. The clump of trees in the background on Sloat at Thirty-fourth Avenue was later cut down to make way for a shopping center. (Courtesy Dr. Richard Koch.)

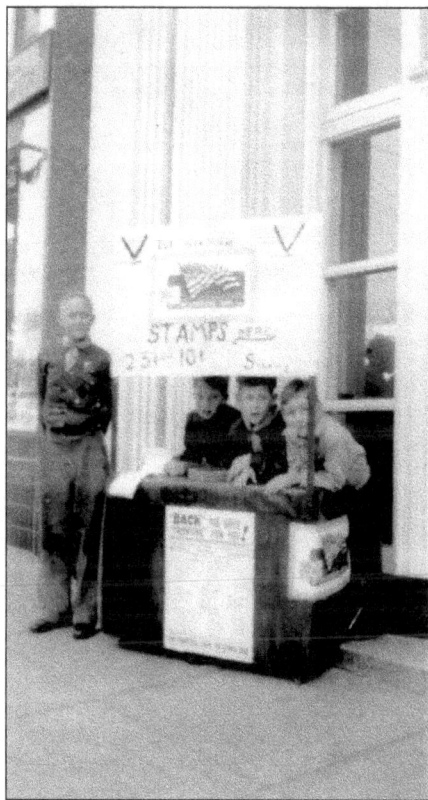

In 1943 Gary Allyne (center under sign), his younger brother Ronald (at right), and two Cub Scouts sat outside the Bank of America at Twentieth and Taraval selling war stamps to customers exiting the bank. "We built the stand from orange crates, skates, wood, and butcher paper," explains Gary. "Each Saturday morning, we rolled the stand down the hill from Seventeenth and Rivera, then struggled to get it back up the hill at the end of the day." (Courtesy Gary Allyne.)

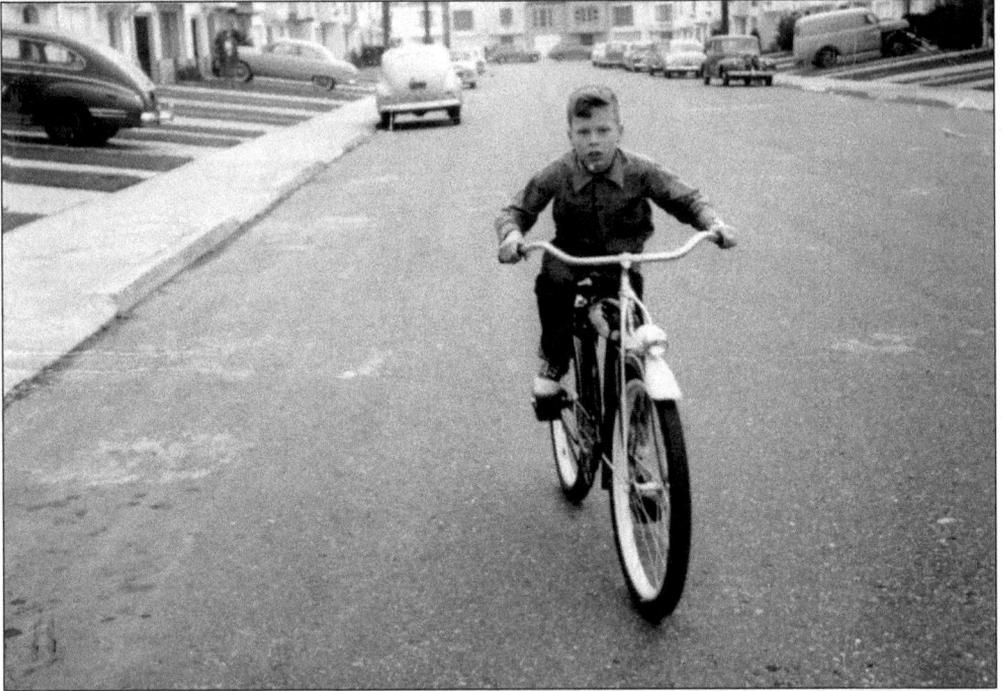

Traffic was light in the Parkside in 1950, and children often rode their bicycles down the middle of the street. This was taken on Thirty-eighth Avenue, just south of Wawona Street. (Courtesy Robert Menist.)

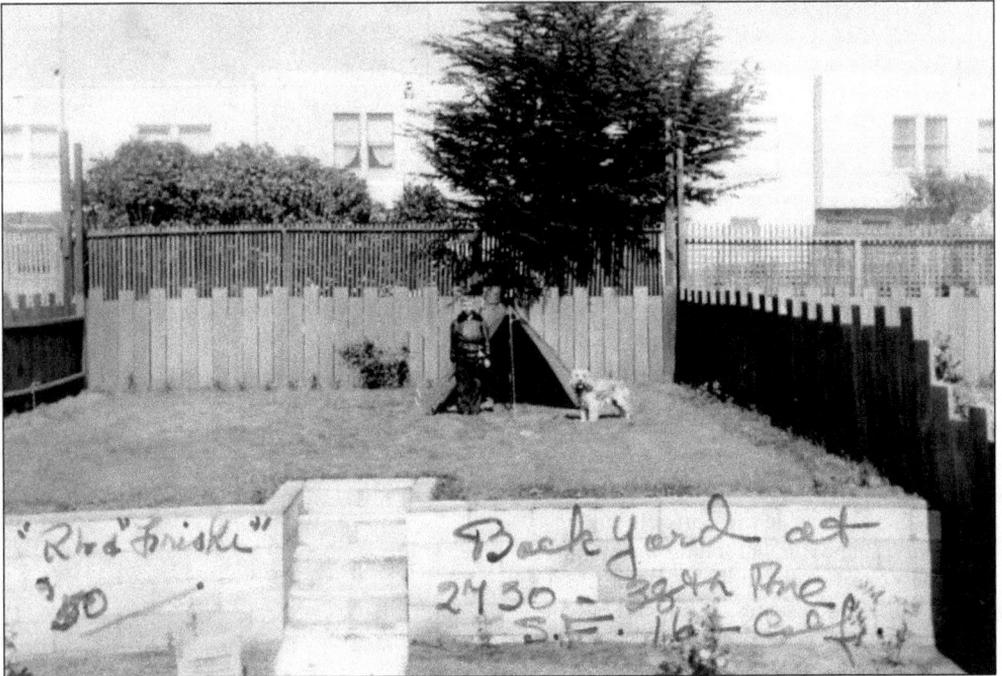

In 1950 this future army general got his start camping in the back yard with his dog Friske on Thirty-eighth Avenue. (Courtesy Robert Menist.)

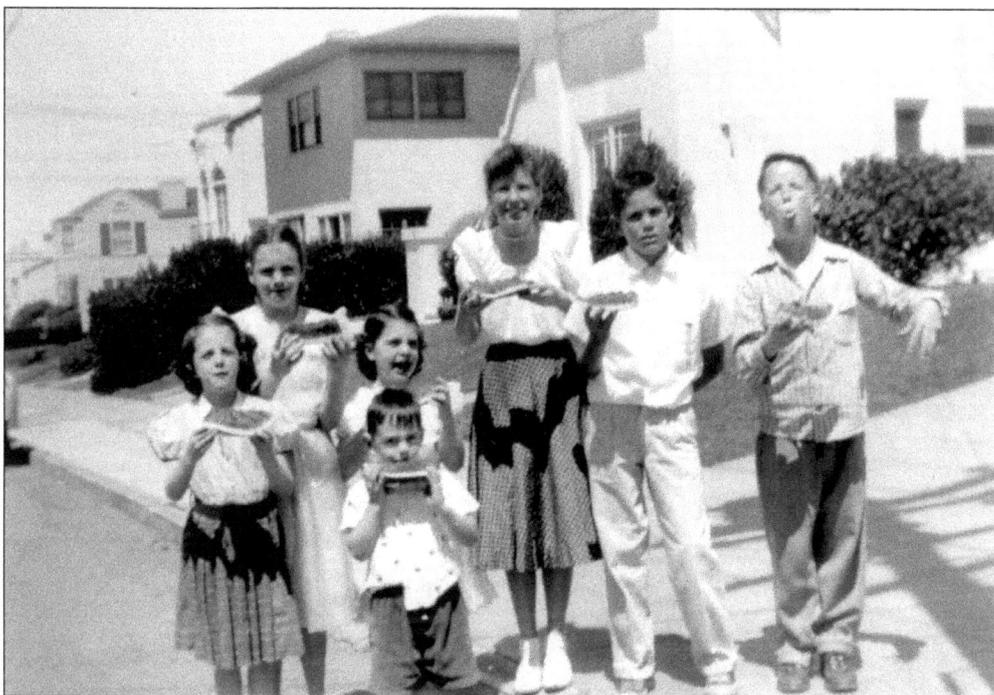
In 1954 children on Rivera Street shared a watermelon on one of the few sunny summer days in the usually foggy Sunset District. (Courtesy Jerian Reidy Crosby.)

In the early 1950s the Parkside was a popular place for families. Children often rode their bicycles and met their friends in front of their houses. (Author's collection.)

As the population grew in the Sunset District, so did the need for additional elementary schools. In the above photo, in 1949, Edythe Newman and her son stood in front of their home on Forty-third Avenue, a sand dune across the street. Shown below, by 1957, son Jerry Newman crouched in front of the house across from Ulloa Elementary School. (Courtesy Edythe Newman.)

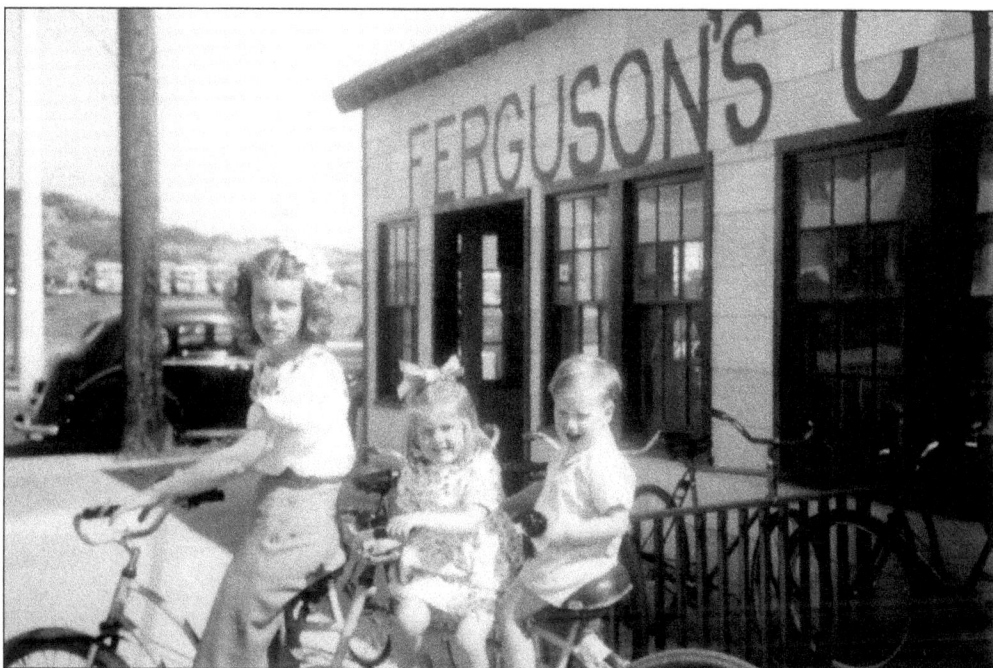

From 1939 to the 1950s Ferguson's Cyclery at Forty-sixth and Wawona rented, sold, and repaired bicycles. Children came from around the city to rent bicycles and ride them on the Great Highway. Mrs. Ferguson posed here in 1950 with her daughter Janie ($4^1/_2$) and son Eddie (3). (Courtesy Jane Ferguson Hudson.)

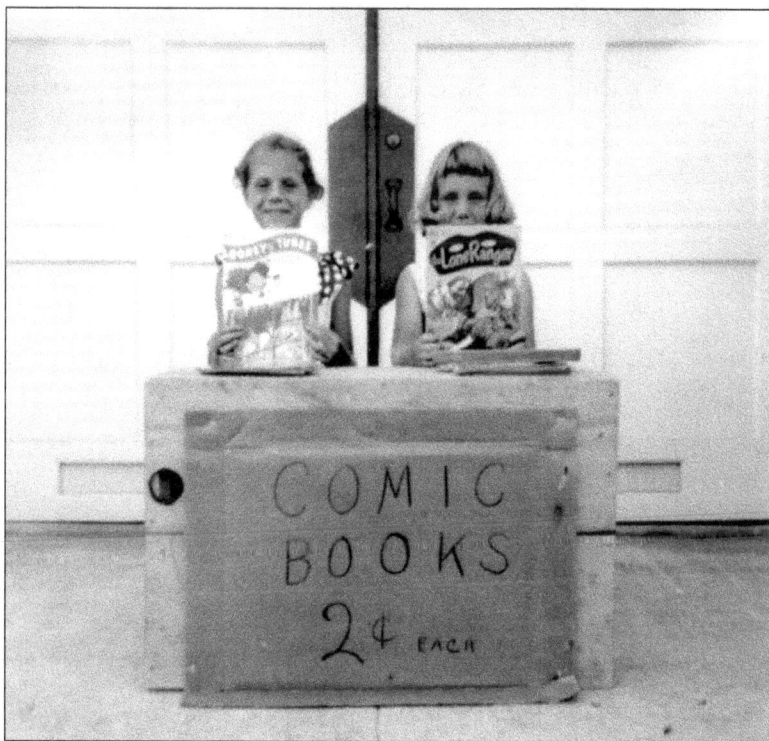

In September 1952 these two Thirty-eighth Avenue residents set up shop. The back of the photo reads, "First business venture Net 32¢." (Courtesy Patricia Dowden Mayer.)

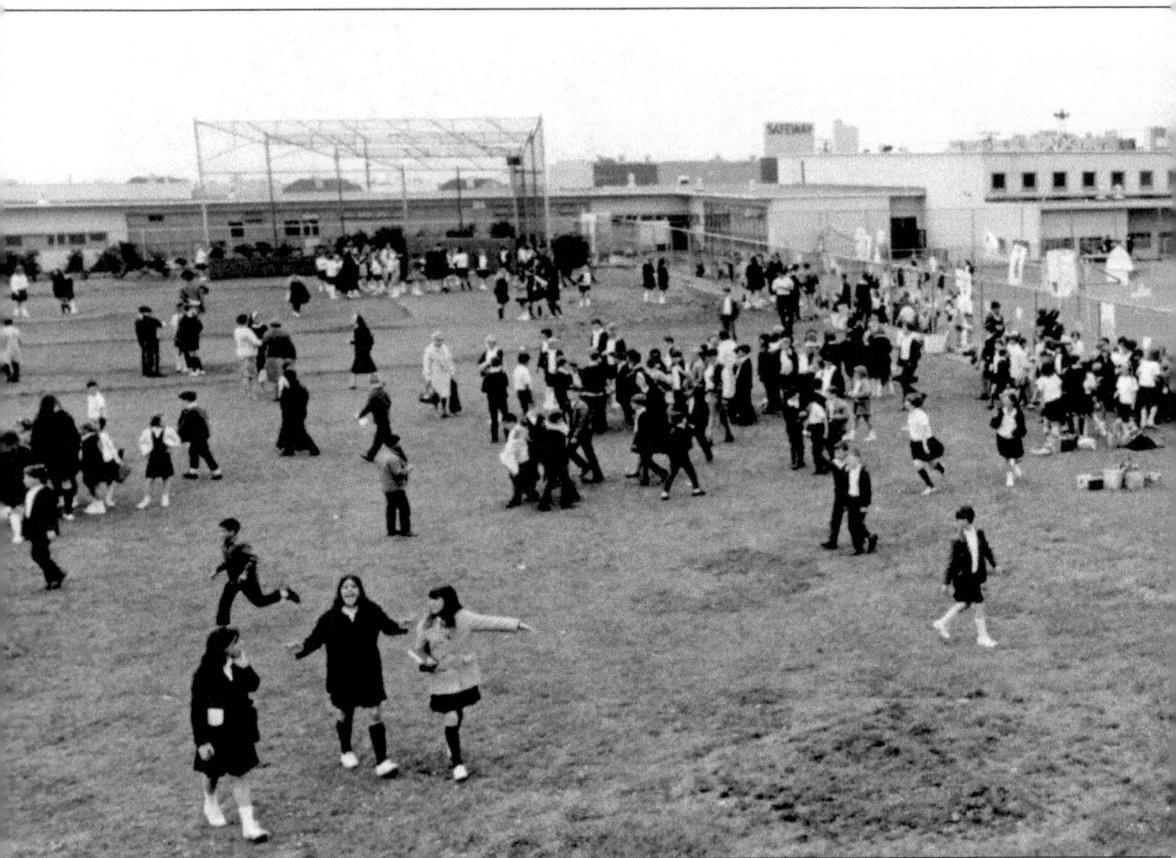

In the 1950s children at St. Gabriel's School on Forty-first Avenue spread out into large playgrounds during recess. (Courtesy Archives of the Archdiocese of San Francisco.)

This 1951 photograph at right shows the kindergarten class at St. Gabriel's School. (Courtesy Archives of the Archdiocese of San Francisco.)

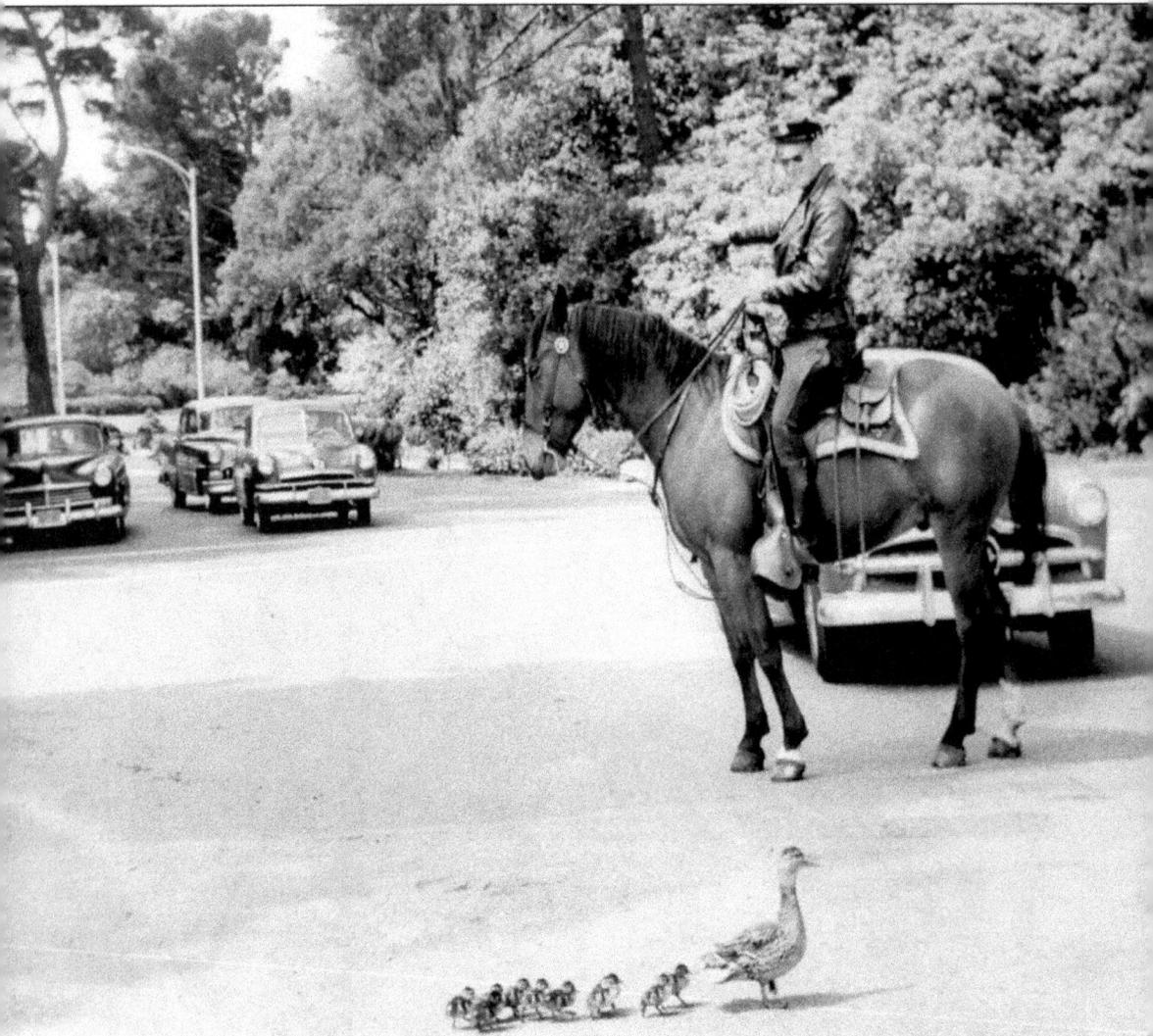

In the 1950s mounted policeman Ed Lawson, who lived on Thirty-eighth Avenue in the Parkside, stopped traffic to allow safe crossing of important residents of Golden Gate Park. Mounted police still provide police protection in the park. (Courtesy Lawson-Faulkner family.)

In the mid-1960s these boys played on an empty lot. The houses behind John, Joe, and Tom Faulkner sat on the east side of Forty-first Avenue. (Courtesy Lawson-Faulkner family.)

By 1968 the playground was gone, as building began on the eastern side of the lot. This photograph shows the back of a new row of homes being constructed. (Courtesy Lawson-Faulkner family.)

One day in 1963 a sixth-grader ran home to get her "Brownie" camera because, after a hot sunny day, there was a sudden downpour, causing steam to rise from the street. This picture, taken on Twenty-second Avenue north of Rivera, shows manicured lawns on the left, Lincoln High School yards on the right, and a phenomenon rarely seen on that street today: no parked cars lining both sides of the street. (Author's collection.)

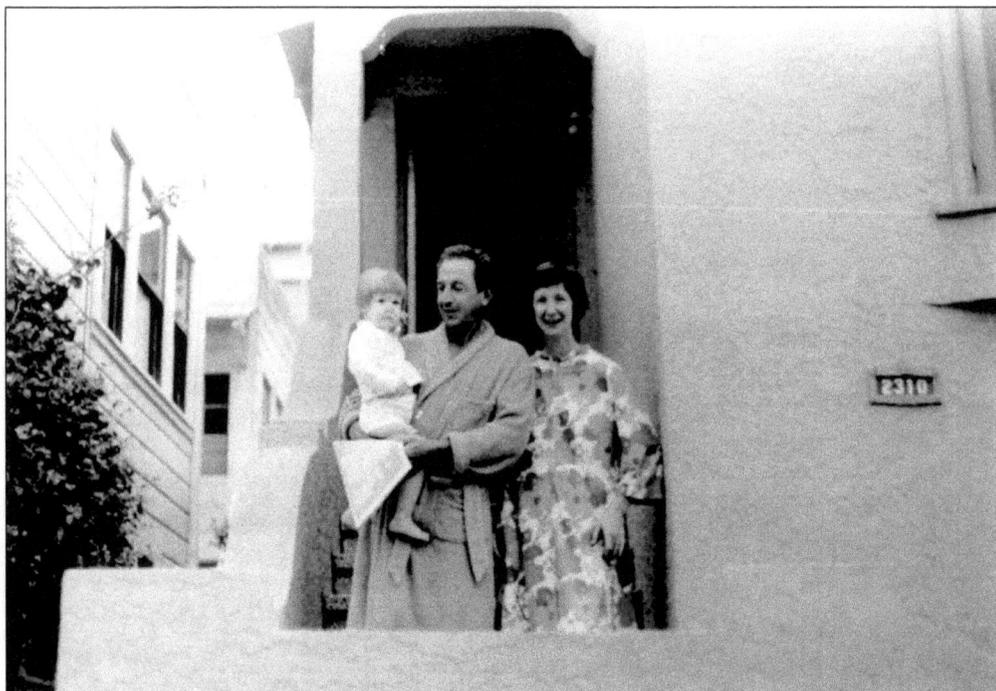

In 1970 Parkside residents Lou and Elisabeth Ungaretti posed with their daughter Elena. (Author's collection.)

Four

THE CENTRAL/OUTER
SUNSET

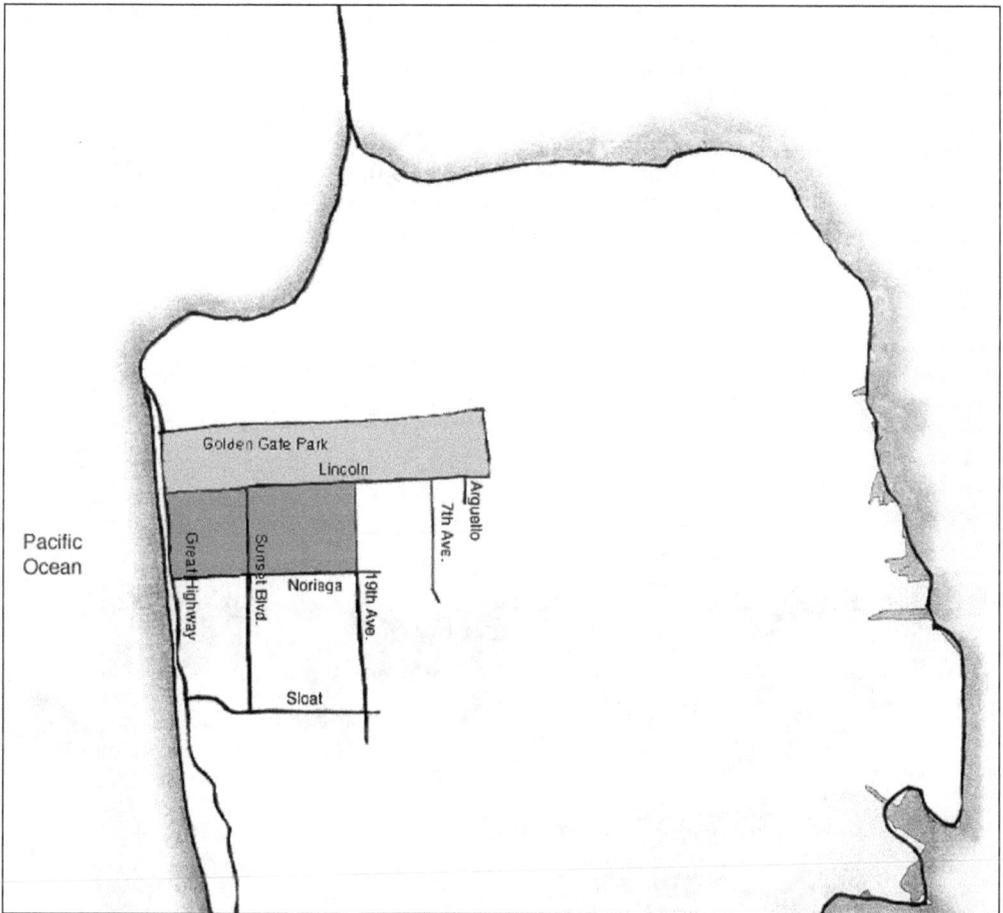

The central/outer Sunset is roughly bounded by about Nineteenth or Twentieth Avenue on the east and the Great Highway on the west, Noriega Street on the north and Sloat Boulevard on the south. The outer Sunset was one of the earliest areas of the Sunset to be developed, as people built vacation homes and cottages along the beach. This area was also known for infamous roadhouses and brothels. The central Sunset remained sand dunes the longest and was not fully developed until the 1970s. (Map by Christine Riley.)

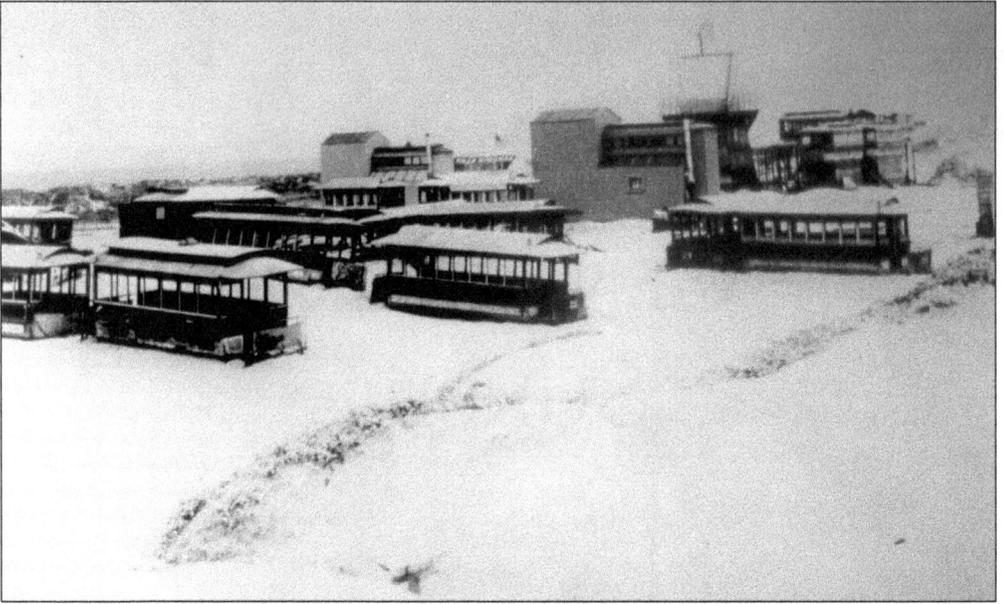

As horse-drawn streetcars became obsolete in the 1890s they were discarded and offered for sale. The cars in this photograph were left in the sands of the Sunset District near Ocean Beach. (Courtesy San Francisco History Center, San Francisco Public Library.)

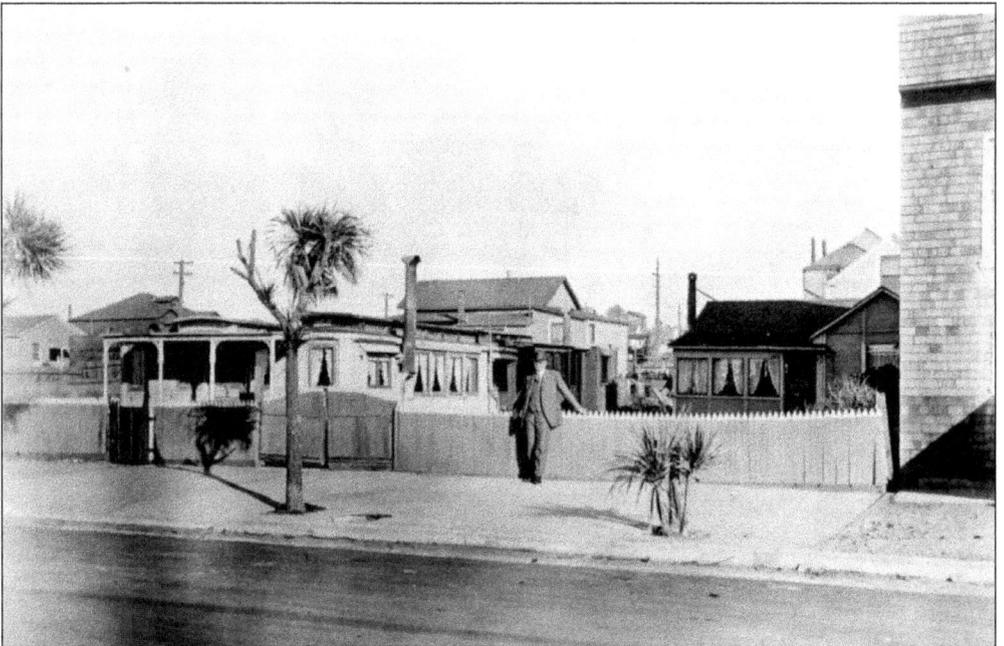

In 1895 people began buying the discarded vehicles, which cost $20 with seats and $10 without. Rental land was inexpensive out by the beach, so people put the cars on the sand without their wheels and turned the cars into beach houses and permanent homes. Most of these car-homes were set along the Great Highway between Lincoln Way and Noriega Street. The area became known as "Car Village" or "Carville-by-the-Sea," later shortened to "Carville." (Courtesy San Francisco History Center, San Francisco Public Library.)

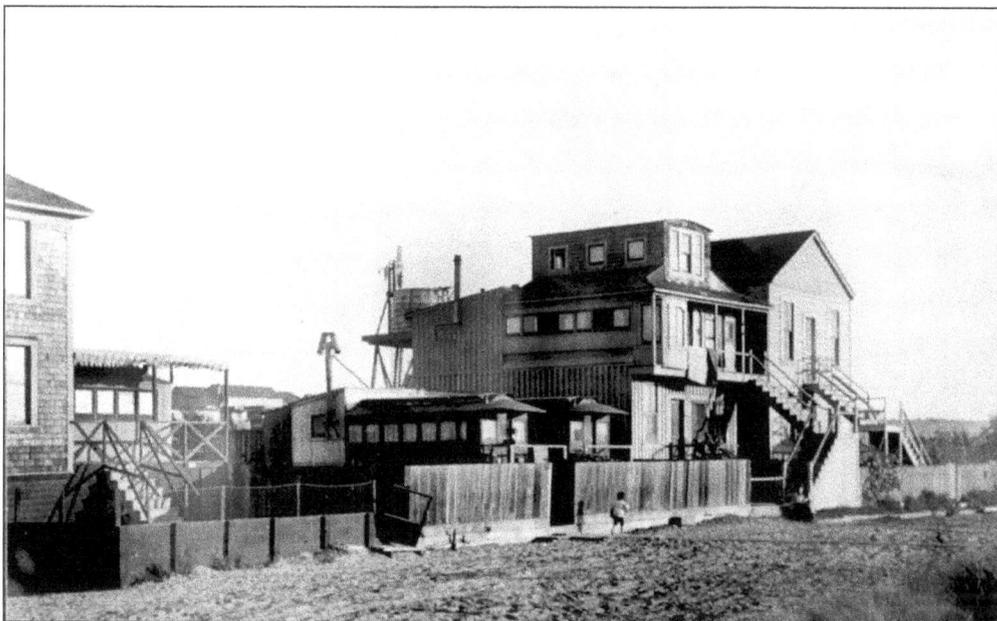

Some Carville residents stacked cars to make multi-story "homes." Others arranged three cars in a "U" shape to create a courtyard. For a time, the area was a thriving community of about 2,000 residents, with cafés, restaurants, club houses, and a two-story Presbyterian church. The area took on the flavor of a seaside "Bohemia." One writer who lived there was Fremont Older, longtime editor of the *San Francisco Bulletin* newspaper. (Courtesy Emiliano Echeverria; photo by Randolph Brant.)

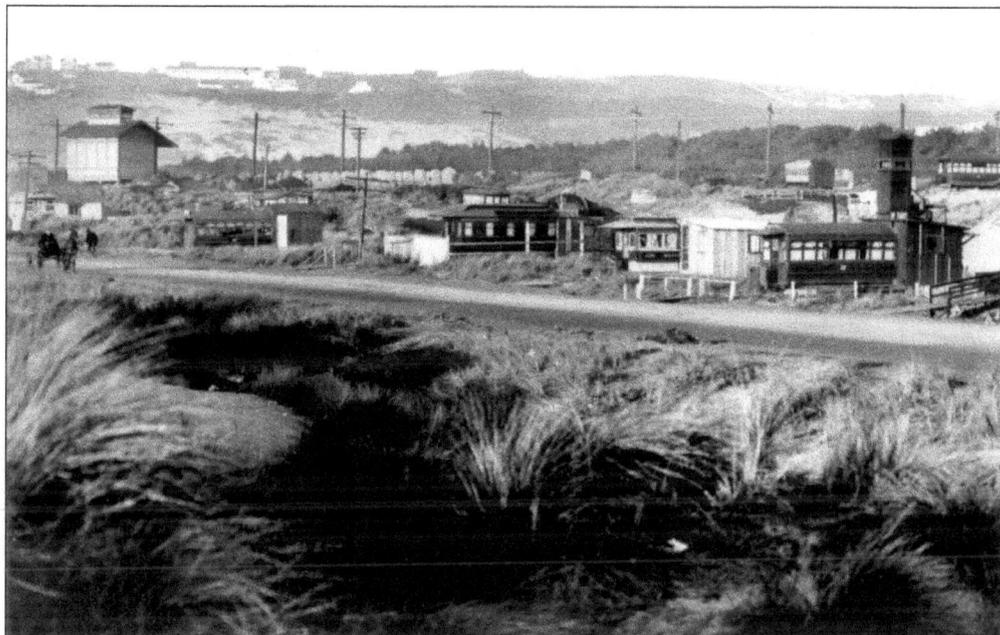

This photograph shows Carville running along the Great Highway across from the beach. In the background one can see the sand dunes of the as-yet undeveloped Sunset and Richmond districts. (Courtesy Western Neighborhoods Project.)

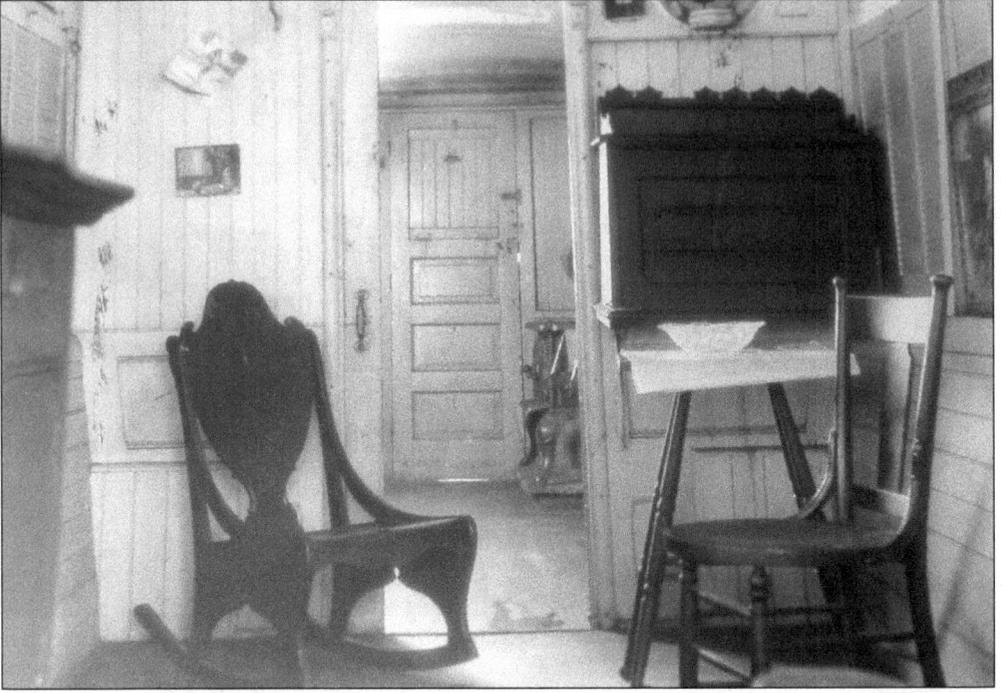

Inside, Carville homes were cramped (or cozy, depending on your view). (Courtesy San Francisco History Center, San Francisco Public Library.)

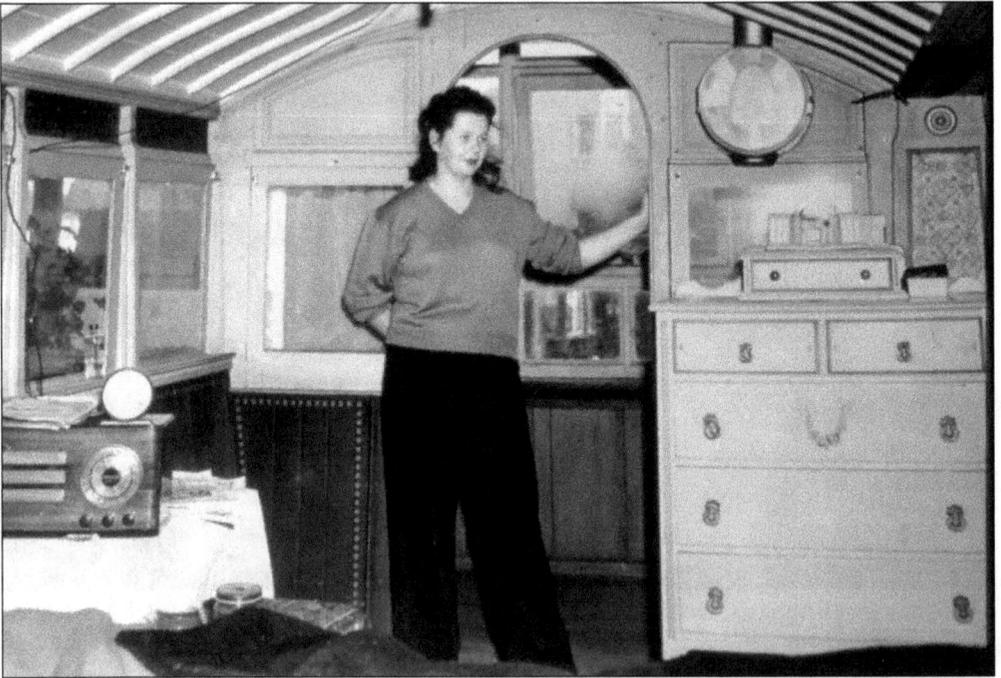

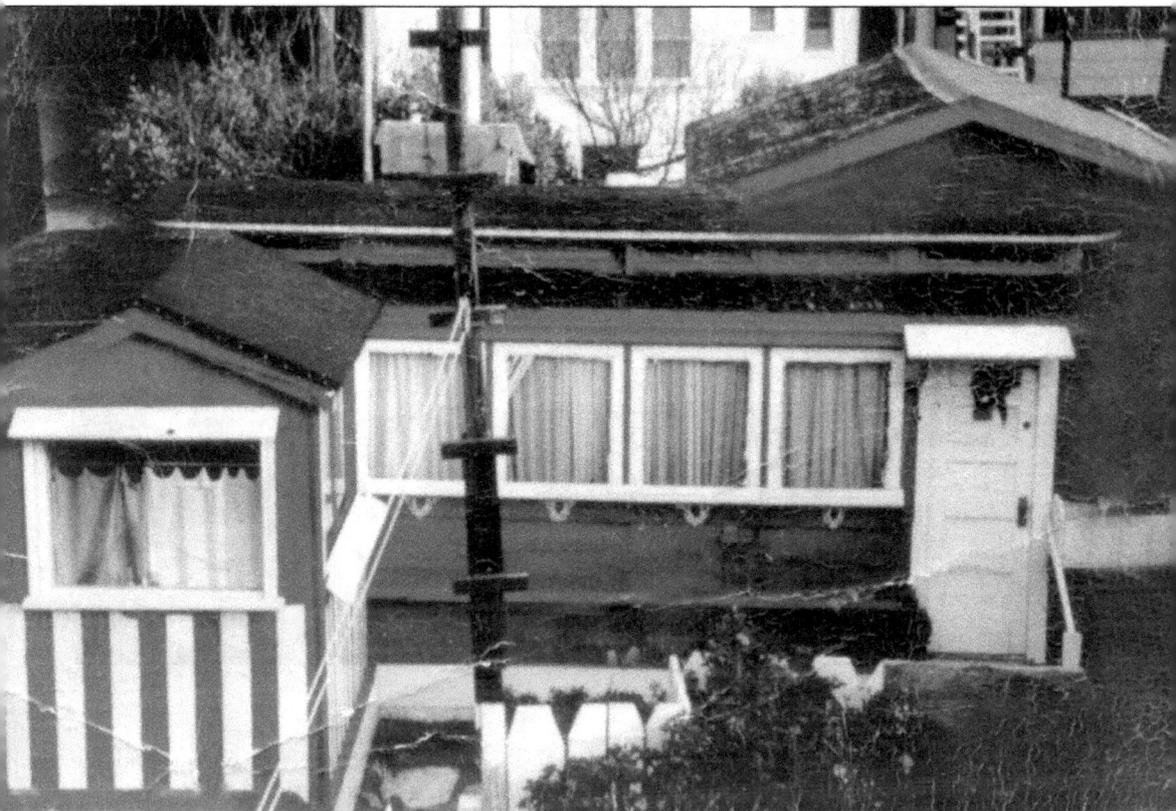

As the population of the Sunset grew, lots near the beach were sold for permanent housing, and Carville began to disappear. By the 1920s most of the cars were gone, and by the 1950s almost none could be seen. But from 1962 to 1965 Ken Malucelli was able to rent this converted car on Forty-eighth Avenue. It was later torn down. (Courtesy Ken Malucelli.)

Two Carville buildings are known to remain as housing, one on Forty-seventh Avenue and one nestled behind a modern garage on the Great Highway. (Author's collection.)

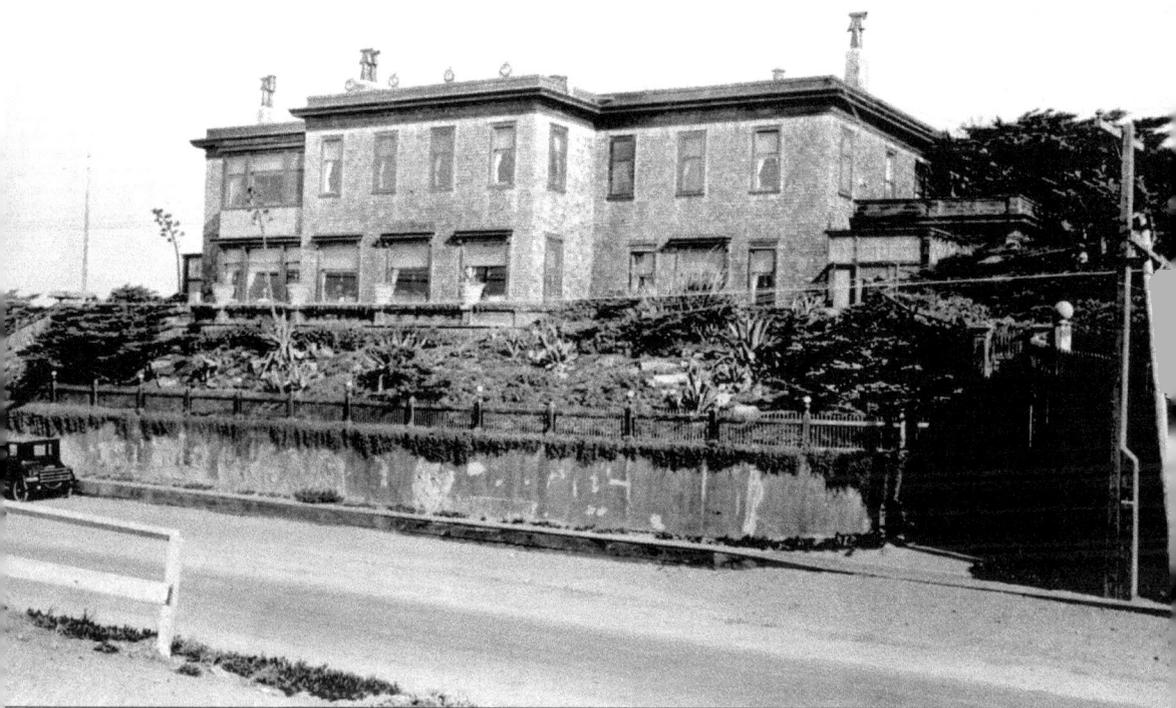

This grand building on the Great Highway between Ulloa and Vicente Streets was originally built as a home in the 1850s. After being sold in the late 1800s, it became the public Oceanside House, and later a residence once again. In 1919 restaurateur John Tait bought the building and opened Taits-at-the-Beach. Politicians, actors, and musicians enjoyed the food and music at this popular roadhouse, which operated for about twelve years before it closed in the 1930s. The building was destroyed in a massive fire on December 1, 1940.

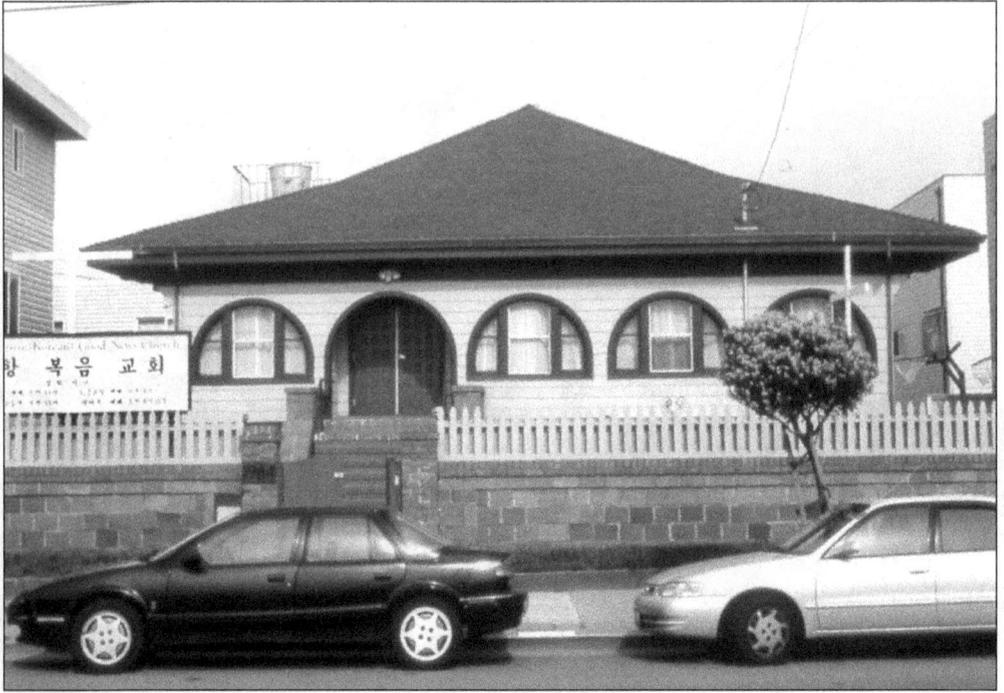

The Sullivan House was built in 1905 at 1984 Great Highway. It was probably used as a vacation home for Fire Department Chief Engineer Dennis T. Sullivan. Chief Sullivan was killed during the 1906 earthquake after he fell through several stories of his house on Bush Street. His widow moved into this house on the Great Highway and lived there until 1922. The house is now the home of the San Francisco (Korean) Good News Church. (Author's collection.)

This view of Twentieth Avenue in 1914 shows that many of the streets were not yet graded. The streetcar running near the center of the photograph appears to be buried in the sand. (Courtesy Emiliano Echeverria / San Francisco Municipal Railway.)

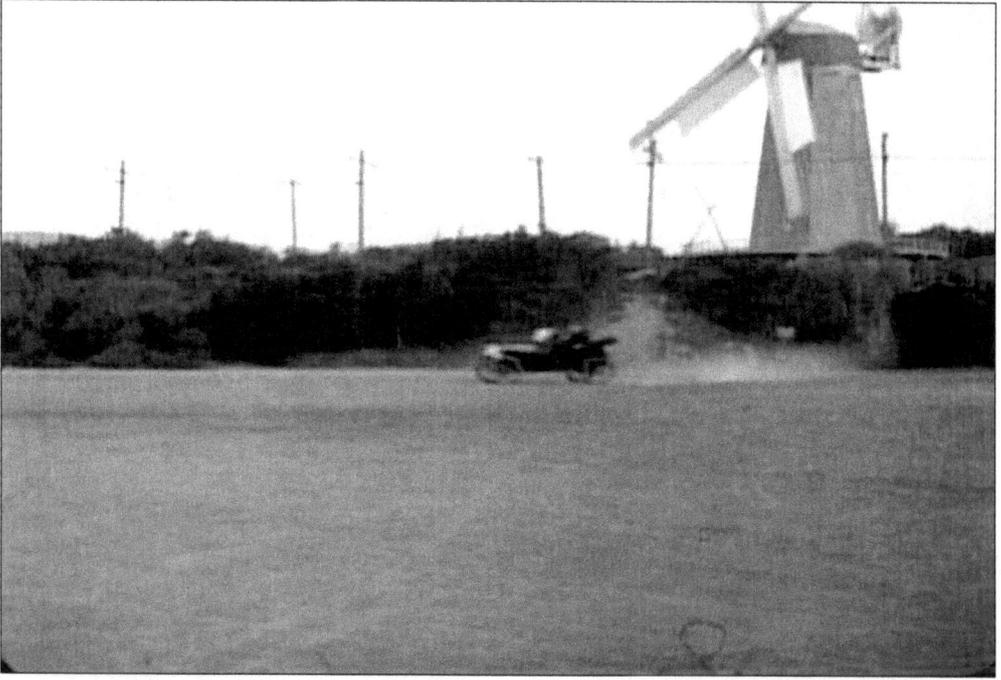

In 1915 Charlie Chaplin starred in a movie, *A Jitney Elopement*, filmed in San Francisco. These images from the film show Chaplin and a companion driving south of Golden Gate Park's Murphy windmill and along the Great Highway. (Courtesy Scott Trimble.)

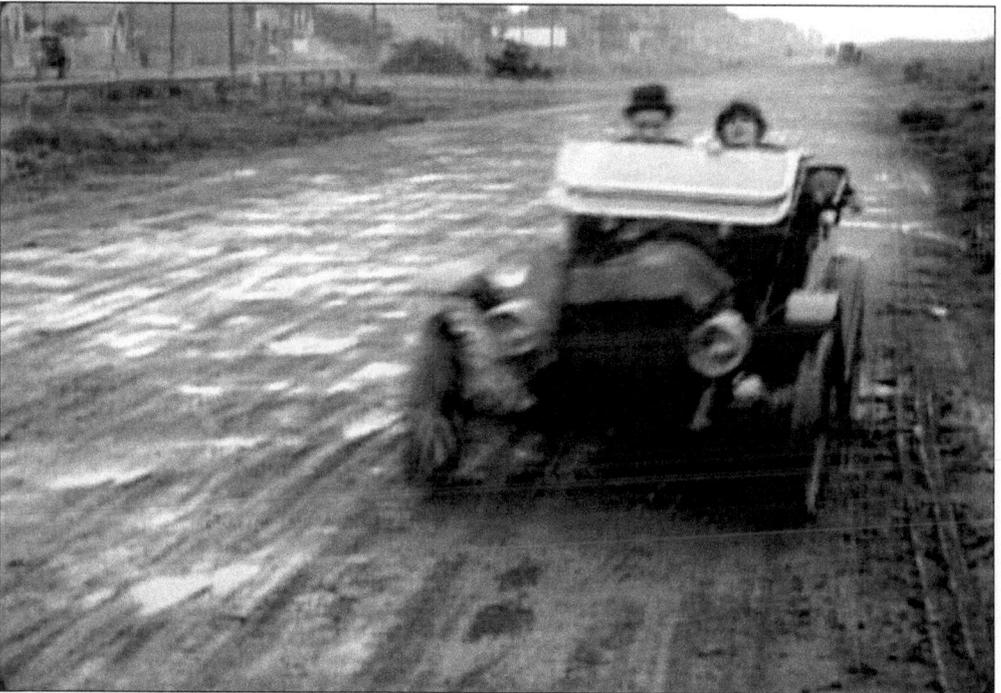

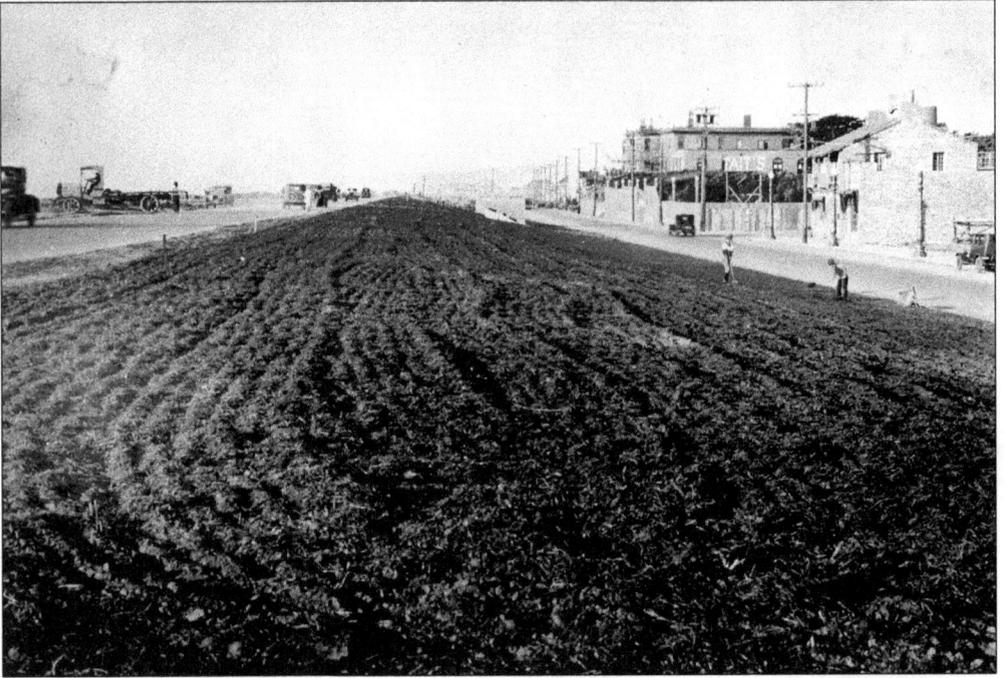

In 1927 the Great Highway, which ran along Ocean Beach at the west end of the Sunset District, was only partly paved and difficult to navigate. Note Tait's-at-the-Beach at the right of the photograph.

This photograph shows the Great Highway (far left) and La Playa (at the right) as later paved and landscaped to allow for automobile traffic. (Author's collection.)

Around the turn of the century James Guildea (right) posed with his friends just south of Golden Gate Park's Murphy windmill. (Don't miss the dog!) (Courtesy Grace Guildea Sholz.)

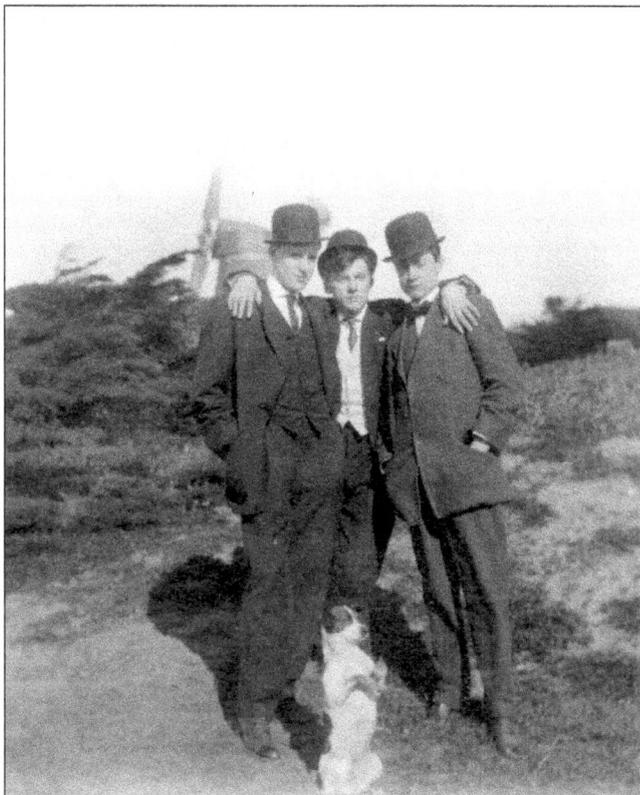

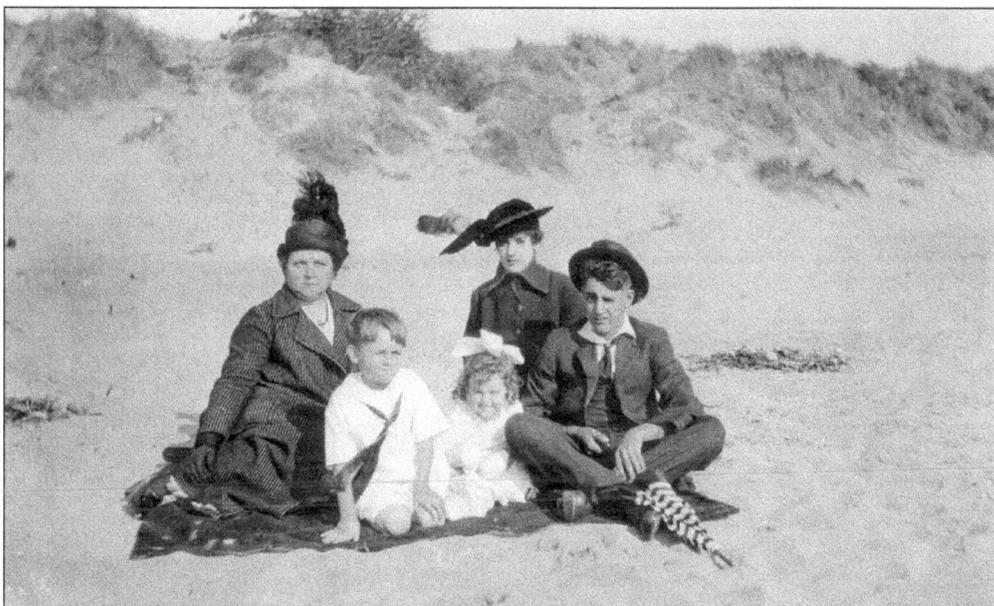

Ocean Beach, just west of the Outer Sunset and the Parkside, has been a popular recreational spot for generations. In 1914 a young family sat on the beach on a sunny, windy day. (Courtesy Joan Juster.)

In 1941 a boy played with his father at Ocean Beach. (Courtesy Bernice Lassiter.)

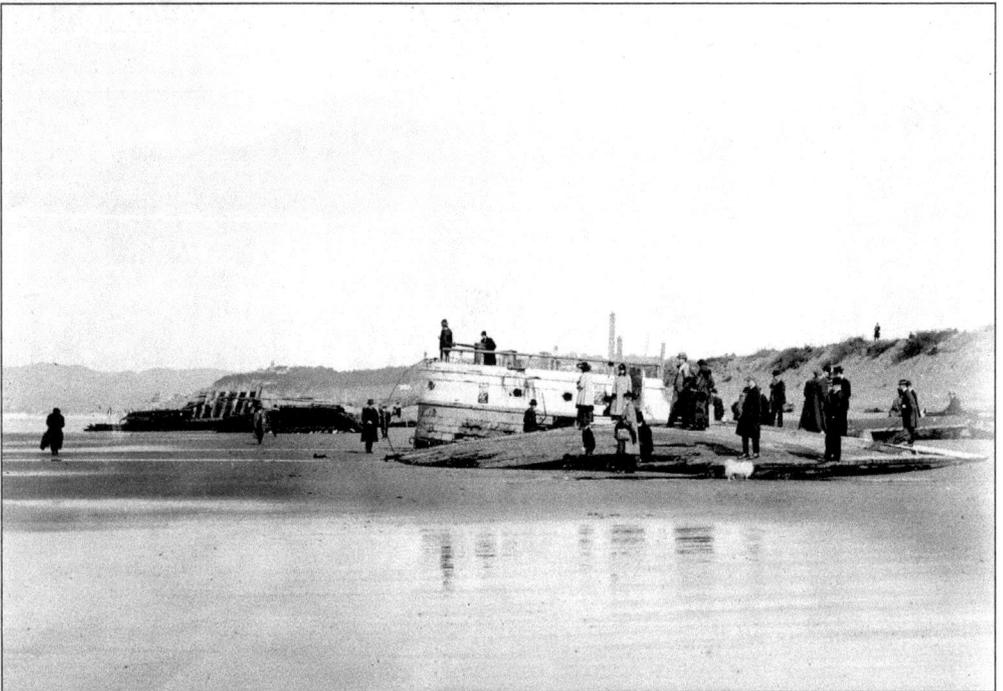

Ships often ran aground, and people flocked to the beach to see them. In 1916 the Aberdeen shipwrecked and washed onto the beach at about Lawton Street. The remains of other old sailing ships are known to be buried in the sands of Ocean Beach. (Courtesy Emiliano Echeverria.)

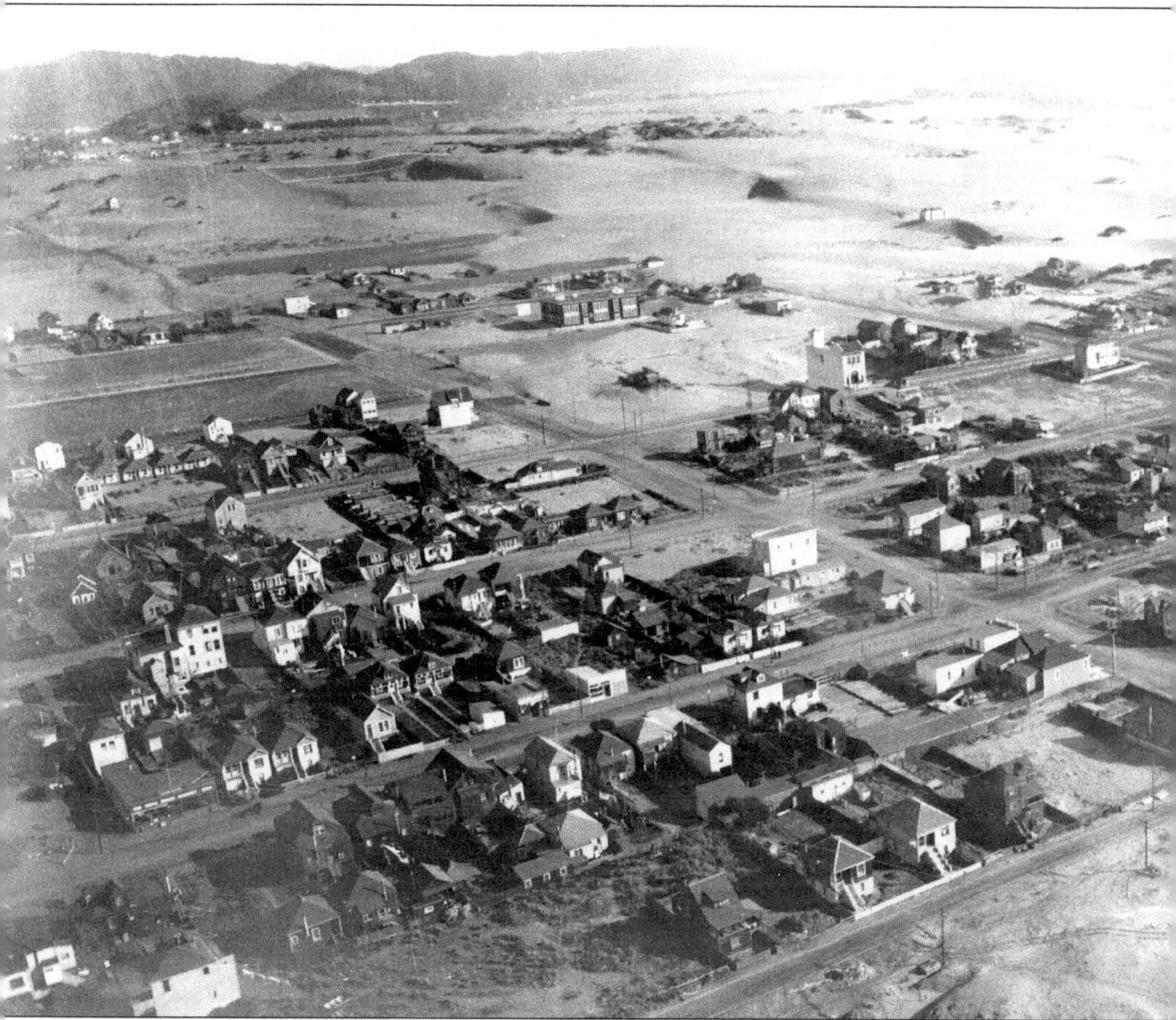

This eastern view in the 1920s from close to the beach shows the development on the western end of the Sunset and the rolling sand dunes of the central Sunset.

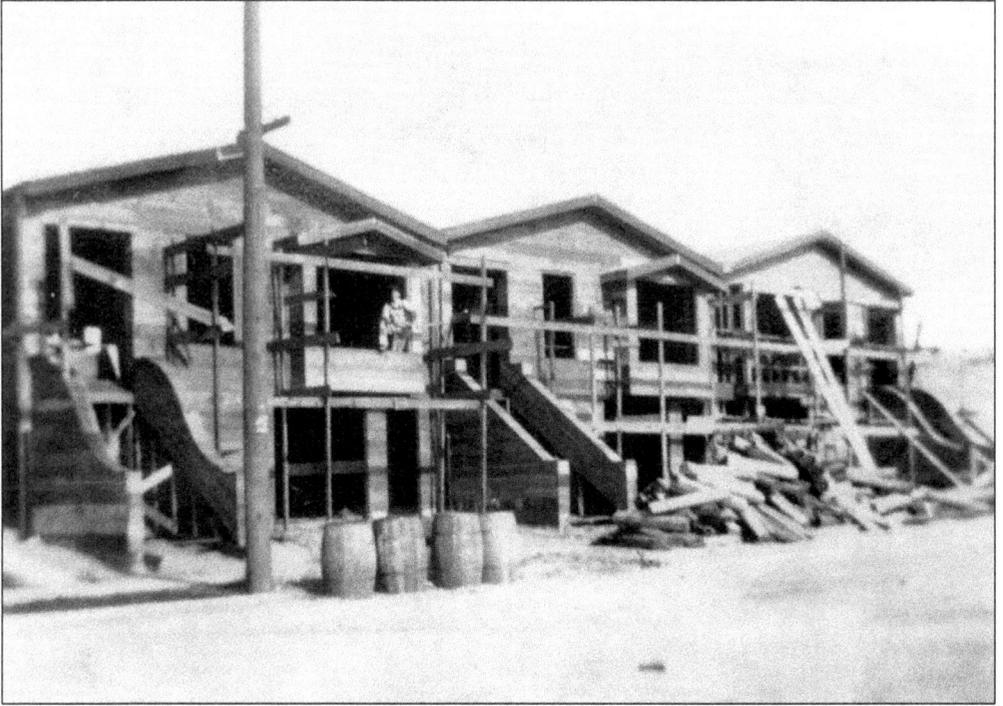

In 1923 the Guildea family built three houses side by side, just south of Lincoln Way. Grace Guildea grew up in 1278 Thirty-sixth Avenue, with her relatives living close by at 1282 and 1288. (Courtesy Grace Guildea Scholz.)

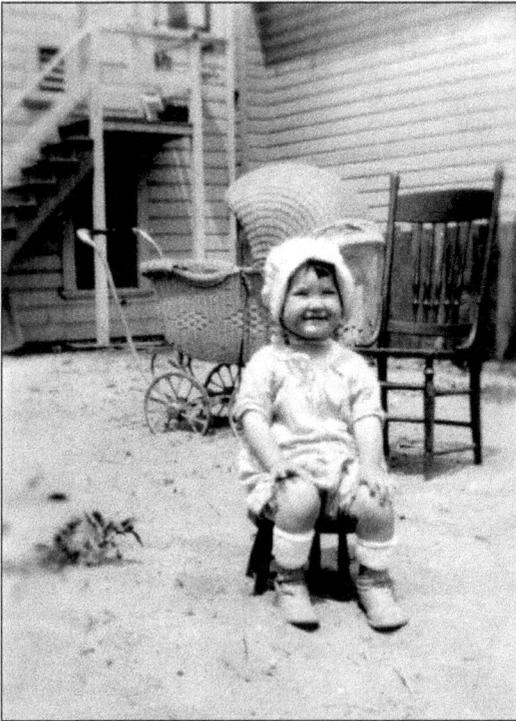

In the 1920s toddler Grace Guildea sat in her back yard shortly after the house on Thirty-sixth Avenue was built. Note the sand, which then covered the back yards of all Sunset District houses. (Courtesy Grace Guildea Scholz.)

In the 1920s, when the Guildea family looked out their front window on Thirty-sixth Avenue, they saw the view in the top photograph. (Grace Guildea Scholz.) In 2003, the view is of the busy Sunset Boulevard, which was cut through and paved in the 1930s. (Author's collection.)

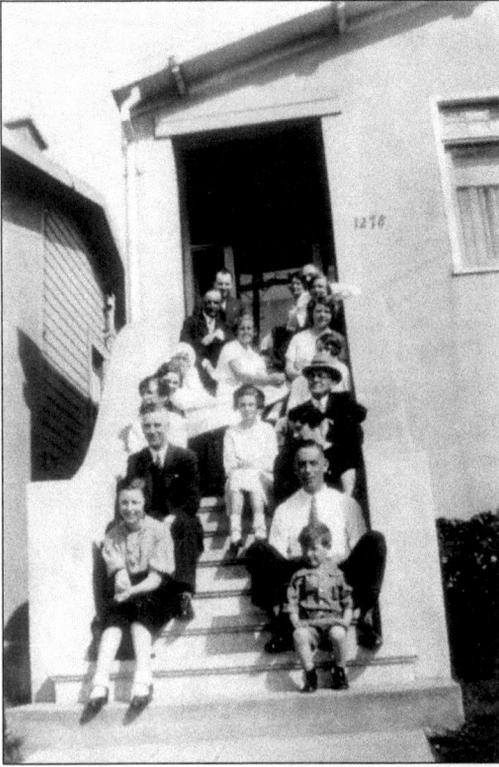

When Grace Guildea made first communion in 1934, the entire family posed on the front steps of the Thirty-sixth Avenue home. (Courtney Grace Guildea Scholz.)

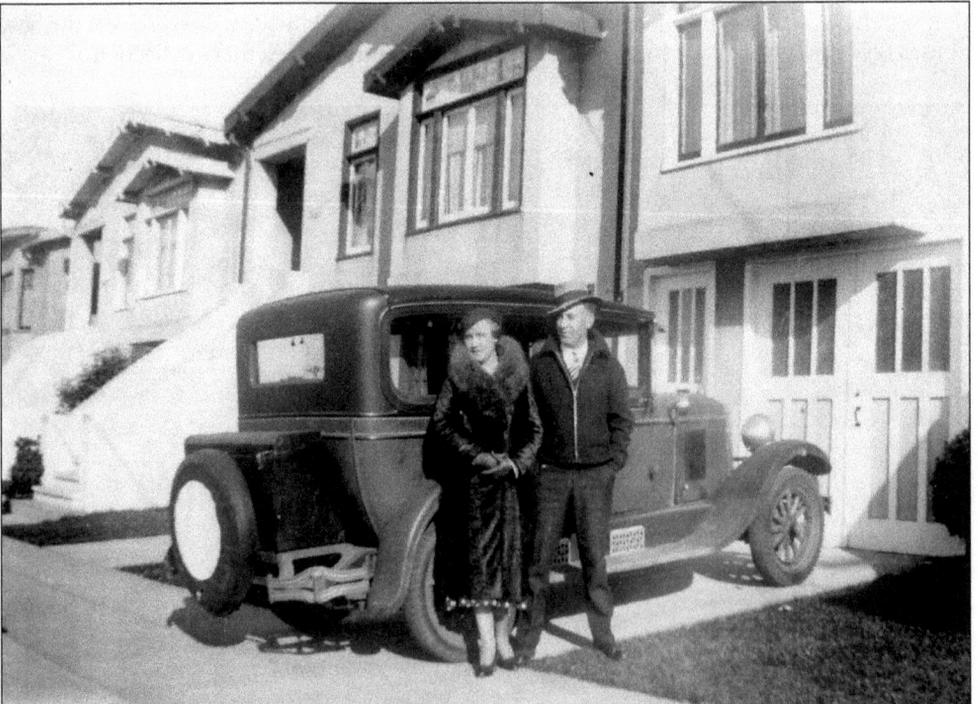

In 1935 Grace Guildea's aunt and uncle stood by their car in front of their house. (Courtesy Grace Guildea Scholz.)

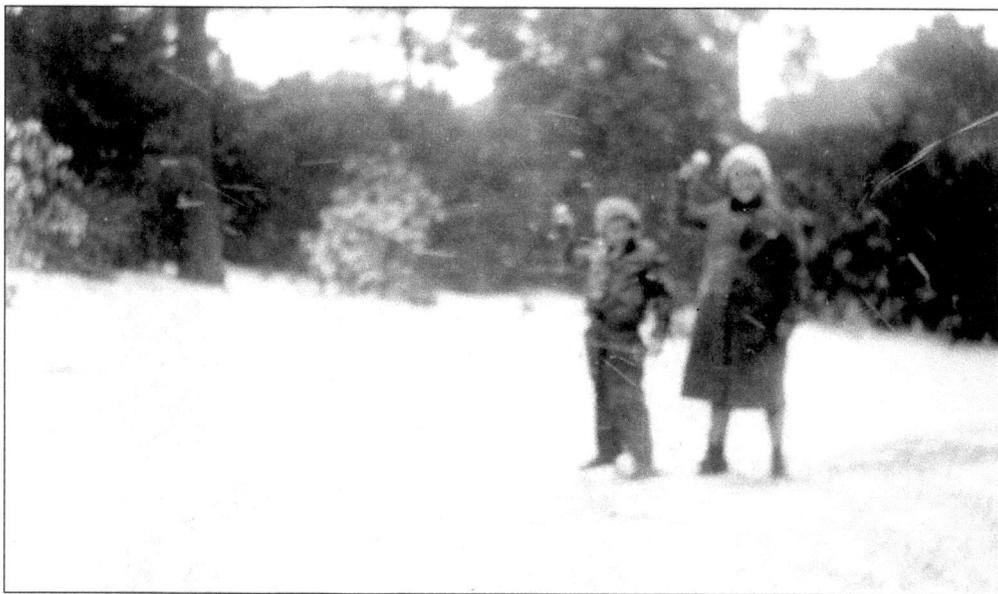

In 1932 it snowed in San Francisco. These children who lived near Thirty-sixth and Lincoln went to the park to celebrate the snow. (Courtesy Grace Guildea Scholz.)

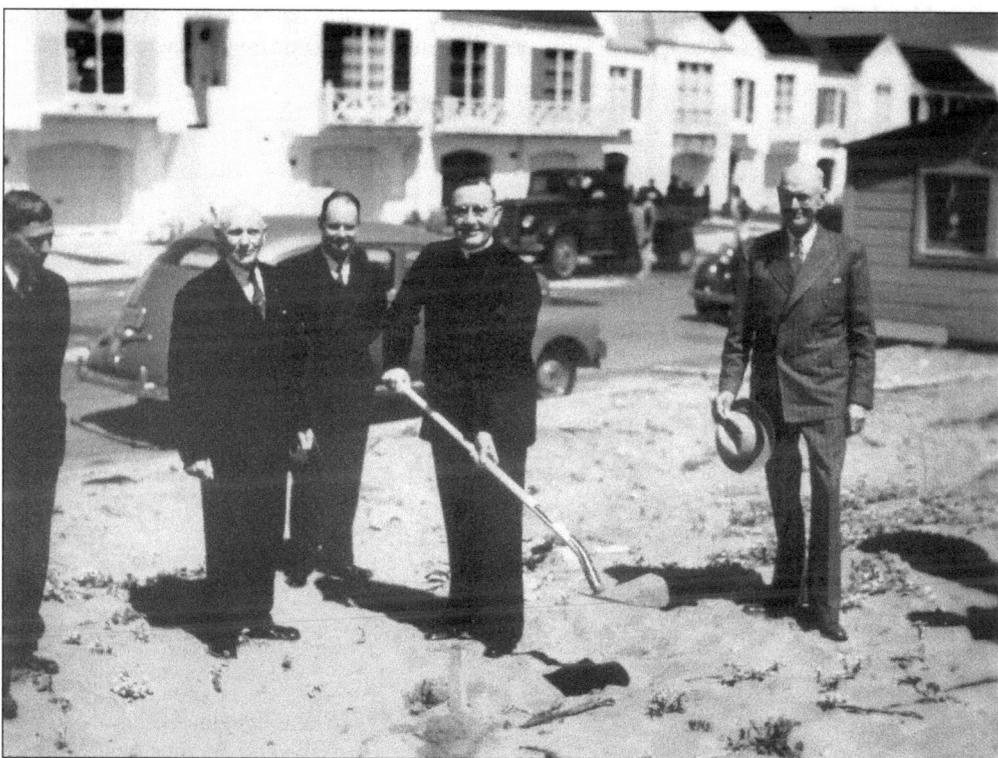

In 1940 groundbreaking ceremonies were held at Fortieth and Lawton for the second Holy Name Church. Father Richard Ryan held the shovel. (Courtesy Al Williams.)

In 1946 the executive committee of the Sunset Community Improvement Club met in the Boy Scout Hall on Twenty-forth Avenue between Irving and Judah Streets. Vice president Jerome Sapiro (bottom center) served as president the following year. (Courtesy Jerome Sapiro.)

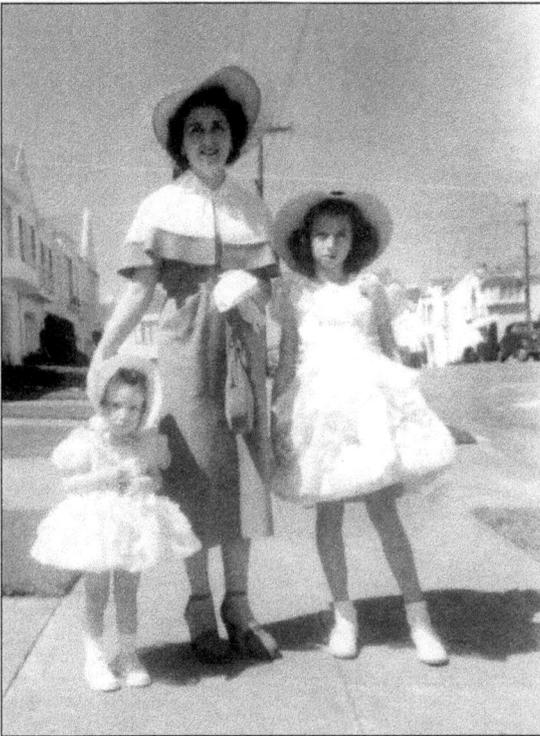

In 1952 the Guglielmone family stood on Thirty-second Avenue near Moraga, ready for Easter Sunday festivities. (Courtesy Murray Hushion.)

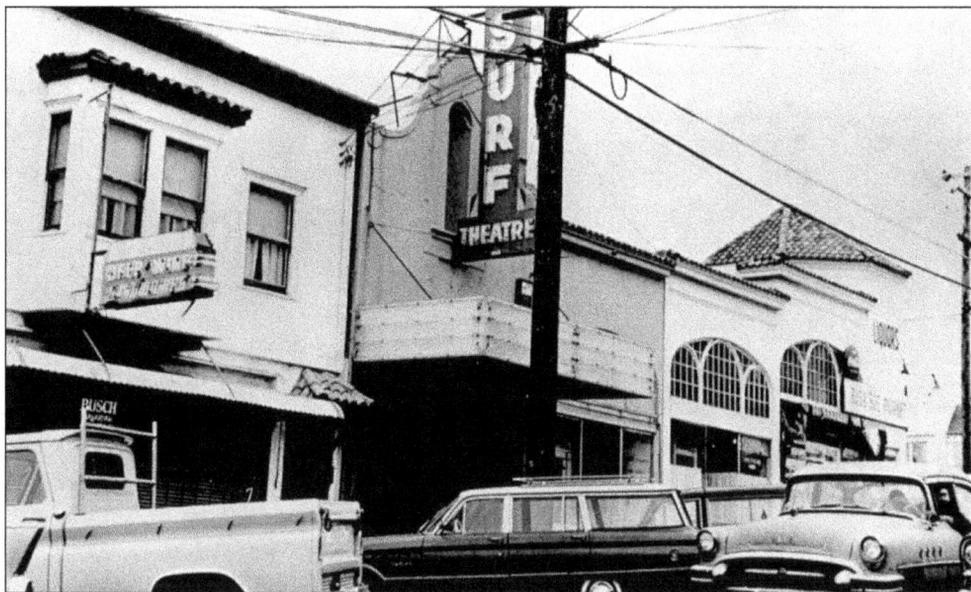

This photo shows the Surf, a popular small theatre on Irving Forty-fifth Avenue. It first opened as the Parkview in 1925. In 1937 it was renamed the Sunset. One resident believes that in the early 1940s the theatre may have had some connection to the local Catholic church. Joan McCormack explains, "Holy Name School used to announce to students that movies like *Joan of Arc* or *The Lady of Fatima* were going to be shown at the Sunset that weekend." The theatre's name changed to the Surf in 1957, and it became known for showing foreign and independent movies. In those days of the scarcity of "art film theatres," people came to the Surf from all around the Bay Area. The theatre closed in July 1985.

The ice-skating rink on Forty-eighth Avenue was a popular spot for birthday parties and skating lessons. The rink closed in the early 1980s.

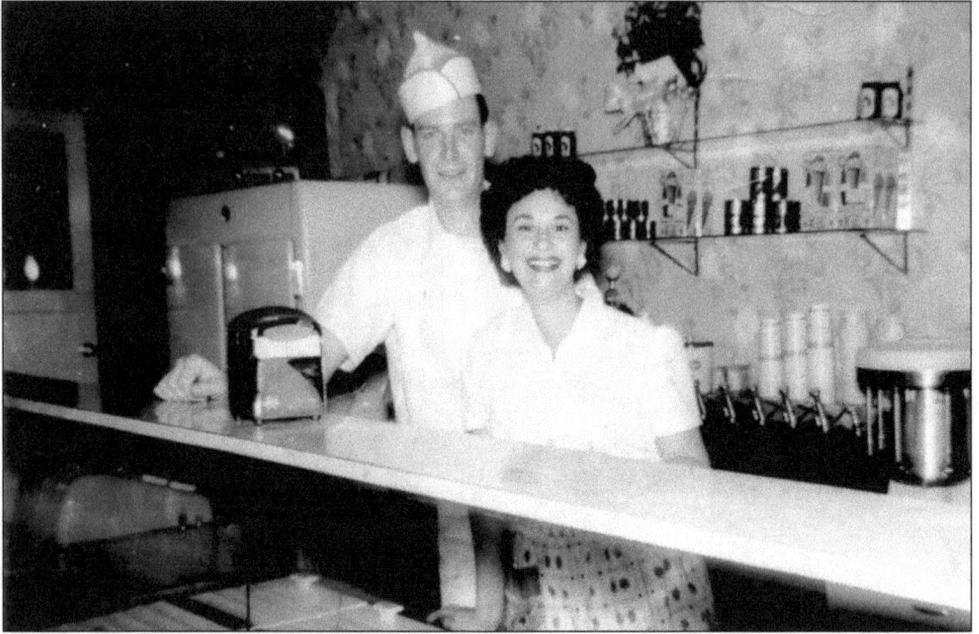

In 1959 Bernice and Chuck Lassiter bought the Polly Ann Ice Cream parlor on Noriega Street. It soon became a popular neighborhood destination. Bernice and Chuck, shown here on opening day, owned Polly Ann's from 1959 to 1967. (Courtesy Bernice Lassiter.)

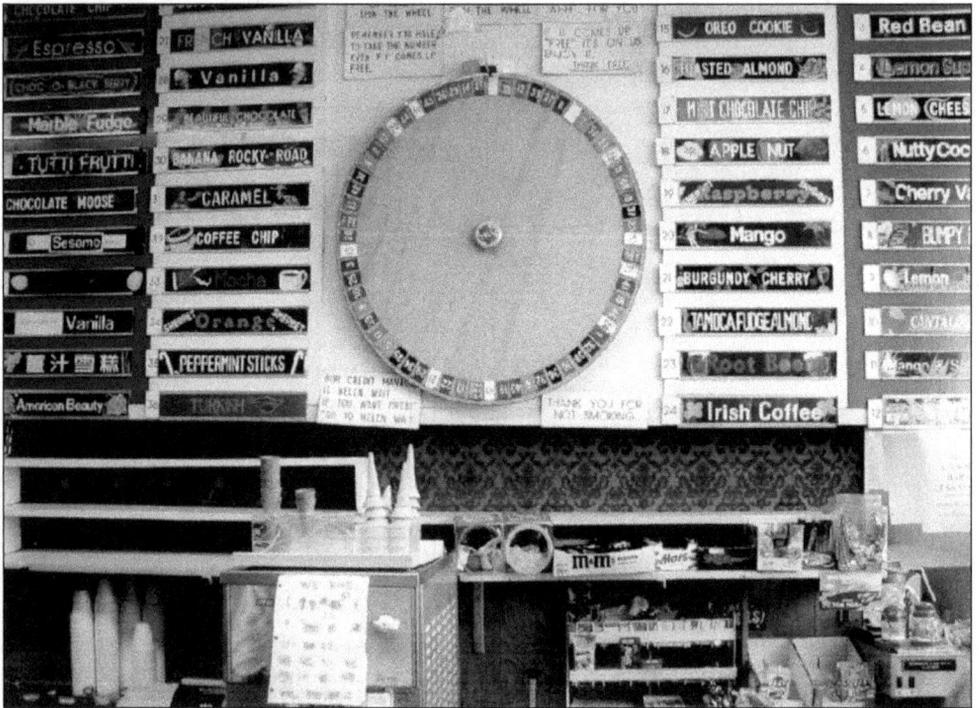

In later years Polly Ann Ice Cream was known for its exotic ice cream flavors and the wheel on the wall. If you couldn't decide what flavor ice cream you wanted, the wheel could decide for you. Polly Ann's closed in 2003 to make way for an apartment building. (Courtesy Bernice Lassiter.)

Five

FLEISHHACKER POOL AND SAN FRANCISCO ZOO

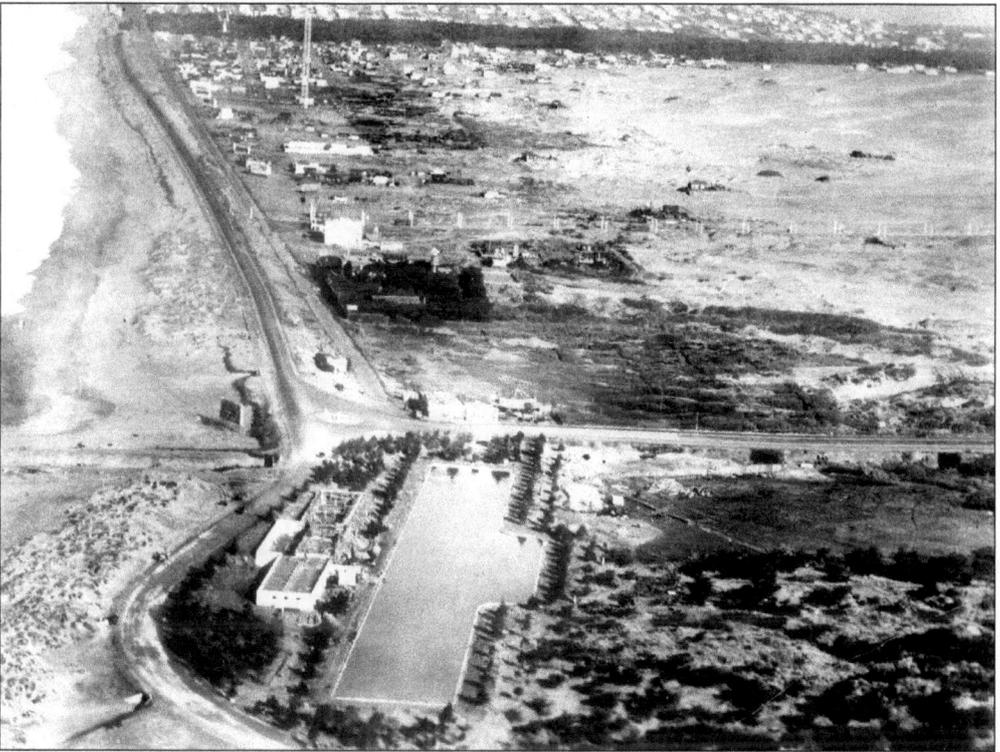

Fleishhacker Pool and the San Francisco Zoological Gardens are technically not in the Sunset District. However, no description of the growth of the Sunset would be complete without the zoo and the pool. Their proximity to the neighborhood made them important aspects of the childhoods of people growing up after 1925. The pool opened first, in 1925, when this picture was taken. The Pacific Ocean and the Great Highway lie on the left side of the picture. The sand dunes appear on the upper right. The dark horizontal strip near the top of the photograph is Golden Gate Park. North of the park, development of the Richmond District is well underway. (Courtesy San Francisco Zoological Gardens.)

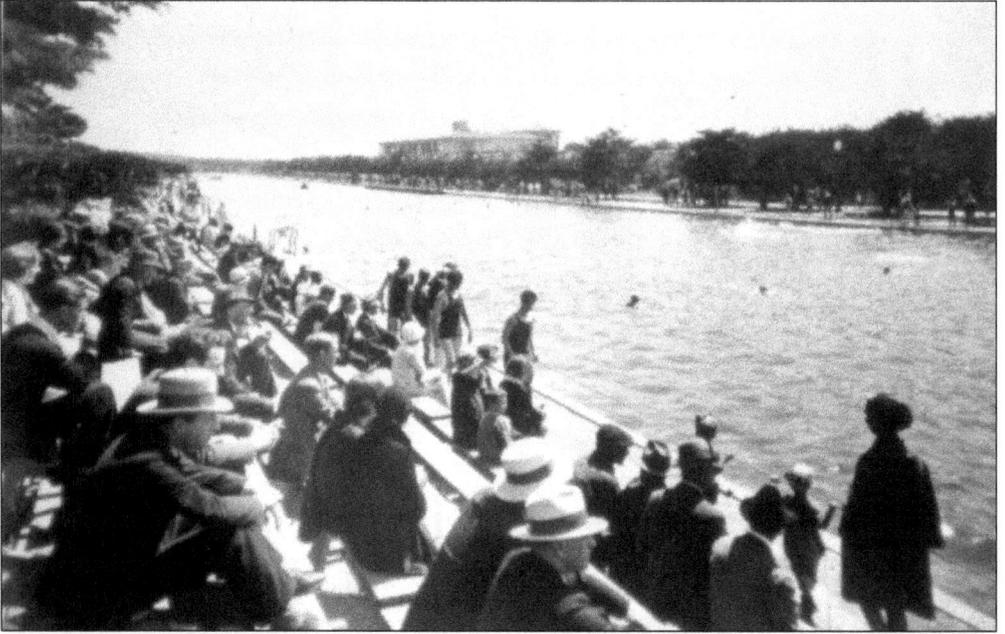

Herbert Fleishhacker, a San Francisco philanthropist and Park Commission president, donated money to provide a swimming pool for the people of San Francisco. For years it was the longest outdoor pool in the world. Six million gallons of sea water were pumped in directly from the ocean, less than half a mile away. People flocked to Fleishhacker Pool to swim and to watch other swimmers.

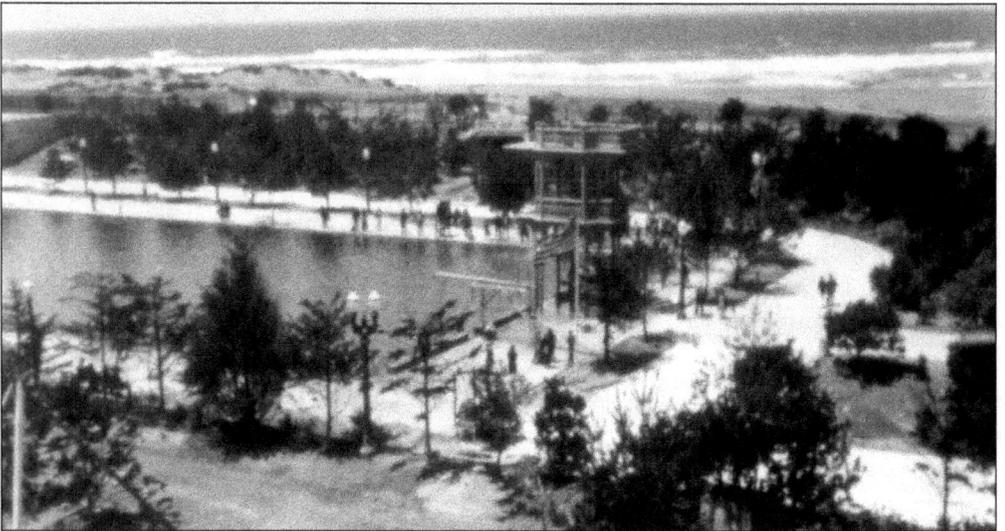

Champion swimmers, including Johnny Weismuller and Ann Curtis (one of Charlie Sava's students), trained at Fleishhacker Pool, and swimming meets were often held there. This photograph shows the high diving platforms—and the pool's proximity to the beach, essential for pumping the millions of gallons of seawater into the pool. Specifications and advertisements described a "heated pool," but one rarely (or never) finds someone who swam there who would testify that the water was anything but cold. (Courtesy San Francisco History Center, San Francisco Public Library.)

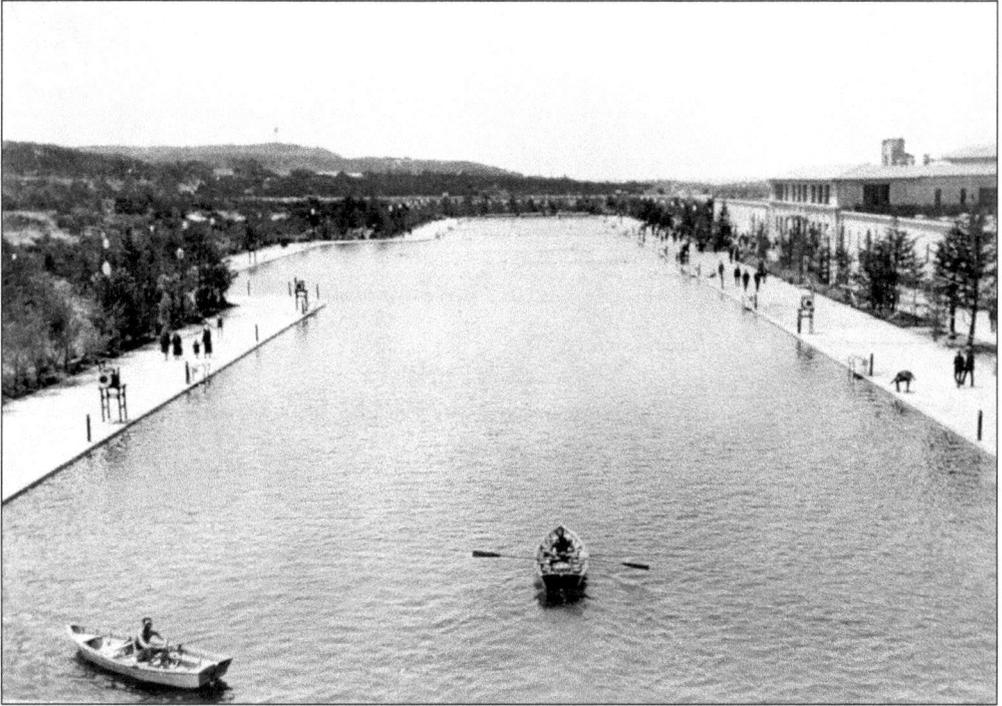

The pool was so large that lifeguards patrolled it in rowboats. Dorothy Calvetti Bryant recalls canoe training at Fleishhacker Pool as part of a lifeguard class taught by Charlie Sava in the late 1950s. (Courtesy San Francisco History Center, San Francisco Public Library.)

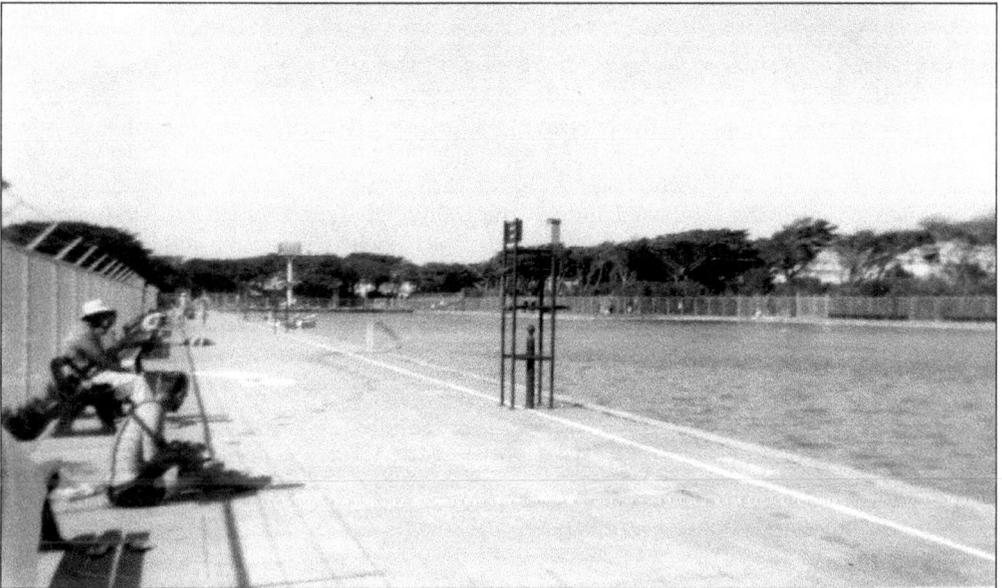

By 1960 more heated indoor pools had appeared in San Francisco. Fewer people were willing to swim in the cold, foggy air along Ocean Beach, and many people felt that the pool was not well maintained. It finally closed in 1971 and was later filled in. The site is now the parking lot for the San Francisco Zoological Gardens. (Author's collection.)

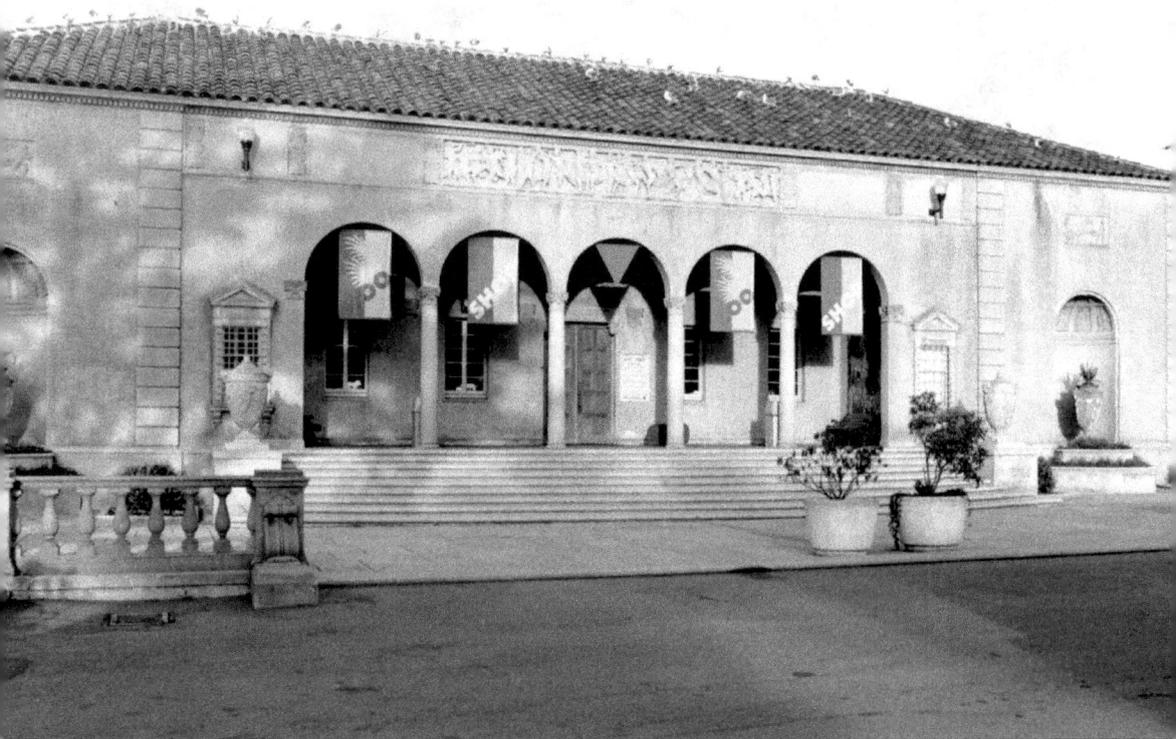

In 1925 the Mother's House and the Herbert Fleishhacker Playground opened near Fleishhacker Pool. Funded by the brothers Herbert and Mortimer Fleishhacker, the Mother's House was a tribute to their mother Delia who had died in the early 1920s. San Francisco architect George W. Kelham designed the Mother's House in the Italian Renaissance style. Its purpose was to provide a resting place for mothers visiting the playground with their young children. (Courtesy San Francisco Zoological Gardens.)

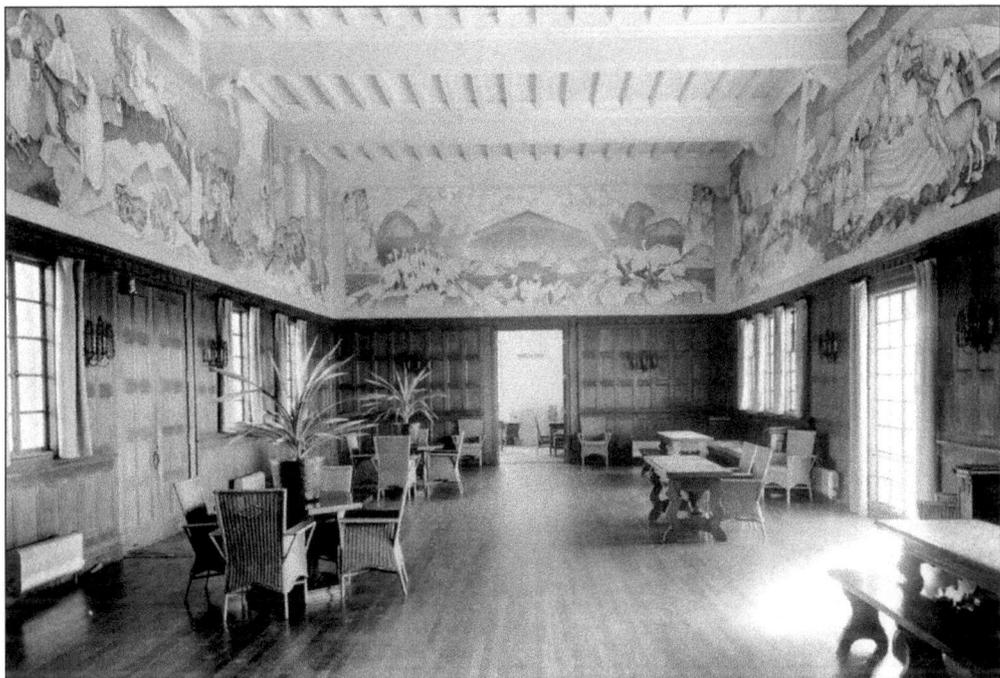

Inside, the beautifully designed Mother's House was a haven for visitors. Its murals, depicting Noah's Ark and animals, were painted by Helen K. Forbes and Dorothy W. Pucinelli as a Federal Arts Project. (Courtesy San Francisco Zoological Gardens.)

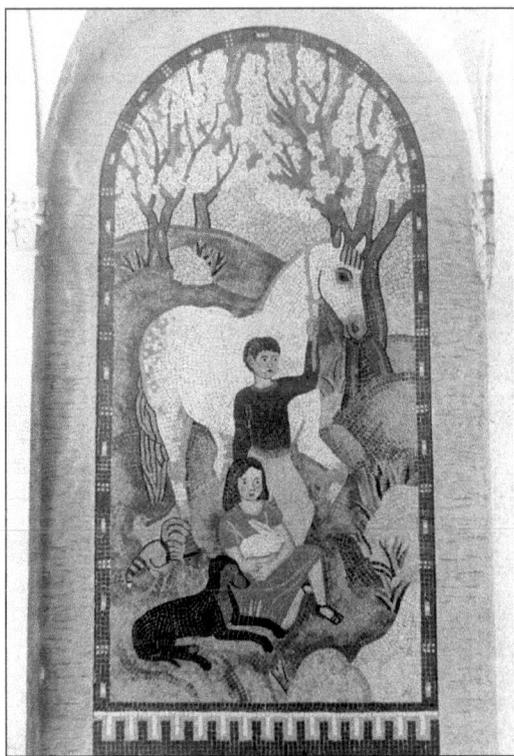

The two mosaics near the entrance to the Mother's Building depict St. Francis with animals and children with animals. The mosaics were designed by artists Helen Margaret and Ester Bruton as a Works Progress Administration (WPA) project. (Courtesy San Francisco Zoological Gardens.)

117

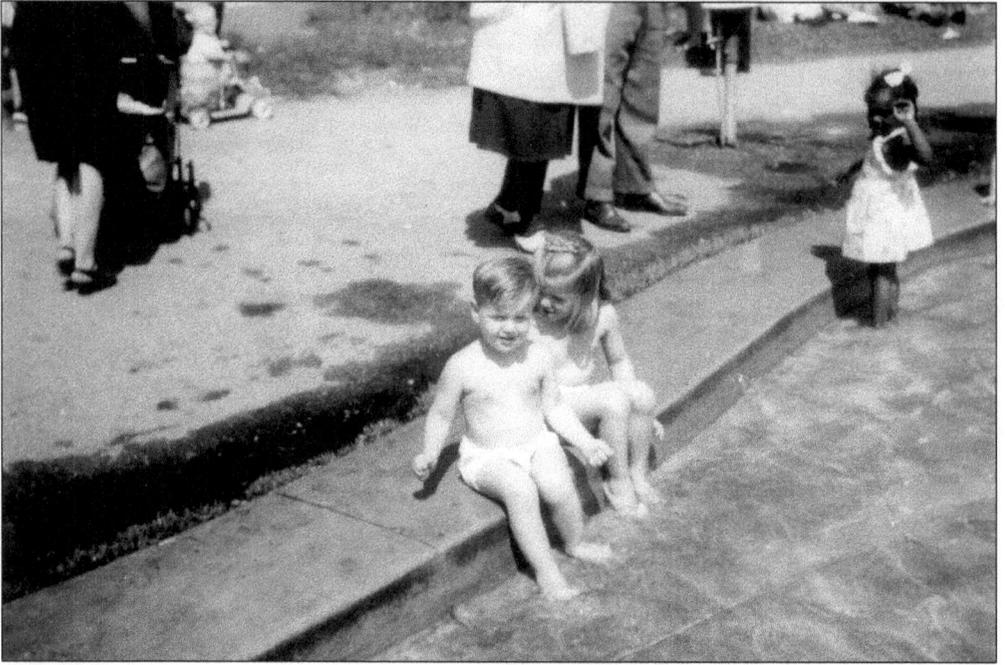

Near the Mother's House the Herbert Fleishhacker Playground offered a children's wading pool and playground. These 1950s photographs show Eddie and Janie Ferguson. (Courtesy Jane Ferguson Hudson.)

In 1957 the Southern Pacific
Company donated Old Engine 1294 to
the children's playground. (Courtesy
San Francisco History Center, San
Francisco Public Library.)

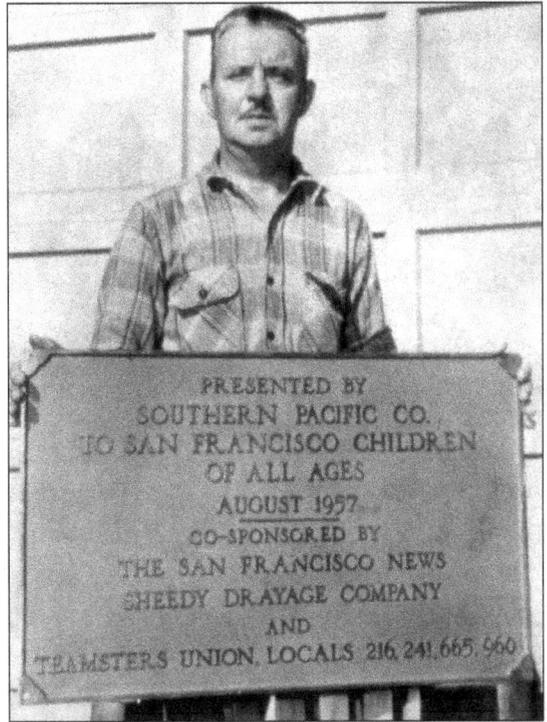

PRESENTED BY
SOUTHERN PACIFIC CO.
TO SAN FRANCISCO CHILDREN
OF ALL AGES
AUGUST 1957
CO-SPONSORED BY
THE SAN FRANCISCO NEWS
SHEEDY DRAYAGE COMPANY
AND
TEAMSTERS UNION, LOCALS 216, 241, 665, 960

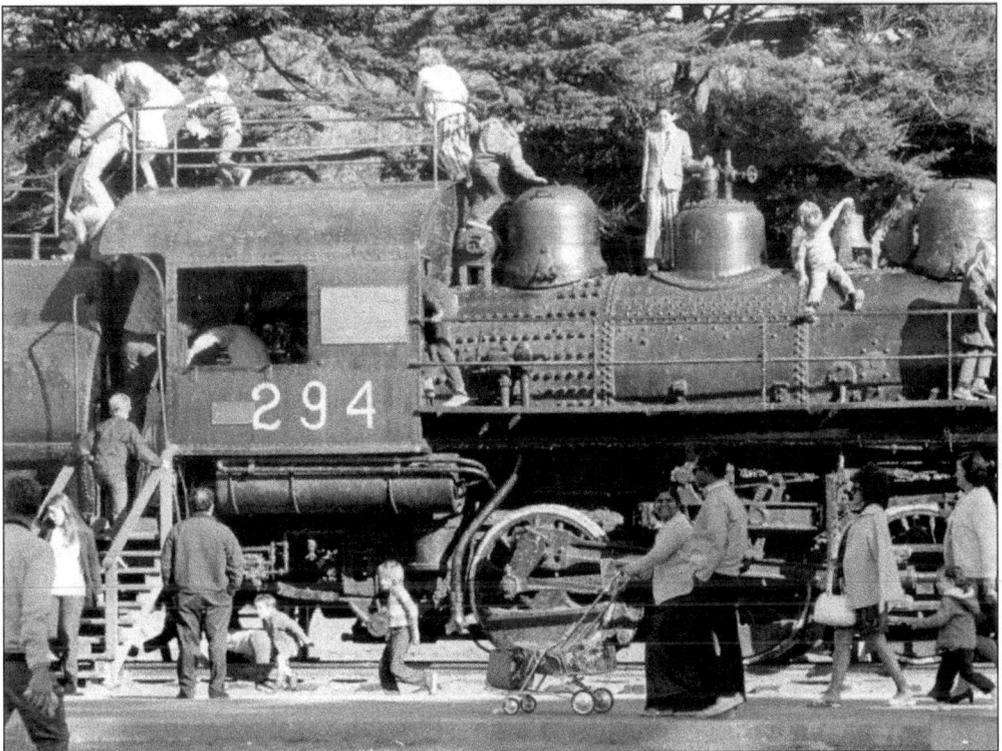

Engine 1294 had traveled 1,500,000 miles. Children spent hours climbing on, over, and
through the train engine. (Courtesy San Francisco Zoological Gardens.)

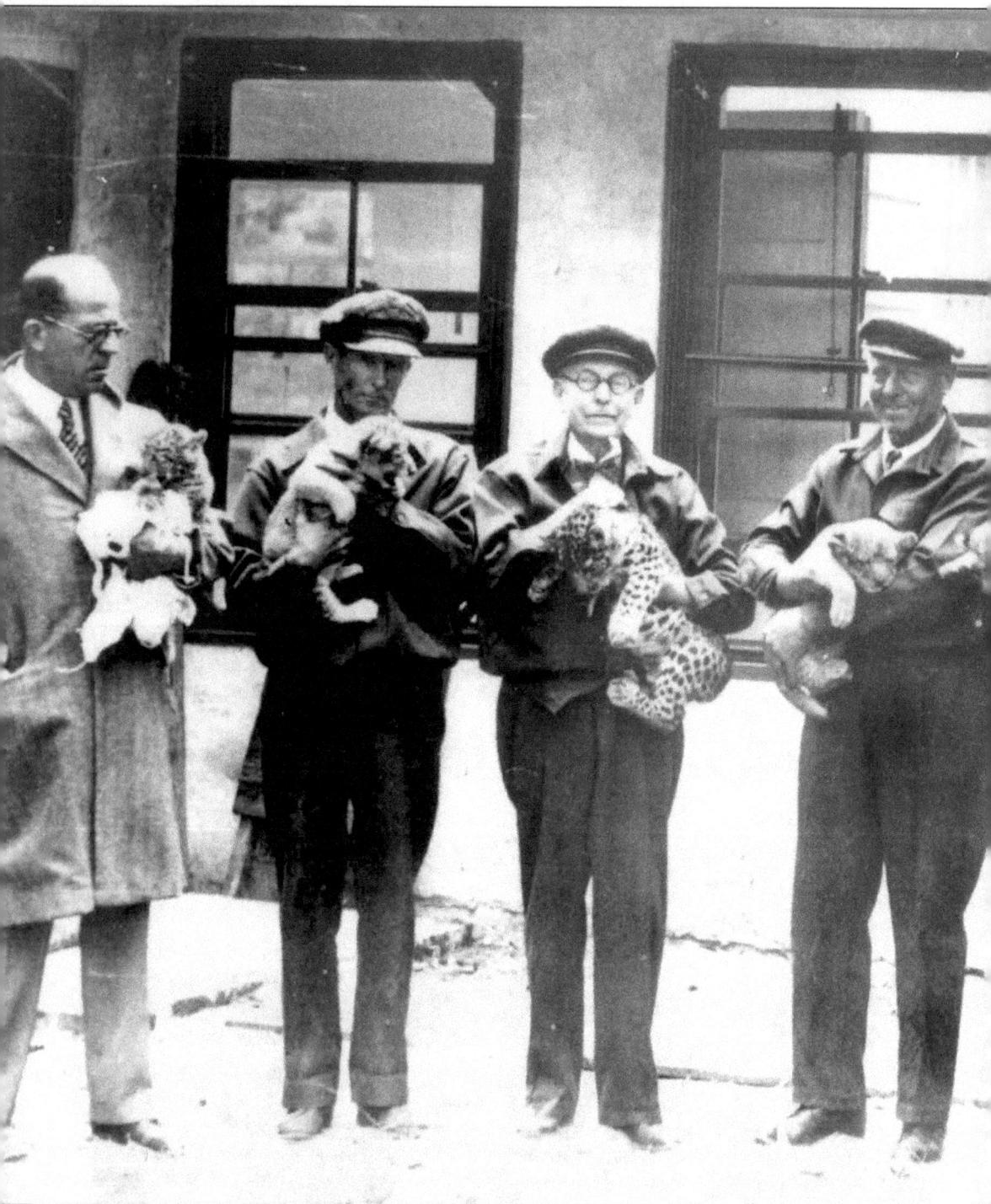

In 1929 Herbert Fleishhacker established the city's zoo next to Fleishhacker Playground and Fleishhacker Pool. The original animals in the zoo (some of which were transferred from Golden Gate Park) included a few baby lions, five Rhesus monkeys, two spider monkeys, three elephants, two zebras, two camels, one cape buffalo, and one Barbary sheep. Various zookeepers

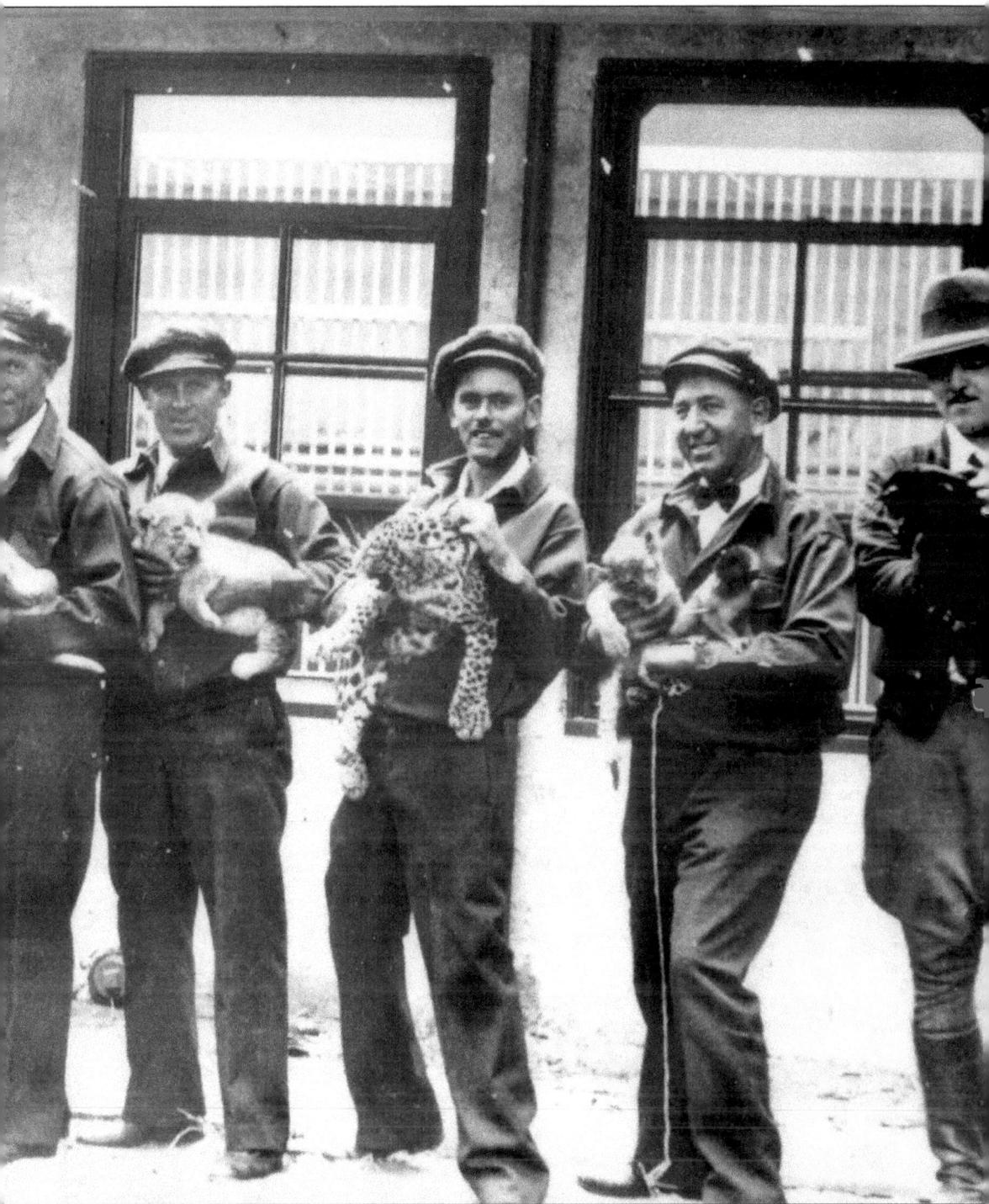

posed for this 1930s photograph holding new "members" of the zoo family. Although the name was changed in 1941 to The San Francisco Zoological Gardens, many long-time San Franciscans still call it "Fleishhacker Zoo." (Courtesy San Francisco Zoological Gardens.)

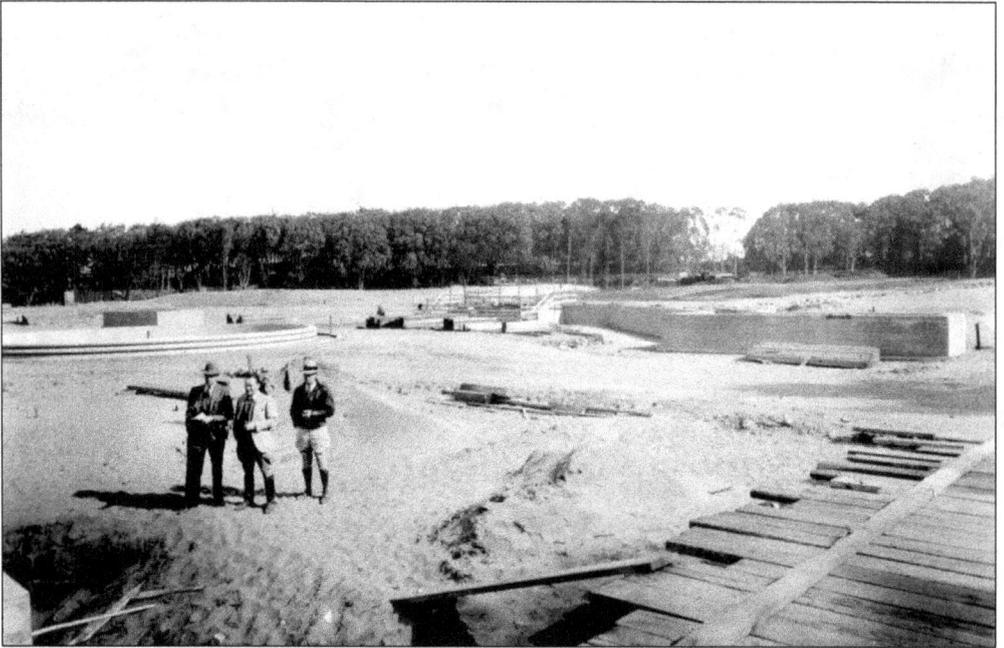

In the 1930s the Work Progress Administration (WPA) built the zoo's major exhibits including the central fountain, the elephant pool, and the lions den. Here, work is beginning on the central fountain. (Courtesy San Francisco Zoological Gardens.)

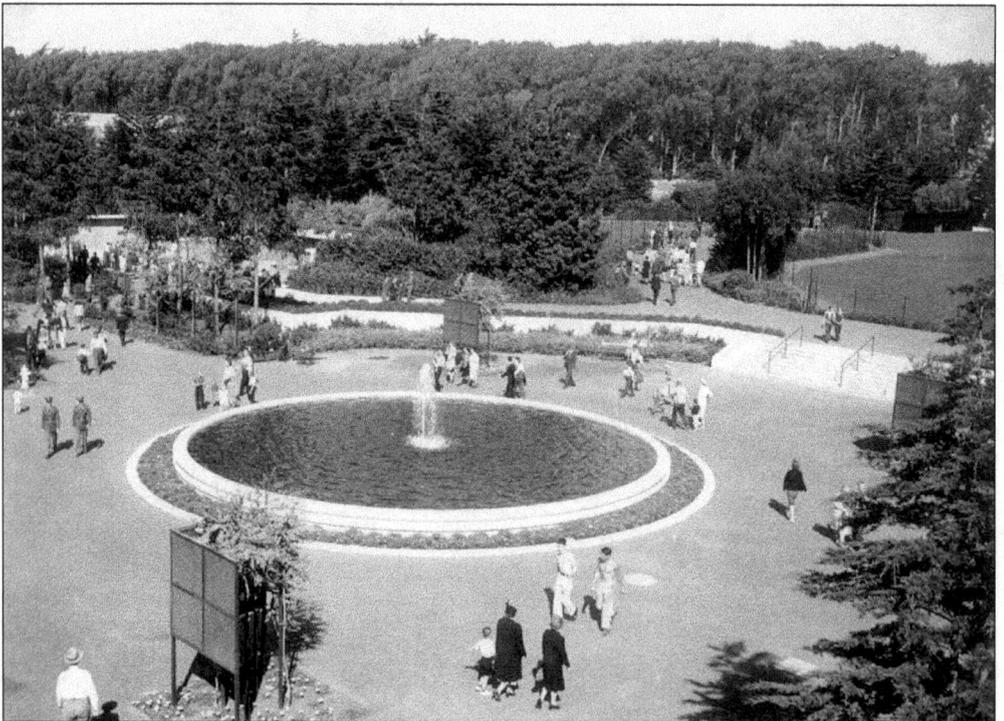

This photograph shows the completed central fountain. (Courtesy San Francisco Zoological Gardens.)

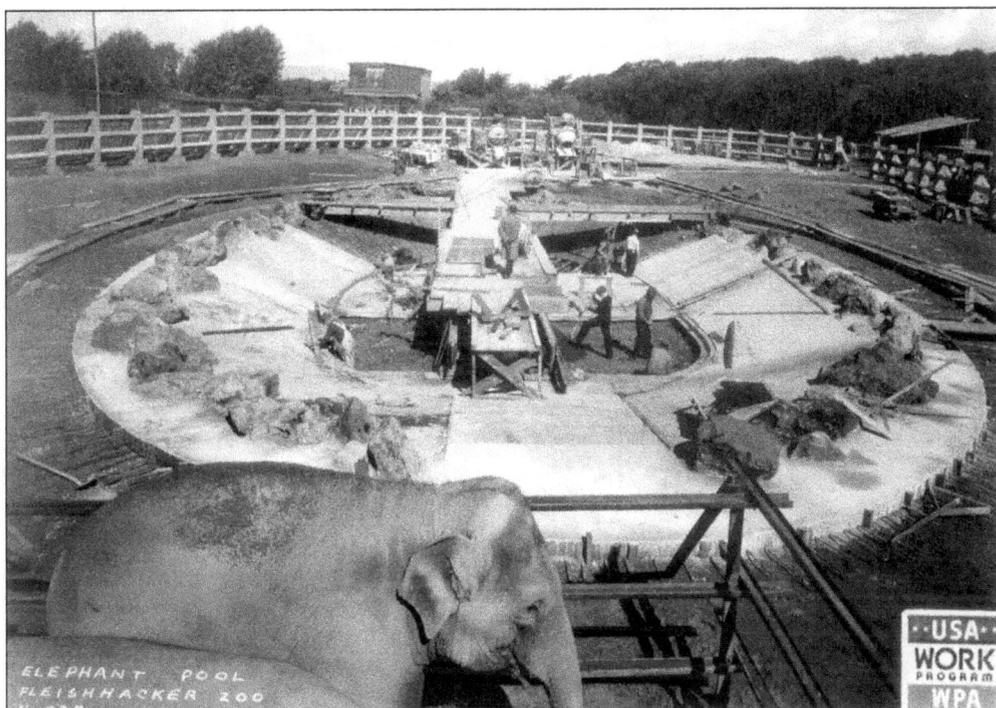
One of the WPA's projects in the 1930s was the elephant pool. (Courtesy San Francisco Zoological Gardens.)

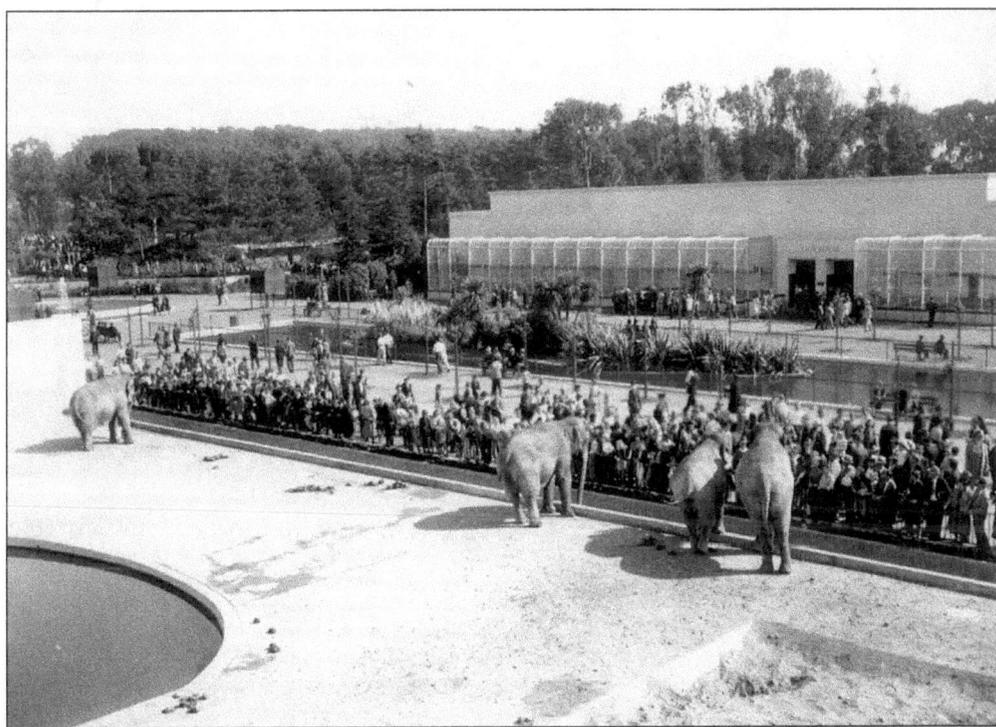
Zoo visitors enjoy the elephant pool. (Courtesy San Francisco Zoological Gardens.)

At the completion of the WPA projects in 1938 visitors enjoyed the grand opening of the zoo entrance on Sloat Boulevard (no longer used). Admission to the zoo and playground was free until May 1970. (Courtesy San Francisco Zoological Gardens.)

In 1964 a young boy at St. Cecilia's School, dressed as a lion in preparation for the parish festival, met Enorma, the zoo's baby elephant. (Courtesy Archives of the Archdiocese of San Francisco.)

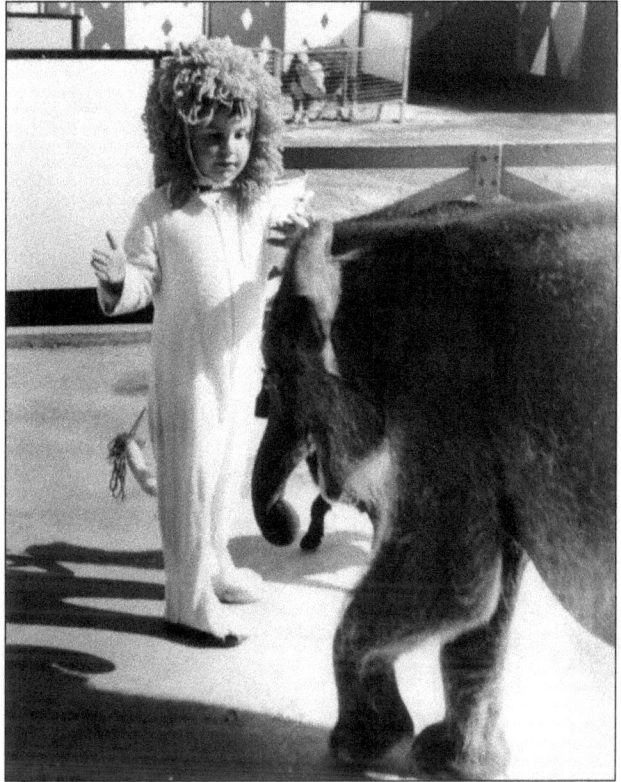

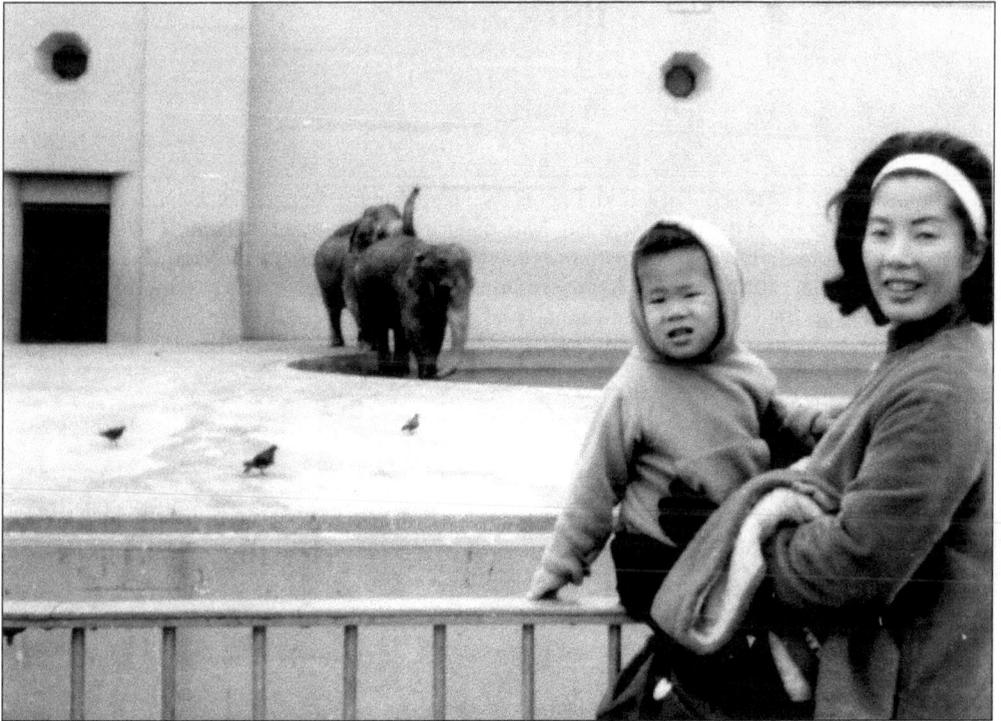

The Lim family visited the elephant pool in 1966. (Courtesy Richard Lim.)

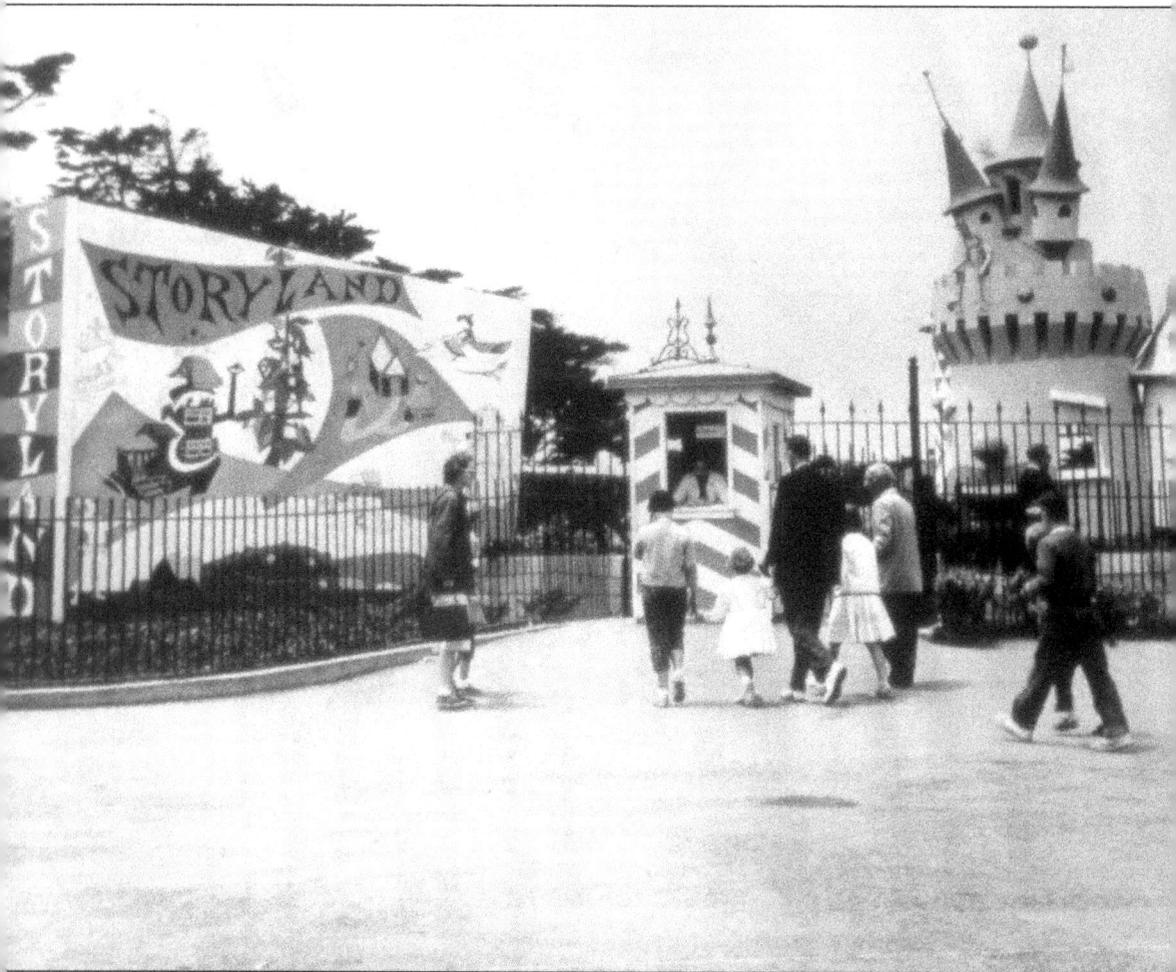

In 1959 the San Francisco Park and Recreation Department opened Storyland next to the children's playground. The three-acre site was designed by architect J. Francis Ward. Visitors entered via Rapunzel's castle. The entrance was the correct height for children, but adults had to bend over or walk through the side pedestrian entrance to get in. It was common for Parkside children to hop on the L Taraval streetcar and make frequent trips to Storyland, an adventure best enjoyed without adults. (Courtesy San Francisco History Center, San Francisco Public Library.)

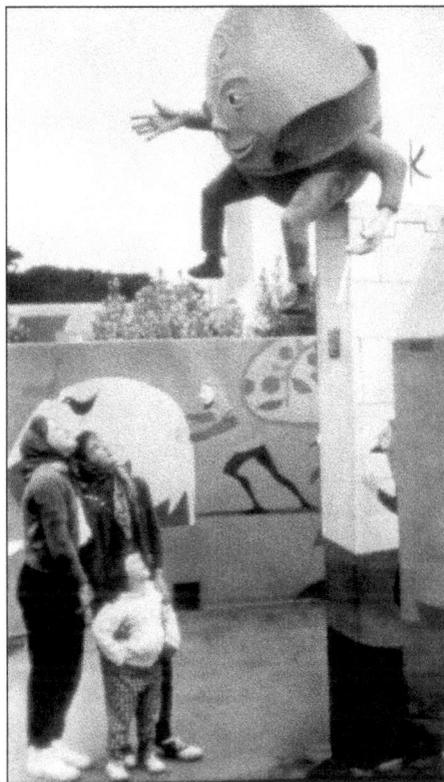

Storyland featured 26 plaster reproductions of nursery rhymes and fairytales. Children listened to "Jack and Jill" and saw the characters splayed out down the side of a "hill." Behind this hill, the children could walk up a stairway and careen down a slide. Or they could walk into the "Hansel and Gretel" witch's hut through the doorway and climb out through the oven. These two displays depicted Humpty Dumpty and the Old Lady Who Lived in a Shoe. Storyland closed in the 1960s; it was replaced by the children's petting zoo. (Courtesy San Francisco History Center, San Francisco Public Library.)

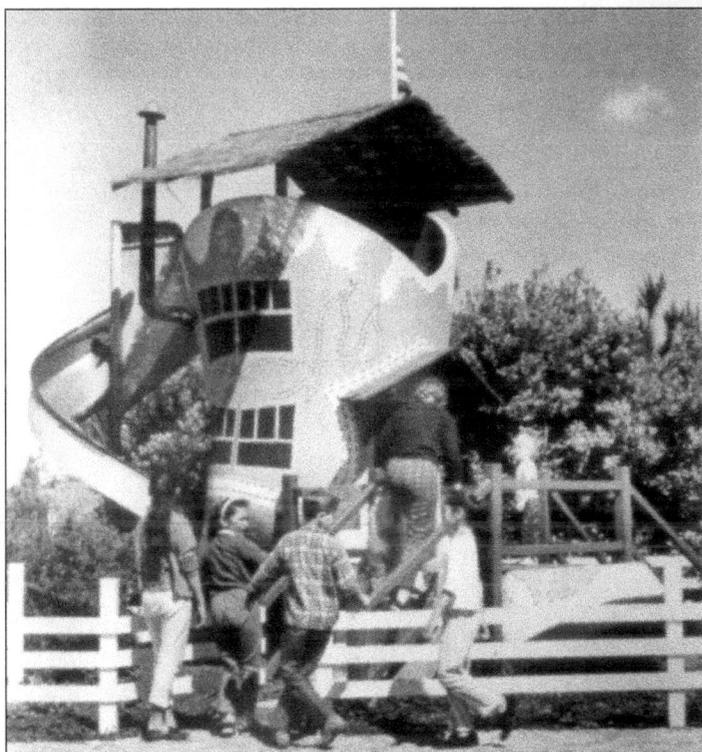

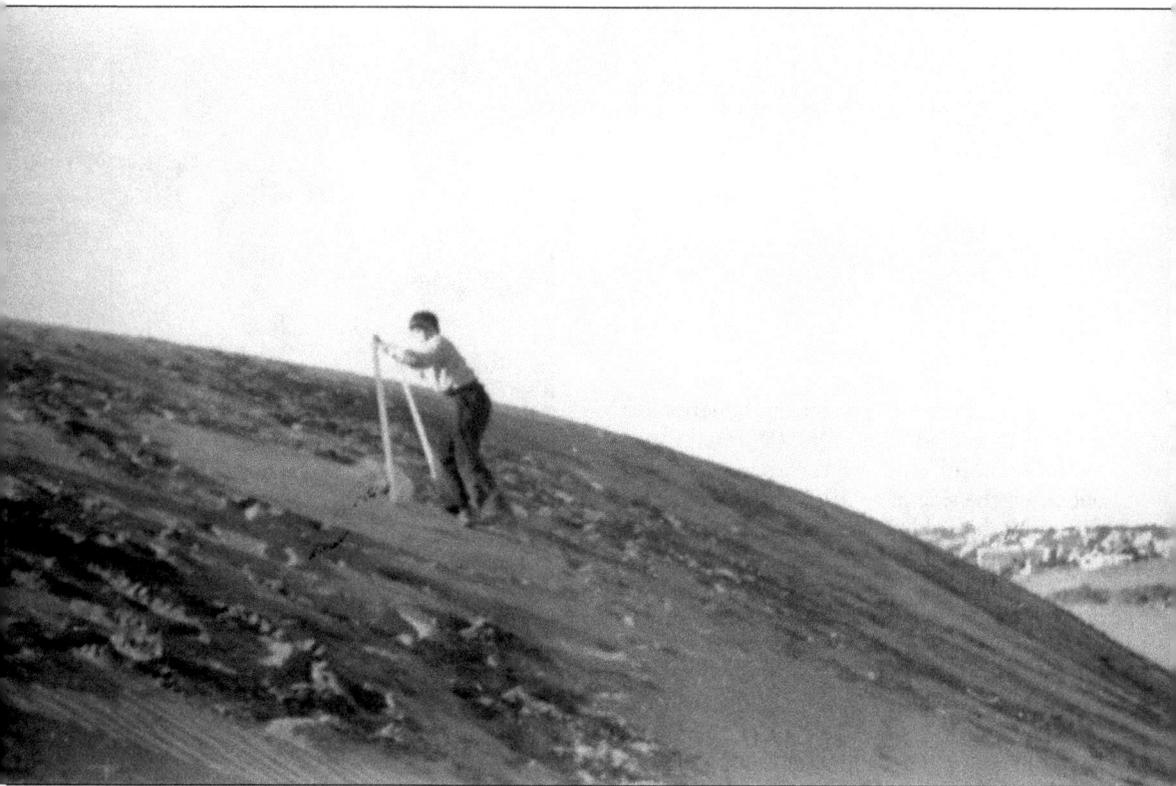

In the 1950s, when I was a child in the Parkside, many people on the eastern side of San Francisco still thought of the Sunset as the Outside Lands, a place where families went only on a Sunday excursion to the beach, the zoo, Storyland, or Fleishhacker Pool. But for me, these sites were my back yard. My friends and I could easily and safely hop on the L Taraval streetcar any day after school and enjoy these special places—for free or nearly free. The dunes provided other adventures for Sunset children in the early days. This March 1940 photograph shows Alfred Williams climbing a sand dune on Thirty-eighth Avenue halfway between Kirkham and Lawton. Boys growing up at that time often went "skiing" in the dunes. Note the houses in the background. (Courtesy Al Williams.)